CRIMES OF STYLE

CRIMES OF STYLE
Urban Graffiti and the Politics of Criminality

Jeff Ferrell

Photographs by
Eugene Stewart-Huidobro

Northeastern University Press

BOSTON

Northeastern University Press 1996

Library of Congress Cataloging-in-Publication Data

Ferrell, Jeff.
Crimes of style : urban graffiti and the politics of criminality /
Jeff Ferrell ; photographs by Eugene Stewart-Huidobro.
p. cm.
Originally published: New York : Garland, 1993, in series: Garland
reference library of social science ; vol. 774. Current issues in
criminal justice ; vol. 2.
Includes bibliographical references and index.
ISBN 1-55553-276-4
1. Graffiti—Colorado—Denver. 2. Graffiti—Social aspects—
Colorado—Denver. 3. Architecture—Mutilation, defacement, etc.—
Colorado—Denver. I. Title.
[GT3913.C62D473 1996]
302.2'22—dc20 96-7383

Printed and bound by Thomson-Shore, Inc., in Dexter, Michigan. The
paper is Glatfelter Supple Opaque, an acid-free sheet.

MANUFACTURED IN THE UNITED STATES OF AMERICA
04 03 02 01 00 7 6 5 4 3

To
Rasta 68, Eye Six, HL86, Mac
and the writers of the Denver scene:

Live like it matters

What is crime and what is not?
What is justice? I think I forgot!

> Ice-T, "Squeeze the Trigger," 1987

What is crime? What is not?
What is art? I think I forgot!!!

> Phaze3's "Crime" piece, Denver, 1990

Contents

Acknowledgments

As a sociologist, it is my task and passion to investigate the social construction of everyday life. This ongoing adventure offers all manner of insights into the collective nature of deviant behavior, human sexuality, ethnic identity, cultural change—and "individual" creativity. In noting here debts of gratitude, then, I also acknowledge publicly those who participated with me in the collective writing of this book.

My debts begin with Trey Williams and Marilyn McShane, who first suggested and encouraged this book, and who provided a much appreciated blend of support and direction. Within the boundaries of this project and beyond, they also provided the kind of intellectual excitement that makes our work worthwhile. For the same sorts of creative sparks and social supports, I must also thank, especially, Gregg Barak, Clint Sanders, Christina Johns, Susan Caulfield, Tom Cushman, David Filewood, Joel Ferrell, Gil Ferrell, and Dorris Ferrell. And this short list, of course, not only omits many others who escape my hurried memory, but all those who kept me supplied with newspaper clippings, inside tips, and other useful information over the course of this project.

Friends and colleagues at Regis University provided invaluable support. Jamie Roth and Alice Reich fought to create the sort of sociology department in which work like this could go forward. Eleanor Swanson demonstrated her continuing commitment to the written word by graciously agreeing to read and comment on large sections of the manuscript. Gene Stewart, whose remarkable photographs give meaning and texture to the following pages, was kind

enough to wander endlessly with me down Denver's railyards and back alleys, and various intellectual and aesthetic back streets as well. This journey across disciplines and traditions taught me, perhaps appropriately, more than I can say. Paula Whitaker and Andrea Stary time and again served as valuable assistants in the sometimes tedious process of research. Kate Secrest helped keep me in a working relationship with computers and printers. Inter-Library Loan supervisor Kathy Goldston put up with my daily visits and, along with the Dayton Memorial Library staff, provided me a world of information.

Others outside academia were also of great help. Ann Cecchine and Troy Williams opened avenues into alternative media and culture. Val Purser and Jay Beswick contributed important information on anti-graffiti campaigns in Denver and elsewhere; and Liz Crow at Wax Trax Records, Denver, helped define a musical and lyrical context for making sense of graffiti. Joe Kennedy took the time to introduce me to the graffiti underground in Denver; and Marion Doorduijn, Jasper Luitjes, and Lars Doorduijn provided not only gracious hospitality, but an entry into the remarkable world of graffiti in The Netherlands. At Northeastern University Press, William Frohlich and Scott Brassart offered a much appreciated environment of professionalism and collegiality.

I must finally note two special debts. To thank the members of the Denver graffiti underground for their "cooperation" in this project would hardly capture the nature of things. Early on, the situation moved well beyond cooperation between researcher and research subjects, to an ongoing interplay of artistry, friendship, and mutual adventure. Eye Six, Rasta 68, HL86, Mac, Voodoo, Z13, Phaze3, Fie, Top, Mode, 2Quik, Toon, Japan, Evad, Shoop, Kash, and the other writers and clowns of the Denver scene have given me more than these pages can hold. Last is Karen Lang-Ferrell. I could mention the transcribing, the library and newspaper searches, and the thousand other kindnesses without which the rest wouldn't much matter. But how can I ever thank you for the love and anarchy?

Crimes of Style

Introduction

Graffiti marks and illuminates contemporary urban culture, decorating the daily life of the city with varieties of color, meaning, and style. In Denver, Colorado, as in other cities throughout the United States, Europe, and beyond, particular forms of graffiti incorporate particularly different styles and meanings. During the late 1980s and early 1990s, for example, Denver and its suburbs have seen the markings of racism and reaction. Near a suburban city hall, a blank billboard is painted with a "W/P" (for "white power") and a swastika. Students at two suburban high schools confront graffiti attacking blacks and other ethnic minorities, and promoting the Ku Klux Klan. And graffiti sprayed on a Greek Orthodox Cathedral—adjacent to the Allied Jewish Federation and Jewish Community Center—features, along with swastikas, the phrases "Skinheads USA," "Hitler Reborn," "White Power," and "Die Jews."[1]

Using both spray paint and brush paint, others during this same period block-letter "Christ Jesus," "Trust Jesus," and similar phrases on back walls and park walkways in and around Denver. In central Denver's Capitol Hill neighborhood, the young followers of Genesis P. Orridge's Temple of Psychic Youth—a sort of international, post-punk performance cult—declare a different faith, writing the Temple's distinctive triple crosses and slogans on garage doors and alley walls. These same alleys reveal, during the war in the Persian Gulf, both spray painted criticisms of U.S. imperialism and jingoistic attacks on Saddam Hussein. In nearby Longmont, Colorado, residents debate the fate of "Cheaper

Charley's shed," an abandoned, graffiti-covered gas station which one city councilwoman describes as a landmark that "represents a lot of history for Longmont" (in O'Keeffe, 1990: 6). In the end, the shed is dismantled, cleaned, and resurrected as part of a charity campaign—with Longmont residents now donating two dollars for each spray-painted birthday or anniversary message. And, especially in Denver's northeast, northwest and west neighborhoods, young members of the Bloods, Crips, North Side Mafia (NSM), and other street gangs define themselves and their territories through an array of painted letters and symbols.[2]

Though a case study in Denver graffiti and the official response to it during this time, this book examines none of these forms of graffiti. Instead, it investigates a wholly different type of graffiti writing—one which dominates both the street production of graffiti in Denver and the concerns of those who campaign against it. One local press report notes, in regard to this predominant form of graffiti, that "most of the graffiti that covers the city is the work of so-called 'taggers'. . . . A much smaller percentage of graffiti is gang-related" (Gottlieb, 1989: 1B). Another explains that

> Graffiti has grown increasingly evident in Denver as an underground subculture of artists has matured. . . . "Serious" graffiti artists, believed to be responsible for about 50% of the graffiti in Denver, are known as "writers." . . . Taggers are believed responsible for about 30%, according to estimates from the mayor's office. Gang members get credit for another 15%, with the remaining 5% attributed to "independents" . . . (Newcomer, 1988: 8).

While these reports manifest a certain confusion about graffiti writing in Denver—due in part, as we will see, to their reliance on information "from the mayor's office"—they do accurately capture the sense that the great majority of Denver graffiti originates somewhere outside of Bloods and Crips, neo-Nazi groups, and unaffiliated individuals.

To focus the present study squarely on this most prevalent and visible sort of graffiti is not to deny the importance of other graffiti

forms. Certainly gang graffiti, and the gangs themselves, merit something more than the usual knee-jerk condemnations by business and political authorities. If we bother to look beyond carefully cultivated anti-gang hysteria, we can surely read in the gangs and their graffiti the experience of being young, poor, and of color in a culture which increasingly marginalizes this configuration. The spray-painted swastikas and scrawled death threats of neo-Nazis and skinheads likewise merit our attention, and our fear. They also reveal, from a different angle, the ugly edge of a culture organized around economic and ethnic inequality. Research into these and other forms of graffiti writing can expose not only the dynamics of crime and culture, but the lived inequities within which both evolve.

This study focuses tightly on Denver's dominant form of graffiti writing—and thereby omits street gang, neo-Nazi, and other sorts of graffiti—not because these other types are unimportant, but simply because they are *distinctly different.* Those who shape public perceptions of urban graffiti—local and national media, anti-graffiti campaigners, and others—intentionally and unintentionally muddy the boundaries between types of graffiti and graffiti writing, confusing one with the other in their condemnations of all graffiti as vandalism and crime. In so doing, they distort public debates about graffiti (in their favor, of course), and obscure our understanding of the specific social and cultural contexts in which particular forms of graffiti evolve. This study stands as a corrective to this constructed confusion—or at least as a counterpoint to it—in two ways. First, it isolates the single most prevalent form of Denver graffiti writing. Second, it investigates with some care the social and cultural circumstances of this graffiti, the actualities of its production.

To undertake a case study of this dominant form of Denver graffiti, though, is also to study a national and international phenomenon. The type of graffiti under investigation here is that which Denver newspaper reporters identify as "tagger" or "writer" graffiti, but which we can more accurately label "hip hop" graffiti. For the past two decades or so, the majority of urban graffiti in the

United States and beyond has been shaped by a set of cultural practices that have come to be called "hip hop."

Emerging out of the Black neighborhood and street gang cultures of New York City—and especially the Bronx—hip hop from the first incorporated new styles of music, dance, and graffiti. During the mid–1970s, neighborhood "DJs" like Kool Herc, Afrika Bambaataa, Grandmaster Flash, and Grand Wizard Theodore provided the music for house parties, on-the-street block parties, and other neighborhood gatherings. In the process, they created new sounds—not with synthesizers, guitars, and recording equipment, but by reworking old sounds on their portable turntables. Cueing records on two turntables simultaneously allowed the DJs to replay and mix the best "breaks" from each into a swirl of dance music. Manipulating the record back and forth produced a sort of "scratching" effect which accentuated the mixed beat of the music. At the same time, those who fronted for the DJs—their "emcees"—drew on black cultural traditions of "the dozens" and "toasting" to entertain the crowds, and developed a new style of verbal play: "rapping." And the hard dancing "B-boys" who danced the breaks which the DJs spun together came to be known as "break dancers," and began to organize themselves into crews like the Zulu Kings and the Rockwell Association.[3]

As even this very brief introduction shows, young urban blacks (and later, Puerto Ricans and others) developed hip hop as a sort of integrated cultural process which both tapped into and transcended their environment. As Max Roach notes,

> These kids were never exposed to poets or playwrights in school. They had all this talent, and they had no instruments. So they started rap music. They rhymed on their own. They made their own sounds and their own movements (Allen, 1989: 117, 119).

Though fractured to some degree as they have been selectively transformed into marketable commodities, these various dimensions of hip hop—mixing and scratching, rapping, break dancing—began as innovations interwoven in an emerging

subculture. Locating these innovations among the pastiches of postmodern popular culture, McRobbie (1986: 57) thus asks

> What else has black urban culture in the last few years been, but an assertive re-assembling of bits and pieces, "whatever comes to hand," noises, debris, technology, tape, image, rapping, scratching, and other hand me downs?

Atlanta and Alexander (1989: 156) answer that, indeed, hip hop constitutes an "expansive ever-proliferating synthesis of word, sound and image in a subculture which embraces painting, poetry, music, dance and fashion."

The "painting" to which Atlanta and Alexander refer is, of course, graffiti. The collective process which produced new styles of music and movement also opened up new avenues of urban art and visual communication. Kool Herc, for example, recalls that even before he became a DJ, "I was known as a graffiti writer. I wrote 'KOOL HERC'" (in Hager, 1984: 32). The hip hop graffiti of Kool Herc and others emerged out of New York City graffiti writing of the late 1960s and early 1970s. Using spray paint and newly available felt-tipped markers, early writers like Taki 183 and Julio 204 "tagged" or "hit" back walls, subway stations and trains, and other movable and immovable objects with their nicknames. As the "fame" of these early writers spread—in part due to their innumerable tags, in part due to a 1971 *New York Times* article on Taki 183 and his "imitators"—other kids decided to become writers, and a subculture began to take shape. With the influx of so many new writers, though, simply "getting up"—that is, repeatedly tagging walls and trains around the city—was no longer enough to distinguish a writer. Writers now began to decorate and redesign their tags, and within the subculture, "new emphasis began to be placed on style, on 'making your name sing' among all those other names" (Castleman, 1982: 53).

Now, as "style became the most important aspect of graffiti" (Hager, 1984: 19), distinctive hip hop graffiti started to emerge. During the early 1970s, Bronx writers like Super Kool and Phase II began to write their tags in "bubble letters"—larger, two-

dimensional, two-color letters which set their tags apart from those of other writers. Innovations such as these pushed hip hop graffiti writing away from simple tagging and towards the creation of still larger, more complex "masterpieces." Now known in the subculture simply as "pieces," these murals constituted a new form of graffiti writing; in comparison to tags, they required far greater amounts of planning, paint, and style. Other writers also began to experiment, increasing the size and color complexity of their pieces, and developing 3-D effects and other design features. By the mid-1970s, New York writers were executing spectacular "whole car" or "top-to-bottom" pieces—intricate, colorful murals that covered the entire sides of subway cars, and often incorporated cartoon figures and other embellishments. They were also increasingly organizing themselves into writers' "crews"—groups of writers who collaboratively designed and painted the elaborate pieces for which hip hop graffiti was now known.[4]

As the young practitioners of hip hop were constructing their own music and dance, then, they were at the same time inventing in their graffiti a new vocabulary of street imagery and visual style. Like much else in hip hop, this new graffiti writing developed from a richness of daring and innovation, but a poverty of technical resources; in the same way that the music emanated from simple turntables and speakers, the graffiti flowed from spray cans and markers. These new styles of graffiti defined the look of hip hop, the visual texture of an emerging subculture. The slashing tags and wildly colored murals mirrored the rapid-fire exuberance of rap; the complex blend of images and styles in graffiti "masterpieces" caught the dense, intricate interplay of sounds and scratches in the DJs' music. Hip hop graffiti became a kind of spray can rap, a series of subcultural markers painted on the surface of the city.

Needless to say, these markers did not go unnoticed by those outside the subculture. In 1972, Hugo Martinez—a City College sociology major and graffiti aficionado—organized a number of top New York City graffiti writers into United Graffiti Artists, and held a graffiti art show at the college. Mainstream media coverage followed, and in the next few years, shows in a variety of New York

City galleries. By the late 1970s and early 1980s, top graffiti artists were exhibiting in shows which integrated their works with those of other young and alternative artists, enjoying recruitment into established New York City galleries, and receiving increasingly positive media attention—including in-depth articles in the *Village Voice* and other publications, and a cover story in *Art Forum.* As Hager (1984: 77) says, hip hop graffiti "may have been started by a hodge-podge of impoverished art school dropouts and unschooled graffiti writers, but by 1982 they had turned it into the hottest art movement in America."[5]

By this time, hip hop graffiti was beginning to heat up not only New York City art galleries, but a variety of other cultural venues as well. Along with increasing dissemination through U.S. art worlds, and coverage in the mainstream and alternative press, came exposure in video and film. Pseudo-documentary films like *Style Wars!* (1985) and *Wild Style* (1983) spread the imagery and style of hip hop graffiti outside New York City, as did a variety of music videos which utilized graffiti murals as part of their background and setting. Even Hollywood produced a hip hop film, *Beat Street* (1984), which, despite its various inauthenticities, also popularized the look of hip hop graffiti. Interwoven with this increasing visibility was the remarkable popularity during this period of hip hop's other dimensions, especially what had come to be called "rap music." As Chalfant and Prigoff (1987: 8) argue, "probably the greatest agent for spreading this [hip hop graffiti] beyond inner-city America was the Hip Hop explosion of the early eighties." As rap began to change the sound and style of popular music, it carried with it—through concert performances and backdrops, album and tape covers, music videos, and other avenues—the larger hip hop culture, and the graffiti which was its visual parallel.

By the mid–1980s, then, hip hop graffiti writing had spread not only through the boroughs of New York City, but to cities throughout the United States—among them Denver. Henry Chalfant—whose photographs had early on helped introduce hip hop graffiti into the New York City art world, and whose 1984 book with Martha Cooper, *Subway Art,* itself became a manual of

style for aspiring writers outside New York—could by 1984–86 (Chalfant and Prigoff, 1987) document sophisticated hip hop pieces in Philadelphia, Pittsburgh, Chicago, Los Angeles, San Francisco, Oakland, and other U.S. cities. These new enclaves of hip hop graffiti in turn began to form links through a national network of publications. As of the late 1980s and early 1990s, these included *IGT* (*International Graffiti Times*, later *International Get Hip Times*, New York City), *Ghetto Art* (also known as *Can Control Magazine*, North Hollywood, California), *Graffiti Rock* (Philadelphia), *Vapors Magazine* (Santa Barbara), and Pjay Seen Productions (Bronx). Increasingly, this new graffiti was defining not just the look of hip hop, but the visual style of U.S. urban culture.[6]

Even as it filtered into cities throughout the United States, hip hop graffiti was also becoming an international phenomenon. As early as 1979, Italian art dealer Claudio Bruni purchased a number of graffiti-style canvases by Lee Quinones, a top New York writer, and presented a show at his Galleria Medusa in Rome. Soon after, Swiss, Dutch and other European art dealers and collectors began to seek out New York City graffiti artists, and to promote their participation in group and solo shows in Germany, the Netherlands, and elsewhere in Europe. These international art world events, and the increasing popularity of hip hop music in Great Britain and throughout the Continent, introduced hip hop graffiti into one European city after another.

Soon, Europeans were not only consuming hip hop graffiti, but producing it as well. Along with recording hip hop graffiti throughout the United States, Chalfant and Prigoff (1987) were able by the mid–1980s to document stylish, sophisticated hip hop graffiti pieces—and emergent graffiti subcultures—in Amsterdam, London, Paris, Copenhagen, Vienna, and other large and small cities throughout Europe and beyond. By the late 1980s, these subcultures were also producing their own print media, with journals like *Bomber Magazine* (the Netherlands), *14 K Magazine* (Switzerland), *Aerosol Art Magazine* (England), and *Hype Magazine* (Australia). My research into European hip hop graffiti during the

late 1980s and early 1990s confirmed its tremendous scope and vitality. In Amsterdam, London, Frankfurt, and other major cities—but also in smaller cities and towns throughout Great Britain, the Netherlands, and Germany—innumerable tags and murals decorated school buildings, apartment houses, bridge abutments, walkways, and, especially, the walls in and around train stations and subway platforms. And while the many tags and pieces certainly incorporated individual innovations, and the shared aesthetics of the local subcultures, they also reproduced with remarkable precision the stylistic conventions of hip hop graffiti.[7]

This, then, is the national and international context in which Denver hip hop graffiti is produced, and through which it must be investigated. Denver's hip hop graffiti underground includes beginning writers in their early teens and veterans now in their thirties. It brings together writers who, for the most part, now live on their own near the edges of poverty, but who have come to the underground from inner city and suburban neighborhoods, from single and two-parent families, from circumstances of deprivation and situations of relative affluence. This underground "scene," as the writers sometimes call it, also incorporates, in shifting numbers and coalitions, Anglo, Black, and Hispanic writers, some outspoken about their ethnic identity, others not. But no matter what their mix of age, affluence, and ethnicity, these writers share a common enterprise. As they write hip hop graffiti, and even as they bring to it their own individual and collective innovations, they participate in a cultural process rooted in young black urban culture, and in a process which continues to expand, both historically and geographically, beyond them.

As part of their participation in this larger world, Denver graffiti writers speak the argot of hip hop graffiti, and of the broader hip hop culture. As do hip hop writers elsewhere, Denver writers use the word "tag" to denote both their subcultural nicknames, and the stylized renditions of these names which they mark or spraypaint on the city's walls. "Tagging," then, refers to the ongoing adventure of marking these nicknames in and around the city, and "tagger" signifies someone especially fond of or good at

this activity. Derived, as we have seen, from earlier notions of "masterpieces," "pieces" are the large, complex murals which writers produce both individually and collectively, and "piecing" the process by which these murals are created. As part of this process, writers design and record pieces in hardbound sketchbooks which they call, appropriately, "piecebooks." Between small, quick tags and complex pieces are what writers call "throw-ups"—bigger, two-dimensional renditions of tags which, despite their stylishness, lack the size and sophistication of pieces. In speaking of themselves and others in the subculture, writers also distinguish between "kings"—experienced writers who are both stylish and prolific—and inexperienced or inept "toys." And, in referring to their informal organization into groups, writers speak of the "crew" or "set" to which they belong. As subsequent chapters will show, these words and activities have certainly taken on new complexities of meaning as they have emerged within the Denver scene; but their roots stretch beyond the local scene, to the shared conventions of hip hop graffiti.

If the Denver graffiti scene thus interweaves with broader cultural processes, if it in many ways manifests social and historical forces that breach the boundaries of individuality and locality, so too does the response of Denver's corporate and political community to it. The particular style and strategy of Denver's anti-graffiti campaign can no more be understood outside this larger context than can the graffiti which it seeks to suppress. Over the past two decades, corporate and political leaders in cities throughout the United States have formulated elaborate campaigns to combat graffiti generally, and hip hop graffiti specifically. The emergence of these campaigns has paralleled the nationwide spread of hip hop graffiti. Since the early 1970s in New York City, and through the 1980s and early 1990s in large and small cities across the country, politicians, transit officials, corporate executives and others have increasingly responded to graffiti as a political and economic issue, and thereby constructed it as a social problem.[8]

As these campaigns have evolved, they have begun to bridge the particular cities of their origin. By 1988, campaigners from a

number of U.S. cities had formed the National Graffiti Information Network. Following an August, 1990, meeting in Los Angeles—attended by representatives from twenty eight cities, and twenty three local, state, and federal agencies—the Network began to seek members for its Advisory Board. It received a variety of enthusiastic acceptances. The president of a grocery chain noted that "you touched a hot button with me with regards to efforts that would be made to stop the desecration of public and private property by those who seem to be bent on serving their satisfaction." An assistant city manager likewise proclaimed that "I find graffiti of any kind horribly offensive. I would therefore be pleased to be involved in any effort whose purpose is to permanently eradicate the unsightly vandalism"; and the Los Angeles City Attorney reminded the Network,

> As you know, I have taken and plan to continue to take a strong position in the prosecution of graffiti cases. I look forward to joining in your efforts to eradicate what has become a costly, unsightly, demoralizing and threatening crime in our cities.

Political figures were also eager to affiliate. A California state assemblyman promised to support this "challenging task of reducing graffiti and graffiti-related vandalism"; and California State Senator Quentin Kopp thanked the Network for "your kind words for my efforts in behalf of the battle against graffiti" and anticipated "an active and productive involvement with your organization." Similar responses were received from county supervisors, transportation officials and transportation police chiefs, and supervisors of existing anti-graffiti programs in Seattle, San Francisco, and elsewhere.[9]

This growing network of activists both promotes particular anti-graffiti efforts in member cities and coordinates the larger campaign among them. As a National Graffiti Information Network press release states:

> The organization's objectives include community organizing, drafting and endorsing state legislation, drafting and endorsing

city ordinances, creating a continuity of city ordinances (city to city), researching new technologies, product testing, the construction and investigation of graffiti vandal sting operations, the collection and redistribution of resource data (Control Resource Center), a newsletter, a municipal advisory service, a speakers' bureau, an education and prevention component and a variety of networking levels that promote informational exchanges between municipal entities (no date; circa 1990–91).

The Network has not hesitated to act on these ambitious objectives; by December 1990, it could list 62 activities for that month alone. These included meetings and exchanges of information with city officials and attorneys, transit officials, corporate supporters, and others; various actions designed to pressure those supporting graffiti-style art, and support those participating in anti-graffiti campaigns; investigations of outbreaks of "graffiti markings"; and participation in a variety of "sting" operations designed to apprehend graffiti writers through the use of "surveillance site[s]" and "spotters." And as the Network reported, another "sting operation is being engineered for the second week in January to take advantage of Senator Kopp's bill, which revokes the license of vandals caught" (National Graffiti Information Network December [1990] Update, Item 61).[10]

The Network's December 1990 report also recorded a number of items regarding its upcoming 1991 national convention—in Denver, Colorado. These included "several inquiries from [anti-graffiti] product manufacturers interested in the Denver Convention . . . with the pre-establishment rate of $500 per booth, acceptable," and updates from Valerie Purser. Listed on the Network's Advisory Board as "Executive Director, Keep Denver Beautiful," and elsewhere presented as the Network's "vice president of the eastern region" (*Rocky Mountain News*, August 30, 1991: 207), Purser has long been active with the Network. Around Denver, though, newspaper reporters, politicians, police officers and graffiti writers have known her in a somewhat different role: as director of the Denver anti-graffiti campaign.

In developing the Denver campaign, Purser has tapped into the increasing coordination of the national anti-graffiti movement, and at the same time provided opportunities for further cooperation. Purser herself worked previously with the anti-graffiti campaign in Atlanta. In Denver, her position as executive director of Keep Denver Beautiful links her, and the local campaign, not only to other cities, but to national operations. Housed within the city's Public Works Department, Keep Denver Beautiful functions as the local center for the nation-wide Keep America Beautiful program. Through Purser and others, this national anti-litter, beautification program has been reshaped around anti-graffiti concerns, and interwoven with national anti-graffiti agencies like the National Graffiti Information Network. Purser's work on the Network's national convention in Denver, for example, involved coordinating the convention "with the National Paint and Coatings Association as well as the National Association of Keep America Beautiful" (National Graffiti Information Network December [1990] Update, Item 24). The Network's letterhead lists telephone contact numbers in two primary states: California and Colorado. Not surprisingly, the Colorado number is that of Purser's Keep Denver Beautiful office. And as part of the Denver anti-graffiti campaign, Purser and her aides have distributed widely a key document: the *Denver Graffiti Removal Manual* (Clean Denver, 1988). This manual, however, did not originate in Denver, but in Providence, Rhode Island, after "over a year of research conducted by Keep Providence Beautiful."[11]

By investigating Denver hip hop graffiti and the local response to it, then, this book also inquires into two larger processes: the emergence of hip hop graffiti as a national and international phenomenon, and the coordinated development of campaigns designed to criminalize and suppress it. Both these processes, though, can themselves only be understood within a still larger set of circumstances. These are the circumstances of injustice and inequality in the United States today: the domination of social and cultural life by consortia of privileged opportunists and reactionary thugs; the aggressive disenfranchisement of city kids, poor folks,

and people of color from the practice of everyday life; and, finally, the careful and continuous centralization of political and economic authority. Neither the efflorescence of hip hop graffiti, nor the hard-edged campaigns against it, can be understood outside this larger context. Ultimately, then, this case study in urban graffiti investigates the interplay of cultural innovation and institutionalized intolerance, and the politics of culture and crime.

NOTES

1. On the incidents of racist graffiti, see Kirksey and Robinson, 1988: 2B; Fong, 1989: 13; *Rocky Mountain News*, October 11, 1990: 26; Culver, 1990: 1,4; Culver, 1990a: 1B, 4B. Anti-Semitic graffiti was likewise sprayed on the Hebrew Educational Alliance in November, 1988, and on other buildings and private homes during 1990; see Culver, 1990a: 4B. Skinhead and neo-Nazi graffiti also appears with some regularity in the alleys of central Denver.

2. For various manifestations of "Jesus" graffiti in Denver, see Gavin, 1987: 1B; and *Life on Capitol Hill*, October 20, 1989: 11. On the origins of Genesis P. Orridge, see McDermott, 1987: 58–61. On Cheaper Charley's shed, see O'Keeffe, 1990: 6; McCullen, 1990: 26; McCullen, 1990a: 30. Among the many daily press reports on gang graffiti in and around Denver, see for example Pugh, 1988: 26; McQuay, 1988: 1C; Gottlieb, 1989b: 1B, 6B; Gottlieb, 1989c: 1B; *Rocky Mountain News*, March 14, 1989: 26; Soergel, 1989: 12; Pugh, 1990: 8; Duggan, 1990: 2B; Wright, 1990: 7; Ensslin, 1991: 16; Gutierrez, 1991: 7. See also Lopez, 1989, for a compilation of Denver gang identities and symbols.

This discussion only begins to touch the varieties of graffiti writing, of course. For example, during this same period the Utah state capitol building in Salt Lake City was painted over in slogans supporting the homeless; and at Bucknell University in Pennsylvania, students debated the merits of feminist graffiti—written in chalk on the sidewalks. See *The Denver Post*, February 25, 1989: 4B; *The New York Times*, October 14, 1990: 39.

3. On the social and cultural history of hip hop, see Hager, 1984; Toop, 1984; Garofalo, 1984; Greenwald, 1984; Allen, 1989; Jazzy V., 1989; Craddock-Willis, 1989 (1991). Other useful sources on hip hop

culture in the United States and elsewhere include Rose, 1988; Leland and Reinhardt, 1989; Owen, 1989; Ebron, 1989 (1991); DiPrima, 1990; Santoro, 1990; and the entire special hip hop issue of *Cash Box* magazine, 1989.

4. For more on the development of hip hop graffiti, see Castleman, 1982; Cooper and Chalfant, 1984; Hager, 1984; Garofalo, 1984; Chalfant and Prigoff, 1987; Atlanta and Alexander, 1989.

5. The definitive discussion of hip hop graffiti's move into the art world remains Hager, 1984: 25–27, 59–77, who documents the *Village Voice* and *Art Forum* articles noted above. See also especially Castleman, 1982: 117–133, and Gablik, 1982; as well as Garofalo, 1984; Chalfant and Prigoff, 1987: 7–12; and Lachmann, 1988: 245–248.

6. These hip hop graffiti publications are listed in "GPS #1 Graffiti Buster," a document produced by Jay Beswick of the National Graffiti Information Network (no date). See also Timothy Power, Ghetto Art Publications (*Can Control Magazine*) to Jay [Beswick] (copy of letter, in author's possession; no date); and Brewer and Miller, 1990: 347. On Henry Chalfant's early involvement with hip hop graffiti, see Hager, 1984: 64, 70.

7. Chalfant and Prigoff, 1987, also document hip hop graffiti in Australia and New Zealand; and during the summer of 1991, I photographed scattered examples of hip hop graffiti in Prague. Atlanta and Alexander, 1989, provide an interesting account of the introduction of hip hop graffiti—and top hip hop graffiti writers like Futura and Ali—to London around 1980. The European press also contributes to the spread of hip hop graffiti through often detailed reports on local activities. See for example Morgenstern, 1991; and the various articles and photographs in the Dutch newspaper *de Volkskrant* (Onrust, 1991, 1991a, 1991b), which even provide a glossary of U.S./Dutch hip hop graffiti terminology. See also Huber and Bailly, 1986, and Riding, 1992, on Paris graffiti. The European graffiti publications noted above are listed in "GPS #1 Graffiti Buster" (Jay Beswick).

8. On anti-graffiti campaigns in New York and other U.S. cities, see for example Castleman, 1982: 87–89, 135–174; Cooper and Chalfant, 1984: 100–101; Hager, 1984: 60–62; Chalfant and Prigoff, 1987: 42, 46, 48; Lachmann, 1988: 243–244; Vuchic and Bata, 1989; Rus, 1989; Akst, 1990.

9. William S. Davila to Jay Beswick, November 2, 1990; Bridget Distelrath (Claremont, California), Assistant City Manager to Jay Beswick, October 30, 1990; James K. Hahn (Los Angeles), City Attorney (by Juana Webman, Deputy City Attorney) to Jay Beswick, October 3, 1990; Paul A. Woodruff, Assemblyman, to Jay Beswick, October 5, 1990; (State Senator) Quentin L. Kopp to Jay Beswick, September 15, 1990. See also Sue Honaker, Seattle Anti-Graffiti Coordinator, to National Graffiti Information Network, October 22, 1990; Tymeri Cuervo, Program Supervisor, Neighborhood Beautification Program (Glendale, California) to Jay Beswick, October 9, 1990; Barbara A. Conway, Graffiti Prevention Program (San Francisco Municipal Railway) to Jay Beswick, October 11, 1990; Arthur J. Sutcliffe, Special Projects Manager (The Jersey City Incinerator Authority) to Jay Beswick, October 31, 1990; George F. Bailey, Supervisor, Second District (San Diego County) to Jay Beswick, October 3, 1990; Ted Reed, Director (County of Los Angeles Department of Beaches and Harbors) to Jay Beswick, October 19, 1990; Michael D. Antonovich, Supervisor, Fifth District (County of Los Angeles) to Jay Beswick, October 4, 1990; David R. Phillips, Registrar (Contractors State License Board, Department of Consumer Affairs, State of California) to Jay Beswick, October 23, 1990; J. L. McCullough, Acting Chief, Maintenance Field Branch (Department of Transportation, State of California) to Jay Beswick, September 25, 1990; Sharon Papa, Transit Police Chief (Southern California Rapid Transit District) to Jay Beswick, November 6, 1990; Gary McAdam, Paint Technical Advisor (City of Los Angeles) to Jay Beswick, September 18, 1990. [Letter copies in possession of the author; from Jay Beswick and Valerie Purser.]

These responses do not constitute a complete listing of the National Graffiti Information Network Advisory Board which, although still evolving as of 1990–1991, also included a representative of the California Department of Transportation, and the director of the California Department of Parks and Recreation; a Los Angeles city councilman; the executive director of Keep Denver Beautiful; a commander of the Chicago Transit Police; a representative of the New York Transit Authority; and various corporate executives. During this period a number of other political and municipal figures were also in contact with the Network in regard to positions on the board; see National Graffiti Information Network December [1990] Update (copy in possession of author). And as a National Graffiti Information Network press release (no date; circa 1990–91) noted, "verbal commitments include representation from the

Southern California Association of Government, the State Office of Criminal Justice Planning and the Co-Chairman of the East Los Angeles Interagency Gang Task Force."

10. For media coverage of the National Graffiti Information Network, see, for example, Beaty, 1990; *Rocky Mountain News*, August 30, 1991: 207; Lignitz, 1991.

11. For more on Valerie Purser and Keep Denver Beautiful, see for example Asakawa, 1989; *Denver Magazine*, 1988: 34.

Denver Graffiti and the Syndicate Scene

It's about 7:30—nearly dark—on a September Saturday evening in Denver, and I drive by Scooters, the neighborhood liquor store, to pick up a six pack of cheap beer. A few minutes later I arrive at the P. Gallery, an alternative gallery/living space across from the homeless shelters in the "worst" part of downtown Denver. Waiting for me out on the roof are Eye Six, Mac (also known as Xerox), and J., a young woman who photographs graffiti and "hangs" with members of the subculture. After a couple of beers, we head out by car, first to "Wino Willy's" down the street for a twelve pack of cheap beer and a pocket-size bottle of Yukon Jack, and then on to a parking lot near Denver's lower downtown railyards.

Leaving the car, we walk down an alley to the abutment of a viaduct which spans the railyards, and scramble down into the yards. We're cutting crosswise though the yards, heading for what graffiti writers call the "Towering Inferno." An abandoned grain mill and warehouse, the Inferno is home not only to hoboes and the homeless, but to graffiti in a variety of forms. Up and down its seven floors, amateur writers have sprayed names and phrases, and on a couple of floors, quotations from philosophers. The Bloods and Crips (the "B's and C's," as some graffiti writers call them) have also been here, and have left various gang markings and symbols, including crossed out "b's" and "c's," and the image of a "B-Boy." Skinhead graffiti—swastikas, white power slogans— adorns the rooftop. The more elaborate graffiti of Denver's graffiti subculture is also here. On an outer wall, above an old loading platform, is an unusual Eye Six throw-up of some years ago; it

21

combines a painted eye, looking out over the word "SIX" in block
letters, with a series of stylized Oriental letters. Beneath this is one
of Rasta 68's tags—in this case tagged as ":Rasta:"—and around the
corner one of his early murals, now tagged over by other writers. A
few floors up, on an inside wall, Top has painted an elaborate,
stylized "TOP!" mural in red, orange, pink and blue, and tagged
"Syndicate"—the name of his crew—above it.[1] Tonight, as
discussed back at P. Gallery, we plan to paint a mural on the roof.

As we walk, though, Eye Six and Mac spot a wall which
borders the yards, consider the graffiti pieces along some stretches
and the lack of pieces along others, and decide to paint a section of
the wall, instead. A half mile later, we arrive at a stretch of the wall
which wraps around the back of a storage yard, and which can be
seen—in the daylight, anyway—from another of the viaducts.

Now we light cigarettes, open beers, and get to work. Eye Six
and Mac pull from their bags cans of spray paint, some the more
expensive Krylon brand, others cheaper off-brands; an old gallon
can of pale green house paint, a paint tray, and a roller; and Eye
Six's piecebook. J. hunkers down to keep watch over the railyards. I
go off looking to scrounge equipment, and come back with two old
beverage cases and a piece of sheet metal.

Eye Six pours the house paint—which has, with age, turned the
consistency of cottage cheese—into the tray, and he and I take
turns rolling it onto the wall. Standing on the beverage cases for
added reach, we eventually manage to cover an area roughly nine
feet high by 25 feet long. As the paint begins to dry, Eye Six and
Mac start outlining the piece, painting with light Krylon colors and
referring often to a sketch of the piece in the piecebook. As
designed in the piecebook, the piece is to be a large, elaborate
"3XB," the name of one of the two graffiti crews—the other being
Syndicate—to which Mac and Eye Six belong. Eye Six suggests that
they make the letters "3XB" "the size of a New York subway car,
top to bottom." For the most part, Eye Six and Mac work together.
At times, they paint side by side, discussing the piece, the night,
and graffiti generally. At other times, while one paints, the other
stands back and checks the proportions of the piece as it unfolds on

the wall. When Eye Six is unsure of his work, he asks Mac to "spot my dimensions for me"; when Eye Six notices a mistake or misdirection in Mac's painting, he tells him, or occasionally grabs a can of Krylon and begins to fix it.

As the outline begins to take shape, I also help with "erasing" the mistakes which Mac or Eye Six point out to me. I "erase" by spraying over sections of the outline with white spray paint—not Krylon, but one of the cheaper, "trash paint" brands. Though the work requires close attention, especially in the near-darkness illuminated only by some security lights across the rail yards, we maintain a sense of our surroundings. Those that are painting turn often to check the railyards, the sky, or real and imagined sounds; those that are not sit, squat, or stand so as to see behind and around us. When a police helicopter flies nearby with its searchlight scanning the ground, we press against an unpainted section of the wall and wait. And when a railyard security truck passes within a hundred yards or so in the course of checking trains, we hunker down in the grass and wait. The piece is further interrupted when J. notices the way in which the security lights cast our shadows on the wall, and suggests that we outline them in black spray paint. The resulting outlines form an oddly sinister group portrait of the night's crew.

As the elaborate outlines of the "3" and "X" are completed, the work of filling in the piece begins. The Krylon cans have long since been separated from their color-coded plastic tops, so Eye Six and Mac squint to ascertain the paint's color from the fine print on the cans' bottoms, occasionally risking a quick flash of light from a lighter or match. As they fill in the letters, they also pay attention to and discuss the amount of paint remaining, which they determine by the weight and feel of the can; at one point, Mac complains that there is only "about an inch" of paint left in the can he is using. I now move from "erasing" to another sort of work appropriate for a "toy," or inexperienced, writer: I fill in large, undifferentiated sections that Eye Six or Mac mark off for me.

During this process, we notice that four people—as best we can tell, two women and two men—walk by a few yards away in the

railyards. A while later, two women—the same two as before?—
walk up and, shyly and casually, begin to comment on the piece.
Fifteen minutes later, two men arrive, and now we are sure that
they must be the same four who passed earlier. And, during this
process of introduction and negotiation, I realize that I recognize
one of the women from an earlier encounter. Now I know who
they are and why they are here. They're huffers.

A few days before, I had been photographing graffiti near the
Platte River, which borders the yards opposite the wall where we
now paint. As I approached the area beneath a viaduct, I noticed a
young woman holding a can of spray paint. Given the scarcity of
women in the Denver graffiti subculture, the fact that the paint was
a cheap off-brand, and that I didn't recognize her, I wondered if she
were a writer. Despite this, I asked, "What's up? Are you piecing?"
but got no response. Instead, she walked slowly towards me, and as
she came closer, I could see that her eyes were glazed. I could also
see the rag into which she sprayed the paint before inhaling, and
then I understood. She was a paint sniffer, a "huffer," and she was
far gone on the fumes.

Now she and her three friends have found us, and as they sit
around the edge of the scene, they begin to ask for, and occasionally
grab for, cans of paint. Busily at work on their piece, Eye Six and
Mac resist, both on ethical grounds ("No, man, you're gonna fry
your brains on that stuff") and practical grounds ("Hey, man, leave
that Flat Black alone, I'm using it"). The huffers counter that they
will be happy to make do with our empty spray cans, since even
those still contain enough fumes to be useful. So, the four
newcomers take our empty spray cans, spray the residual fumes into
our empty beer cans, and hold the beer cans to their noses while
they sit and watch us paint. We talk a while—Eye Six pretends to
know one woman's brother, and kids that he will tell him about her
huffing—and then the huffers get up to leave. As they do, one of
the men uses a can of paint not to sniff, but to scrawl some amateur
graffiti—"California"—on the wall near the piece.

Despite the interruptions, most of the fill-in work is now done,
and Mac and Eye Six turn to the more detailed styling of the piece.

Mac uses the piece of sheet metal which I found earlier as a straight edge to sharpen angles and lines within the piece. He and Eye Six both add star-bursts, circles, and other stylized touches. Mac kids Eye Six about the "bubbles" he is adding to the piece, and hints that they are now passé; Mac chooses to paint in squares and other geometric patterns. As this is completed, Eye Six and Mac outline again the borders of the piece, this time using Krylon black to set the piece off from its background of pale green housepaint.

It's now almost midnight; the paint, beer, and Yukon Jack are running low; and enthusiasm for painting is being replaced by talk about police patrols and missed dinners. Despite the police helicopter, the railyard security, and the huffers, the piece has been completed, except for one thing: the "B" in "3XB" never made it onto the wall. So, although the crew name is "3XB," and although this is how the piece was designed in Eye Six's piecebook, it now stands as the "3X" piece. As we gather our gear to go, we again check the paint cans, keeping those with paint, and tossing empties out into the railyards. Before we throw away the empties, though, we carefully remove the spray nozzles and put them in pockets or bags.

We walk back-streets and alleys to the car, carrying both the pleasure and excitement of a piece well done and a few left-over cans of paint. This coincidence of attitudes and resources leads, without much discussion or planning, to tagging. As we walk, we tag bridge supports, loading docks, and back walls. In almost every case, the tags are those of crews rather than individuals; "3XB" at one spot, "SYN" or "SN" at another as a shorthand for "Syndicate." Mac even pauses long enough to execute an "SN" throw-up on the side of a warehouse. Back in the car, we drop Mac off at his house, and then head to a cheap, all-night cafe for dinner.

As this and the following chapter show, each moment in this night of wandering, piecing, and tagging illuminates the dynamics of the Denver graffiti subculture, and the social process of doing graffiti in Denver. The P. Gallery and Wino Willy's, the Towering Inferno and the railyards sketch the physical and social environments of graffiti work, the urban ecology of the subculture.

Eye Six and Mac, 3XB and Syndicate hint at the social organization of graffiti writing, and the subcultural identities that evolve from it. The conversations between Mac and Eye Six, the on-the-spot evolution of "3XB" into "3X," point to the shared conventions, the negotiated sense of style, by which graffiti is produced. And the helicopter overhead, the railyard patrol nearby, the shadows thrown by the security lights across the way, all reflect the legal, political and economic context of graffiti work.

How I came to be a part of this night is, of course, itself an issue of methodological significance. My interest in and research into graffiti dates back many years; my immersion in the actualities of graffiti writing dates from January 1990. Since that time I have been engaged in intensive fieldwork and participant observation with Denver's graffiti subculture, and specifically with Denver's top graffiti "posse" or "crew," Syndicate. Made up of eight or ten of the city's best graffiti writers, Syndicate is neither a "gang," in the usual sense, nor gang-affiliated. Instead, it is a loose association of graffiti writers who regularly tag, piece, drink, and roam together.

My research has taken a variety of forms. On a near daily basis I have talked by phone or in person with Syndicate members and other local graffiti writers, and in this sense have conducted countless informal "interviews" as part of my association with them. I have also conducted formal, intensive interviews with local graffiti writers in and out of Syndicate, and with gallery owners, city officials, police officers, and others associated for good or bad with the subculture. Based on my own experience and on information from the writers, I have wandered Denver's back alleys and railyards, viewing and photographing tags, throw-ups, and murals; paying attention to empty paint cans and beer bottles; and watching the reactions of neighbors, transients, and police patrols. Most important, I have participated time and again with graffiti writers in the process of doing graffiti.

This participation has ranged across the many activities that make up graffiti writing. I've taken part in numerous negotiations between graffiti writers and art galleries, business associations, homeowners, and others in regard to the painting of sanctioned

murals. Here, I've resisted, not always successfully, a role which can easily develop for the sociologist or criminologist: that of go-between between the straight world and the criminal subculture. I've often participated in the painting of sanctioned murals, and the late night (and sometimes all night) painting of illegal murals under viaducts and on abandoned walls, as just described. I've gone out with graffiti writers on late night (and all night) tagging forays, and been part of innumerable associated paint-buying trips, beer and cigarette runs, drinking episodes, parties, and periods of general hanging about.

In this work I have followed the now classic injunctions of Becker, Polsky, and others that, to understand individuals and groups labelled as deviant or criminal, we must study them in the course of their daily existence. Nearly thirty years ago, Becker (1963: 166; see 165–176) argued that

> . . . there are simply not enough studies that provide us with facts about the lives of deviants as they live them. Although there are a great many studies of juvenile delinquency, they are more likely to be based on court records than on direct observation. . . . Very few tell us in detail what a juvenile delinquent does in his daily round of activity and what he thinks about himself, society, and his activities.

Around the same time, Polsky (1969: 109,115,133; see 109–143) urged, in the context of his discussion of "career criminals," that

> . . . if we are to make a major advance in our scientific understanding of criminal lifestyles, criminal subcultures, and their relation to the larger society, we must undertake genuine field research on these people . . . as they normally go about their work and play. . . . Sociology isn't worth much if it is not ultimately about real live people in their ordinary life-situations.[2]

The intervening years have certainly seen a number of such field studies, though hardly to the point of disciplinary saturation. But, no matter how many studies are done, they are not enough, since

the study of deviant or criminal subcultures must emerge as the subcultures themselves evolve. Urban graffiti stands as a case in point; research into graffiti prior to its recent reemergence within hip hop culture tells us little about the phenomenon today.[3]

In doing this research I have, inevitably, broken the law. As Polsky (1969: 133–135; see Becker, 1963: 171–172) notes, in field research on criminally deviant subcultures, the researcher becomes an "accessory" to crimes simply by witnessing and failing to report them. In this sense, my research has regularly made me party to trespass, vandalism, paint sniffing, marijuana smoking, underage drinking and other illegal activities which I have, needless to say, not reported to the authorities.

Beyond this, I have directly participated in illegal graffiti tagging and piecing. In field research, as in life, one's knowledge and understanding of a subject is enriched by involvement in it. And, if the sociological perspective points to the construction of the world out of group participation and interaction, it would seem difficult to justify sociological field work in which the researcher does not become involved, to the fullest possible extent, in the social life of his or her subjects. Certainly there exist limits to this involvement; and if the activity under study is not only labeled "deviant" or "criminal," but unfolds along the lines of sexual assault or suicide, for example, these limits are profound. The limits to involvement with graffiti writing—a non-violent act which, as we will see in the following chapters, threatens property values and aesthetic imperatives rather than human life and liberty—are surely much less severe.

Perhaps a simple example will communicate the methodological importance of participation in illegal graffiti writing. Graffiti writers have told me, time and again, that they do graffiti for the rush one gets when piecing or tagging illegally—a rush more exciting and pleasurable than any drug they know. And they emphasize that this feeling comes not from just being out at an illegal location, but from the act of painting itself, from the intersection of creativity and illegality as the paint hits the wall. Now, what is one to make of this claim: an honest accounting, a

moment of braggadocio, an overdrawn drug analogy? One way to begin to find out is to paint illegally. To do so, of course, is not only to investigate the claim, but to confront the apparati of moral entrepreneurship (Becker, 1963) and legality which define graffiti painting as crime. Such activity forces us, then, to consider not only methodology and morality, but, as always, whose side we are on.[4]

From my experience, such creative lawbreaking does, in fact, generate the sort of incandescent excitement that the graffiti writers describe. In field research on graffiti or other criminal and noncriminal subcultures, though, such excitement balances with the tedium of everyday existence, as well it should. Graffiti writers spend far more time working menial jobs, discussing graffiti on the phone, arranging transportation, washing dirty clothes, and drinking cheap beer than they do piecing and tagging. To understand their world generally, and to understand the specific excitement of doing graffiti, one must become involved with and pay attention to these quotidian dimensions as well. As Goffman (1961: ix–x) has said, ". . . any group of persons . . . develop[s] a life of their own that becomes meaningful, reasonable, and normal once you get close to it, and . . . submit oneself in the company of the members to the daily round of petty contingencies to which they are subject." This has meant, in my research, many hours spent on the phone, in the car, and at bars and apartments for every hour spent painting under a bridge.[5]

Engagement with the subculture has in turn led to my involvement with alternative and mainstream media. Early on, I published an essay on graffiti, and an extended, two-part interview with local graffiti artists, in *Clot*, a Denver alternative music magazine. As is often the case with media dynamics, this first media exposure became the basis for subsequent attention, first in other alternative publications, and then in the local daily press. There, an article on my research was followed by an editorial criticizing my research and graffiti generally, and by both supportive and critical letters to the editor. This subsequently led to national newspaper and radio coverage.[6]

In this media work I have been guided by Barak's notion of "newsmaking criminology." Barak (1988: 566,576) argues that criminologists must consciously participate in "interpreting, influencing, or shaping the presentation of 'newsworthy' items about crime and justice," and in so doing "become part of the social construction of public opinion." As Barak implies, such a position presupposes that neither criminology nor the mass media are value-free enterprises, but rather social activities intertwined with influence and power. In such a world, criminologists who recognize the media's role in shaping and distorting perceptions of crime do more than simply analyze this role for their colleagues; they seek to counter the distortion by participating in the media process. In the present case, my intention has been to undermine the consensus on graffiti which media in Denver and elsewhere carefully present; to strike a discordant note in the chorus of condemnation; and, in the best traditions of sociology, to debunk the taken-for-granted notions about graffiti which are manufactured for public consumption.[7] To the extent that such efforts succeed, first-hand research on graffiti bleeds over into "newsmaking criminology," and becomes a part of the contentious, complex process by which graffiti is socially produced and defined.

By going inside the network of social relations and activities that make up the graffiti subculture, I have been privileged to see dimensions of that subculture which would surely remain invisible to the outside observer. Central among these is the manner in which members of the subculture share material and aesthetic resources as they engage in the collective production of graffiti.

A Cultural History

The contemporary history of hip hop graffiti in Denver dates to the early 1980s, and to one person in particular: a graffiti writer now known as Z13, but known at the time as "Zerrox," or more elaborately, "The Amazing Zerrox." As Z13 says, there were of course at the time others "scribbling and that sort of thing," but

"nothing really interesting . . . no murals at all or anything." Z13 thus began what would come to be a thriving graffiti subculture when in 1983 he decided to paint a mural at the spot where the Cherry Creek bicycle path crosses under Colorado Boulevard, one of Denver's major streets. Attracted by the possibilities of "the big spectacle of seeing that out in the open," he started painting a piece that was "probably 60 feet or so long and . . . about 10 or 12 feet high." The piece—which survived "the buff" (that is, sandblasting or repainting) for "close to five years"—featured "The Amazing Zerrox":

> It was cut into frames, like a comic book. And the very first frame was like the title frame, "The Amazing Zerrox," and then the character was smashing out of the wall. Then it just lapsed into different frames. Like I had one that said, "This is 1984," because it was pretty close to the new year. And then . . . in the next frame it was a nude, it was a woman lying on her back, or on her side, looking at her from behind, and then it had a big word that said "art." It said, "neo art," or something.

This first piece was enough to set the subculture in motion. Z13 recalls that another originator of the Denver scene, Eye Six, was "kind of inspired by that." Fie, who with Z13 became one of Denver's first "kings," likewise remembers:

> I saw a piece of Z13's on Colorado Boulevard. . . . So that was like the first thing I'd ever seen. I was amazed that someone could have done that. . . . I saw that and I got together with one of my friends. . . .

During this time Z13 went on to paint a series of similar pieces: a "Zerrox is Watching You!" on the back wall of a Safeway supermarket near East High School, which still survives; a "big piece . . . about ten feet tall" with the character of "The Amazing Zerrox," on an elementary school playground; and

> a continuing series of [the first] piece down along the Cherry Creek wall . . . a continuation of The Amazing Zerrox, like comic

book frames. I was doing the graffiti police, and . . . the very first frame was this cop and he was saying, "I'm going to get that Zerrox," or something. . . . But I started on a couple of frames and then it had been buffed off before I was able to finish that.

These and other early pieces generated further interest and excitement, and drew those who would become Denver's "kings" into graffiti writing. Fie remembers that, "I looked around and I saw one by East High on the Safeway . . . [and] there's one on that school on 14th and Ogden or whatever. So, I saw those . . . and that was it. There wasn't any tagging going on. . . ." Rasta 68, another of Denver's first and most famous "kings," likewise recalls that, upon his arrival in Denver from Las Vegas, "I saw his pieces on East Colfax, on Safeway, and he had this other one down by the Mammoth Gardens, and they were both just really cool. And that was the only pieces I saw besides the stuff at Wax Trax."[8] Fie thus claims, with perhaps a bit of overstatement, that Z13 was "the sole person, probably from this side of the Mississippi until you get to California . . . he was my idol." Voodoo—himself a legendary Denver graffiti writer—adds: "I think Z13 was the undisputed founder of it all."

Inspired by Z13, Fie was the next writer to develop and define Denver graffiti. At the time a freshman in high school, Fie was the first to begin tagging systematically—at first on the bus he rode to and from school, and then "all over the city and bus stops, telephone poles, just everywhere, alleys." Fie's early fame came not only from his prolific tagging, but, ironically, from the mystery which surrounded his identity; as Voodoo says, Fie was "a little bit more mysterious to people" than other writers. Fie remembers:

When I first started doing it, the first year and a half, two years, no one knew it was me. I mean, I told my sister. My mother didn't even know. You know, a couple of my friends knew, but no one else knew. I just loved that. . . . Even if I saw a tag and I was with someone else and they were looking at it . . . I wouldn't tell them. . . . I was doing it to get up for people to see it a lot, but not for personal fame.

Fie's standing beside Z13 as one of Denver's all-time "kings" was assured, though, when he began piecing. Fie decided that he "had to paint, to be authentic," and began painting pieces around central Denver—the first a couple of miles down the Cherry Creek bike path from Z13's first piece. Perhaps to a greater degree than any other Denver writer, Fie developed a tight, technically brilliant style which set his pieces apart. As Eye Six says,

> . . . Fie was the first guy I saw tagging in Denver—he was the only one. And I remember at the time thinking, yeah this guy could tag, but can he paint? And then I saw some piece of his, and I was just blown away. He's white and he's one of the few people who was commonly attributed to being a king.

Voodoo adds that "Fie would be the king of Denver," because

> he took it all to the extreme, to where I think any artist in the United States who is a spray painter, Fie could stack up next to, to anyone else's work. . . .[9]

To speak of Z13 and Fie as the founders of the Denver graffiti scene, and Eye Six, Rasta 68, and others as "kings" who further defined the nature of Denver graffiti writing, is to begin to sketch the outlines of a subculture, and to identify those most active in creating it. It is not, of course, to imply that these writers stood alone. The limits of research methodology and collective memory tend to narrow the focus; but certainly others began also to write graffiti in Denver during the early and mid–1980s. Eye Six remembers seeing in these early days a piece by "Lava." Z13 recalls a group, the "Skull Babies," who did "quick line drawings" of "skeleton heads." And Fie recalls not only a number of early taggers and crews—Echo, Koz, J and J, KGB (Kings Gone Berserk), MGM (Magnificent Graffiti Men)—but also meeting, around 1985, The Kid:

> . . . The Kid popped up, and he started tagging. . . . I started seeing him in a ballpoint pen. I saw him a lot, with just the

ballpoint. And then finally I saw him in wide marker and then he started really putting it everywhere. So, I put a message up to him and he put a message back on Colorado and Colfax [Boulevards]. And so we got to meet through that.[10]

This meeting between Fie and The Kid was not unique; as writers continued to tag and piece, they began to see each other's work, to meet and talk, to work together, and to coalesce into a subculture. Rasta 68 began to see tags left by Fie and another writer, Zhar Zhay, and to meet writers who "would see me carrying a piecebook or they would see me maybe tagging." He also met Zone and Zypher when they left a message near a piece he painted at Rock Island, a local dance club. When Voodoo met Eye Six, Eye Six "showed [him] all these different places to spray," and Voodoo began doing the "big pieces" for which he became known. Z13, who had quit piecing for "a couple of years," met Eye Six at a local alternative gallery:

We happened to meet by chance at the Pirate Gallery. I had some of my comic strips down there that night and I was showing him, and somehow we got onto this graffiti type scene and he had mentioned something about the Colorado Boulevard piece. And then I told him that I was the one who did it. . . . And I had always admired his work before, too, because I had seen some of his gallery work. . . . So he told me that he really admired that, and when he found out that I was the one that did it, then we kind of grew together that way.

Eye Six subsequently introduced Z13 to Rasta 68, and Z13 found himself drawn back into the evolving scene:

I kind of laid back out of it for probably a couple of years, but that's really when everybody else started getting into it, getting involved, I guess, seeing what I'd done, and just everybody getting together and seeing each other's work. So then, once I saw that that was happening, then I started getting more involved in it too, since I said, well, now there's like a scene going on.

The most visible physical manifestation of this emerging Denver subculture was what the writers would come to call the "wall of fame." Eye Six lived at the time near a spot where the walled Cherry Creek bicycle path cut through lower downtown, northwest of Z13 and Fie's earliest pieces. Painting, as he says, in his "backyard," he put the first piece on the wall—a large, stylized "EYE SIX" complete with cannon balls and flames. Z13 was next, painting an Amazing Zerrox/"spray man" figure whose cloud of spray paint washed into Eye Six's piece. As Z13 says,

> Eye Six started the wall. He was the first one up there and I was the second one down there. I did my piece right next to his. I did that on purpose kind of, just to flow in.

As other "kings" added their pieces, a "wall of fame" began to emerge. Voodoo used 18 cans of spray paint to paint what he calls his "signature piece": an "organic" and "moody" "VOODOO" intertwined with vines and roses. Rasta 68 added his own distinctive pieces, including a "ROCK" with a face in place of the "O," a wild "SIN RASTA" backed by streetlamp and skyline, and a stylized scroll which read, "Graffiti is like cancer: 'tis no cure." And, as Z13 notes with some regret, the wall served not only to bring together the considerable skills of the "kings," but to encourage the participation of the less skilled writers—the "toys":

> . . . that wall of fame, that's when all the real toys came out. You could tell what was going on. That's what screwed up the wall of fame. 'Cause you know, the quality artists, they were out there doing their gig, but then the others came out to try and do their thing, too.[11]

During the late 1980s the subculture continued to take shape. Although Fie left Denver to attend college, and Voodoo moved, at least temporarily, back to Louisiana, new writers and crews emerged. Mir, Eoosh, and Vestige founded the crew XMen (later XMenII), and were soon joined by Phaze3, a tireless tagger and stylish muralist as well. In addition, a number of Denver's existing

kings formed a new crew: Syndicate. Begun by Rasta 68 and Eye Six as "SKS"—"Spray King Syndicate"—the crew is known as "Syndicate" because, as Rasta says, "Syndicate is like underground and, in the dictionary, Syndicate is like a crew or an organization." As Rasta and Eye Six "let people in that were down with us," Syndicate came to include also Z13, Top One, Setster (a visiting New York City graffiti writer), underground artist HL86, and later, Mac (aka Xerox).[12] Top One, who has become a skilled graffiti writer in his own right, came to the subculture by way of Rasta, with whom he worked at a local sports bar. Mac, a young protégé of Eye Six who was voted into Syndicate at a 1990 group meeting, has also become one of the most accomplished and prolific writers in the subculture. For a time, Syndicate also included Amaze and Mode, girlfriends of two Syndicate members. Although Amaze's membership was largely honorary, Mode tagged and otherwise participated in Syndicate activities. Eye Six's girlfriend, though not a Syndicate member, was also a member of an earlier Denver crew—FTC, or Female Tag Crew.[13]

Syndicate operates as a sort of casual collective, a loose network of support among its writers. As Z13 says, "It's kind of an informal thing, you know. We don't have any guidelines or anything set up." Within the limits imposed by job schedules, finances, and other obligations, Syndicate members get together in various combinations to talk, hang out, drink, party, tag and piece. Rasta notes that Syndicate members piece collectively "as much as possible. If we can't all get together at least it's nice if three, four, or five of us can get together" (in Ferrell, 1990: 11). Eye Six, Z13, Rasta 68, and Top One, for example, executed a collective "Syndicate" piece on a second "wall of fame" which has evolved within the subculture: a giant, multi-colored "E Z 68 TOP," complete with gun images taken from a Z13 stencil. Rasta thus describes Syndicate as "ten people with ten brains and twenty eyes to watch out for the opposing authority or enemy and to get down with the brain waves thrown down on the wall" (in Ferrell, 1990: 11). And he adds:

What holds the Syndicate together is art, graffiti. Motivation, too, because you got to be motivated to do a piece. What holds the Syndicate together also is, because me and Eye Six are just like best friends. . . . And everybody is just like real cool. . . . We're just all really tight and cool. It seems like we're kind of close, you know. It's not like we're gangsters. We're a gang that needs a sense of belonging and a sense of togetherness or whatever. Just get together. It's like a band. You get together and do your thing.

As the Denver graffiti scene moves into the 1990s, its contours and configurations continue to emerge. Syndicate still operates as a well-known and well-respected crew. XMen and XMenII have faded from the scene, but then re-emerged with a new series of "XMN" tags in and around central Denver. Mac, Japan and Corey have formed a new crew, 3XB, which has included Phaze3 (also of XmenII), super-tagger Shoop, and other writers. Eye Six and Mac now also claim membership in 3XB as well as Syndicate, despite informal sanctions among the writers against membership in more than one crew. And, as 3XB tags proliferate on back walls, bus benches, and signal boxes, so do the tags of new writers not yet established in the subculture. As Eye Six says, "There are new people coming out now. . . . I would say every six, eight months, there's a new generation."

Social and Aesthetic Resources

If the Denver graffiti scene grew out of the creative efforts of Z13, Fie, Eye Six, and other writers, it also emerged out of particular social and cultural contexts. As Denver writers negotiated individual and collective styles of graffiti writing, they drew not only on one another, but on pre-existing cultural resources. Although these resources certainly did not predetermine the direction of graffiti writing in Denver, they did constitute a sort of common aesthetic and stylistic stockpile which the writers utilized in developing and defining Denver graffiti. The emergence of an active graffiti scene in Denver has in turn altered the city's cultural

terrain, and thus become a part of the cultural processes out of which it developed.

The world of conventional art has provided a central context for graffiti's emergence in Denver. From the first, the Denver graffiti scene drew on the kinds of training, attitudes, and aesthetic orientations which develop out of participation in various art worlds.[14] Many Denver graffiti writers, and especially those acknowledged as "kings," share a common characteristic: prior involvement in legitimate art worlds. Z13 has been drawing since he "was a little kid in grade school," and in high school won best-of-show at a Denver Art Museum exhibition. He subsequently attended the Colorado Institute of Art (CIA) for a year, worked as a freelance commercial artist, and "progressed into painting and sculpture," as well as stencil art. Voodoo likewise learned painting early in his life from his grandmother, attended the Colorado Institute of Art upon moving to Colorado, and now works in media ranging from stencil to postcard to tattoo. Eye Six is himself an accomplished stencil and airbrush artist, conversant in the fields of art theory and art history. Fie's development has followed a somewhat different course; his involvement with graffiti, and the influence of a professional artist who is a family friend, led him to high school art courses, and then to a college art major.[15]

For these young artists, though, graffiti painting emerged not as a smooth extension of their artistic training, but out of the contradictions and limitations they found there. Z13 remembers the Colorado Institute of Art as "kind of bogus," in that it

> was too structured. I liked some of it. I didn't really appreciate the teachers that much. Some of them were okay, and I felt that I was learning something from them. But then the other half, they were like grade school teachers up there, and just stand there to make their money and they didn't care what they were teaching.

Commercial art was, for Z13, also too restrictive: "I didn't like the structured format of that. I just like going off on my own and doing whatever I want."

Voodoo likewise remembers his time as a CIA student as "a big mistake," and for much the same reasons: the limitations of a "controlled environment" and "mechanical" techniques.

> Yeah, it was weird. I was making D's and F's in my airbrush class, and then . . . I was making all kinds of money spray painting sheets and canvases and stuff—just freehand spray paint. I brought the pictures back to show my teacher, and he couldn't understand why I couldn't do that with the airbrush. And I was like, 'cause it was just too much of a controlled environment, just too mechanical. . . . I like the way that spray paint, you can get the edge and at the same time you can get the funkiness. And there's so much in between there, to work with, that you can get all kinds of effects. . . .

For Voodoo, the aesthetic contradictions between art training and graffiti writing took on social dimensions when he took three CIA students along to help paint one of his first pieces.

> That was a mistake 'cause they weren't used to spraying out in the railyards, and it was starting to snow and they started whining about how cold it was getting. And I was like, you know, you guys can split if you want. We're making history here—I mean, we're not going to let a little bit of snow ruin the night. . . . That was the last time I brought commercial art students.

Denver writers have encountered similar contradictions as they have moved out of art training and into the local art gallery scene. It is certainly no accident that the P. Gallery—a local alternative gallery—served as the launching point for the "3X" piece described previously, or that another provided the common cultural ground on which Eye Six and Z13 first met. Denver's alternative art world—organized for the most part into co-operative galleries, and linked through the Alternative Arts Alliance and less formal networks of friendship and association—has intertwined with the development of Denver's graffiti writers and graffiti scene. Eye Six and Z13 have for many years participated and exhibited in

alternative galleries, showing both "graffiti style" works and others
developed out of stencil art traditions. Voodoo, Top One, Rasta 68,
Mode, and others have also contributed works to shows at Pirate,
Core, and other alternative galleries. In addition, Eye Six in 1988
curated the "Denver Throw Down/Spray Art" show at Progreso
Gallery—a group show in which Eye Six, Voodoo, Z13, Rasta 68,
Fie, Xerox (Mac), Zipher, Zone, Jayzer, Tempest, Mir, and other
Denver kings exhibited graffiti-style pieces painted on large
plywood panels.

The social connections linking the local graffiti and alternative
arts scenes run deeper, though, than entry fee and commission
arrangements between graffiti artists and the galleries in which they
exhibit. The Alternative Arts Alliance, for example, publicizes and
defends the activities of graffiti writers in its publication *Point* and
other public fora. Gallery shows likewise publicly display and
legitimize the artistry of graffiti writers, and in turn serve as forces
of social organization and integration within the graffiti subculture.
Opening night of Eye Six and Z13's fall 1990 "Modern Spray
Policy (Nuvo Grafito)" show at Edge Gallery thus produced a
gallery filled not only with art patrons and friends, but a remarkable
assemblage of local graffiti writers catching up on recent pieces,
sharing piecebooks, and arranging escapades. Beyond this, many of
the top graffiti artists move in the same circles as alternative gallery
owners and artists, attending parties, sleeping over, perhaps earning
a bit of money. For local graffiti writers, then, the alternative
galleries and the alternative arts scene constitute an informal
network of social and cultural support.

At times, though, the aesthetic distance between gallery
watercolors and railyard graffiti, the social and economic expanse
separating a middle-age, white-wine gallery opening from young
blood, cheap beer alley piecing, stretches and strains this support
network. Some years ago, Eye Six participated as a member of
Pirate Gallery, and as such attempted to organize a graffiti show
featuring the artists from the Progreso "Denver Throw Down"
show. When, however, word got out that one of the Progreso artists
was a member of the Bloods, and another a Crip, Pirate's members

voted to prohibit gang members from participating in the proposed show. Eye Six responded with a "nasty letter," and his resignation from the gallery. As he says,

> They took it as a young/old thing. Because, I think a lot of it was a racial issue. . . . "We don't want no niggers in our show—it's an art gallery." But I felt like my integrity was being questioned. Because I had been in there quite a few more years than a lot of those people. . . . After that, I really had to question the validity. I never went to college, Pirate was kind of like my college. A lot of those people had Masters in whatever they do and so, that was my whole idea of alternative art. It's like these alternative arts are snubbing me for whatever I want to do as alternative.

More recently, members of Spark Gallery decided to invite Syndicate members to paint a mural on an exterior wall of their gallery. As with the Pirate incident, much was revealed about the meaning of "alternative art" in the moment the liberal, well-intentioned members of the gallery were confronted, by their own invitation and in their own clean, non-smoking gallery space, by a group of Syndicate members smoking cigarettes and swilling from forty-ounce malt liquor bottles. This encounter exacerbated tensions among Spark members in regard to the proposed mural, and contributed to the mural's being postponed for many months. (It was finally painted in May 1991 as part of a "Graffiti Inside and Out" event at Spark.) It also highlighted the odd dual lives which Eye Six, Z13, and other local writers lead as they bounce between the roles of legitimate, exhibited alternative artists and outlaw street writers.[16]

In developing and doing graffiti Denver writers thus draw on the aesthetic training and social support of legitimate art worlds, but at the same time intentionally and unintentionally violate the conventions which these worlds carry. The graffiti which they produce in this sense threatens not only the legal boundaries of private property and public space, but the political and aesthetic boundaries of legitimate—and even legitimately "alternative"—art. Writers like Voodoo and Eye Six make clear that they do graffiti

not because they take artistic imperatives lightly, but because they take them seriously—perhaps a bit too seriously for most mainstream or "alternative" artists. Interestingly, Eye Six grounds his graffiti, and his critique of gallery art, in an earlier effort at pushing back the boundaries of art and culture:

> I was reading *Dharma Bums* by Jack Kerouac and it's amazing to me that over thirty years ago they could see plain as day that the American culture was turning into something where there were rows of houses and in each house there was someone watching the t.v., seeing what people wanted them to see. They were just absorbing these standards and ideas about the American Dream and the American Norm. And I think that thirty years later, unfortunately, it's come true. People just sit on their asses. That's what differentiates us [graffiti writers] from most people, and even artists, because the art galleries are the same thing—they edit what art the public sees by choosing whatever their standard is of art. When you're doing graffiti, you choose your own vision . . . (in Ferrell, 1990a: 10).

For Eye Six, though, graffiti is about not only "your own vision," but the collective artistic vision which develops out of creative collaboration:

> I think it's a lot more dynamic than, say, in the art gallery setting, 'cause in the art gallery setting they call it collaboration and it's a real esoteric, artsy-fartsy kind of thing where it's not even so much co-operation, it's more like a battle to have your own personality show. That's the feeling I always got out of collaborating in so-called high art. I've never seen the best collaboration, I mean even nationally of what I've seen, compete with the best collaborations of graffiti (in Ferrell, 1990: 11).

Denver graffiti has also developed out of cultural contexts which extend beyond local art worlds to encompass national media, music, and style. Many Denver writers first became aware of and interested in graffiti not only through direct exposure to the works of Z13 and other early kings, but through mediated visions of

graffiti writing and graffiti subcultures elsewhere. Z13 himself first encountered contemporary graffiti when in the early 1980s he saw the graffiti film *Wild Style* (1983) on a Denver public television station. As he says, this became his "main influence," since "there weren't any artists around here doing that sort of thing." Around the same time, Fie likewise discovered hip hop graffiti when he saw another graffiti film, *Style Wars!* (1985), on television. Inspired by the film, and Z13's first Colorado Boulevard piece, Fie and a friend "tried to research, and we got any books we could find. I got *Getting Up*, and I read that and you know, from then on I was just addicted."[17] Voodoo also drew inspiration, and a sense of graffiti's dynamics, from the media:

> I'd seen a couple of movies. Different movies that had to do with spray art, graffiti. I saw this one, *King 65*, and they showed how he went out in the railyards and sprayed at night, and that movie kind of inspired me. I mean, I saw that when I was about, shit, 17 or 18. And he'd go out and spray and some of his pieces would get buffed. . . . And then I'd seen some other things about New York graffiti and how it was like a world of its own. . . . To me, I'd always been kind of in the background, kind of not really in the mainstream—put it that way. And this just seemed like the ultimate way to do what I wanted to do.

These recollections, of course, implicate not only the mass media as a primary channel of cultural and subcultural dissemination, but hip hop culture as the primary stylistic influence in the development of Denver graffiti. As shown earlier, Denver writers were not just seeing generic graffiti on television and in books; they were seeing graffiti redefined and restyled by the hip hop culture of the Bronx and New York City. These mediated encounters with hip hop graffiti were in turn cemented by direct experience. Rasta 68 began doing graffiti when he lived in New York City, continued in Seattle and Las Vegas, and ultimately brought his attitudes and expertise to Denver. Fie visited New York City for only a week in the summer of 1985, but once there "went nuts" viewing and photographing graffiti. While photographing a

piece, he also met a New York graffiti writer, Shock, who painted a
t-shirt and autographed the book *Subway Art* for him.[18] "Blown
away" by the encounter, Fie tagged "Shock" for a time after his
return to Denver.

Denver writers are well aware of hip hop's influence on the
local subculture. Voodoo notes that Denver writers have for the
most part been "following the codes of what New York and
Chicago and all those places set down." Lamenting the relative lack
of innovation in Denver, Eye Six adds that Denver graffiti "usually
has words of some sort generally relating to hip hop culture. And
characters which generally relate to hip hop culture—B-boys and
pop characters" (in Ferrell, 1990: 10,11). He further sees graffiti—
in New York and in Denver—as a component of "a whole culture.
There's fashion, there's music, and then there's graffiti." Within
this culture, there also exists for Eye Six a "real tie between graffiti
and rap," in that both "sample" popular culture and play with the
"appropriation of imagery":

> The pop culture and the cultural industrialists are throwing out
> so many images that it's almost, in some regards, not really
> necessary to invent any new images. You could just pull from one
> day's worth of t.v., newspaper and radio and just mash 'em all
> together into a style that's not like anything else—like a mass
> media collage. That's all that sampling is really doing; they pull
> phrases and sounds from mainstream radio, announcements and
> that kind of thing, and collage them into the music.

Eye Six puts this sense of an integrated hip hop culture into
practice by not only doing graffiti, but mixing and dj'ing rap and
industrial music. Mac also dubs and mixes rap and other sounds;
and while other local writers may not mix, they do consistently play
and listen to the music, to the point that rap constitutes an ongoing
soundtrack for subcultural activities. This hip hop soundtrack flows
from writers' beat boxes and headphones and into the texture of the
graffiti itself. Mac, Japan and Corey originally formed the group
"3XB" as much to make rap music as to write graffiti. The "3XB"
crew tag thus abbreviates the phrase "3 times (the) beat," a

reference to its three founders' fame as "human beat boxes"—that is, rappers adept at reproducing verbally the beat and rhythm of rap music. The "Syndicate" crew tag likewise makes reference not only to the general sense of an underground organization, but to the explicit use of "syndicate" by rap musicians like Ice-T ("Rhyme Syndicate Productions," "rollin' with the SYNDICATE my unstoppable battalion") and Donald D and the Rhyme Syndicate.

Rappers like Ice-T provide not only the context of meaning for crew tags, but the text for crew pieces. When, for example, Rasta 68 and The Kid wrote "Remember, if they don't know who you are . . . they don't know what you've done" beside an illegal piece, they took this sentiment from a lyric in Ice-T's song, "Drama":

> "What's your date of birth?" "What's your real name?"
> I stuck to my alias, I know the game.
> If they don't know who you are, then they don't know what you've done.[19]

Similarly, Phaze3—whose tag itself recalls Phase II, one of the "early pioneers" (Cooper and Chalfant, 1984: 17) of New York City graffiti—adapted a lyric from Ice-T's song "Squeeze the Trigger" (1987) in creating the text which accompanies his "CRIME" piece on Denver's second "wall of fame":

> What is crime? What is not?
> What is art? I think I forgot!!!

Hip hop sets the look and feel of Denver graffiti even more broadly than these specific examples convey. Denver writers speak, tag, and piece the language of hip hop, as they "bomb" back walls and alleys with graffiti and deride the "toyz" who lack the expertise to bomb with them. "Toyz," of course, carries hip hop culture with it doubly: in the word itself, and in its pluralization with a "z" rather than "s." This hip hop convention of "z" for "s" also shows up in tags and pieces, such as Rasta 68's "R.I.P. TOYZ" piece on the first wall of fame, or the "METALZ" piece he created for Atlas

Metals Company. Moreover, local conventions of lettering and coloring derive from "wild style" and other hip hop innovations.

While hip hop certainly framed the emergence of Denver graffiti, and continues to function as a primary cultural context for local graffiti writing, it does not, however, deterministically shape Denver graffiti as a subcultural derivative. To begin with, Denver writers continually adapt the language and style of hip hop. While "toy" and other terms persist, other once popular terms—"def" being a prime example—have fallen from use. As could be seen in the account of the "3X" piece, once stylish hip hop techniques of lettering or detailing have also become passé among Denver writers, and begun to elicit criticism in place of praise.

Moreover, Denver writers blend a variety of stylistic influences with those they derive from hip hop. Z13 based "The Amazing Zerrox" not on b-boys or other hip hop characters, but on an android/robot cartoon character, Ranxerox, in *Heavy Metal* magazine.[20] And while Voodoo was influenced early on by hip hop/graffiti films, he traces the origins of his graffiti career, his "Voodoo" tag, and his piecing style most directly to his involvement with the "Gothic death rock kind of scene" and the "hard core. . . angry, punk rock" scene in Baton Rouge, Louisiana. Other Denver writers explicitly present themselves and their style as a mix of hip hop and other influences. Eye Six, who favors rap and industrial music—"a lot of rap and a lot of Ministry's new stuff" (in Ferrell, 1990: 11)—argues that

> A lot of the black graffiti artists, they're real dogmatic in terms of rap. To me, I see no lines between say Ministry or Cabaret Voltaire, and Ice-T and NWA. There is no difference. It's the same technique, a different philosophy.

Rasta 68 presents an even more eclectic list of musical influences: "Dead Kennedys, Donald D and the Rhyme Syndicate, U2, Metallica . . . I just don't like music with nice, sweet lyrics. Clean, Tipper Gore–type crap, soap opera stuff." Speaking for the public record, he adds:

> I want to make one thing very clear. Not all graffiti artists listen to rap, not all graffiti artists wear big fat Adidas laced tennis shoes. . . . Some graffiti artists might want to listen to some thrash, some graffiti artists might want to listen to The Cure.

As Denver writers have mined hip hop films, popular music, and other media products for stylistic resources, they have themselves become resources for the production of media. In the same way that the writers grew out of art training and local art worlds to become regular if rebellious contributors to these worlds, they have now become subjects of the very media they consume. At the level of daily media operations, writers like Fie, Eye Six, Rasta 68, Voodoo, and Z13 have been the subjects of countless reports in the local daily newspapers; and their tags and pieces have provided easy visual backdrops for stories on graffiti, homelessness, urban decay, and the plight of downtown Denver. Beyond this, the writers have become directly involved in all manner of media events and products. An article in *Muse*, a local arts magazine, followed Rasta 68, Z13, and Voodoo in an afternoon of railyards piecing. Rasta 68 has been featured on the pages of *Westword*, Denver's weekly arts and entertainment newspaper, and has won the paper's "Best Denver Graffiti Artist" award—an award which Voodoo won the year before, and Eye Six the year after.

Denver writers have also become part of local radio and television, as well as various public relations and publicity efforts. Eye Six and others have given interviews and fielded phone calls on local (and national) radio shows. Eye Six, Voodoo, Z13, Rasta, Imix, and other writers have appeared in numerous local public television and public access documentaries. Voodoo's experience in taping one show highlighted the odd intersection of subcultural style and media technology which can result:

> Once the interviewer was Mary Jones, and me and her were friends before I went and did it. We went to the studio, Channel 30, whatever it was. I was on mushrooms. They put me on a big table with a glass of water next to me, and I had to sit Indian-style, and they had all the cameras turned on me. . . . I didn't

even tell her 'til afterwards that I was high on mushrooms. She said I did great, and I was just worried about the whole thing.

Pieces by Z13, Eye Six and others have also become the subject matter for local bands' promotional photographs, and backdrops for fashion layouts—often without the writers' authorization. And local writers have produced murals for AIDS awareness campaigns, Stay in School publicity spots, and other public service ventures.

For the writers, the results of these and many other involvements with the media have been mixed. As subsequent chapters will show, increased media visibility has certainly heightened top local writers' status and "fame," both in and out of the subculture, and led to paying jobs as graffiti-style muralists. On the other hand, media coverage has been more often negative then positive, and as such exists for the writers within a larger constellation of legal problems and political pressures. As Z13 says:

> The people that are writing for the art scene have given us a fair shake. But as far as just the normal critics . . . or just the normal media itself, they haven't really given us any interest. . . . They're just on the negative side of it. They're really not for it in any way.

For Rasta 68 and Eye Six, problems with media coverage have reached the point that they have developed a sort of joint policy statement: "No more Denver interviews!" As Eye Six says,

> Me and Rasta talked about this. It seems like we'll throw out all these interviews to people for the radio or the television or whatever, and they just treat it like it's some novelty and then use it to their advantage. Not only do they alter what we said in the first place, but they just use it to their advantage. We get no profit out of it whatsoever. It's to the point now where we're kind of sick of it (in Ferrell, 1990a: 10).[21]

Subcultural Dynamics

Even a quick examination of Denver graffiti begins to reveal the subcultural dynamics out of which graffiti writers and graffiti writing evolved. As already seen, a graffiti subculture—a "scene," in the writers' argot—began to emerge as writers started seeing each others' work, meeting, and forming crews. And as this scene grew, it not only created a collective context in which young writers like Fie and Rasta could develop, but redeveloped the graffiti career of an "older" writer like Z13. Drawing on shared aesthetic resources taken from the worlds of art, media, and hip hop culture, writers within the scene began to collaborate on designs, pieces, and identities—and did so with a sort of shared intensity beyond what many of them had experienced in traditional art worlds. For these writers, graffiti writing began to take on the many dimensions of collective activity.

At the core of this collective activity were the locations where writers came to piece together, and in so doing to create collective bodies of work. These were locations in which the scene became physically and symbolically real—in which the style and meaning of the place and the pieces transcended individual writers and tapped the subcultural production of graffiti. The original "wall of fame" defined the early configuration of the scene; it consolidated the efforts of "kings," encouraged the participation of "toys," and ensured the scene's increasing visibility in the very heart of downtown Denver. At the corner of Broadway and Colfax—the city's center point at the southern edge of downtown—writers also began early on to meet and tag at what they called "writers' corner."[22] Fie remembers that "it was real popular to tag right there," as well he might, since he was arrested after an undercover police officer spotted his tagging there. Writers have subsequently utilized other, less visible locations—like a second "wall of fame" southwest of downtown, a third "wall of fame" evolving along a stretch of railyards wall, and the "Towering Inferno"—to meet and piece together.

Certainly one of the locations most deeply enshrined in the folklore of Denver's subculture is what came to be called, in a play on the subcultural term for graffiti writing, the "Bomb Shelter." During the late 1980s many of Denver's top writers painted elaborate pieces inside the Bomb Shelter—a large, abandoned railroad maintenance building in the railyards. Now bulldozed into splintered wood and broken, painted bricks—some of which have been collected as mementos by writers and graffiti aficionados—the Bomb Shelter became what Eye Six calls a "graffiti art gallery" (in Ferrell, 1990a: 10), and what others have dubbed the "unofficial Denver Museum of Graffiti" (*Point*, 1990).

Places like the first wall of fame and the Bomb Shelter constitute settings for stylistic interplay and social interaction, and in turn become part of the collective texture, the feel, of the local scene. As the number of places, pieces and tags has grown, and as writers have become more aware of and involved with the work of other writers, the dynamic among them has begun to build on itself. With the development of an active subculture, writers piece and tag not only with each other, but *for* each other; they increasingly define themselves and their activities in terms of other writers, and the larger scene. Thus, even when they piece or tag alone, they draw on the subculture's vitality and style—and on their sense of involvement with a larger enterprise—and engage in collective action.

Among those active in the scene, tagging is an inherently social activity. Surely hundreds, perhaps thousands of the city's residents regularly scribble nicknames, slogans, or declarations of love in back alleys and on bus benches; but they should not be confused with the relatively few taggers who account for the majority of the city's tags. These taggers tag within a context of subcultural meaning; they tag for each other. As the following chapter will show, such tagging in some cases directly draws more tagging from within the subculture. Even when it does not, though, it is embedded within a system of visibility, response, and status. Talking about Mac and other prolific subcultural taggers, Eye Six says:

Why do you tag? Well, you think, "I can't quit," you know. What he basically got down to was that he wanted fame and he wanted respect from the others. I mean, when you get down to it, there's twelve or thirteen people actively tagging the graffiti in Denver at any given time. He was interested in the respect of the other twelve.

Eye Six goes on to note, in regard to piecing, that "for me, too, it's to gain respect. . . . If you're painting on the street, I think in any art form, you want the respect of other artists." When writers piece, as when they tag, other writers make up their primary audience. Though they may hope that a piece will be seen and appreciated by the public, they can be sure that it will be seen and evaluated by members of the subculture.

Writers thus emphasize that the subculture functions to accelerate the technical precision and style of their work, and to create a sort of collective aesthetic energy on which they all draw. Voodoo remembers that in Baton Rouge, "everyone kept spray painting bullshit . . . 'cause there's no big scene. There's no cooperation. . . . It's not like there's any kind of competition." Upon arriving in Denver, however, he found that

> there was a good sense of competition, it was real healthy. And you had so many people involved to where it just moved me to go out twice a week, and carry a big load of spray paint on my skateboard to the railyard. I'd burn. It was like really inspiring. . . . If there hadn't been the competition, I probably wouldn't have gotten as good as I did. The fact that it was like a scene sort of, an art scene. Everyone helped each other out.

Z13 likewise recalls that he was drawn back into piecing not only because "now there's like a scene going on," but because "there was competition in town, too, so that's always a part of it. . . . You know, seeing what you can do with the other guy." And Eye Six recalls that, after he "got on the grapevine" and organized the Progreso/"Denver Throw Down" show,

It was like a common energy thing. That was when everybody
got real productive. That competitive edge . . . you're only as
good as your competitor, in a lot of ways. It kind of pushes you
to your best ability.[23]

If the subculture's "competitive edge" pushes writers to develop
and hone their style, though, so does cooperation among them, as
they learn new techniques and share stylistic innovations. Piecing
together in the railyards, sketching designs in each others'
piecebooks, or even arguing the merits of recently completed pieces
over six packs of beer, writers negotiate a shared sense of style at the
same time they elaborate their own. This cooperative development
of individual and subcultural style goes on within and between
crews. Fie, for example, points out that Eye Six has "really helped a
lot as far as style and technique and all that stuff" not only in Eye
Six's crews, Syndicate and 3XB, but throughout the Denver scene.
Z13 adds that, as a member of Syndicate, his earlier "solo project"
approach to piecing—which evolved largely out of necessity—has
changed:

Now that I know these people, I like working with them. . . .
Everybody's got their own unique style. Then I can see a little bit
in their thing, you know. It always helps to learn new things
from other people. So, I never turn down a chance to learn
something from somebody else.

Although present throughout the subculture's activities, this
collective stylistic process is perhaps most clearly manifested in the
"art sessions" which Syndicate members hold. As Rasta says:

Me and [HL86] used to have art sessions. And I learned, you
learn off each other. 'Cause I learned how [HL86] draws this
certain thing, and then I'll see how Eye Six draws this certain
thing, and then I'll see how Z13 like breezes through shit. And
you just, you learn, you know. So that's what keeps the
Syndicate, sort of holds it together, I guess.

As participants in an emerging "scene," Denver graffiti writers thus draw on common stylistic resources and in turn evolve new, collective notions of style as they do graffiti with and for one another. As they add pieces to a new wall of fame, or tag their way down a dark alley, they not only alter the face of the larger community, but develop an aesthetic community among themselves. As subsequent chapters will show, graffiti writing must be understood in terms of crime, power, and resistance; but it must also be understood as an activity embedded in the aesthetic imperatives which develop among the writers. Graffiti writing is not generic criminality, simple trespass and vandalism, with a stylish overlay of Krylon colors. It is an inherently stylish activity, organized around the interplay of writers' individual and collective artistry.

Denver writers make this manifest, talking about themselves and each other in terms of style. Style is the medium in which they move, the standard against which they measure themselves and their work. Z13, for example, notes his pleasure at first meeting Eye Six because "I always liked his style," compliments Fie on having "a real, real good style," and defines his own style as character-oriented, "illustrative graffiti." Voodoo attributes his "fame, I'd guess you'd say, or my notoriety" to the fact that other writers appreciated that "my style . . . came from another direction," with its "organic" inclusion of roses and vines. And Eye Six points out the "long, drawn-out process" through which Denver writers must go in developing a distinctive Denver style that moves away from "New York style or L.A. style."[24]

In doing graffiti, then, Denver writers engage in crimes of style—crimes which must be located within the aesthetic operations of an emerging subculture. The next chapter will explore the elements of practical style which make these crimes possible, along with the specific dynamics of tagging, piecing, and other criminally stylish activities. Subsequent chapters will show how, for economic and political authorities, graffiti writing also presents itself as a crime of style.

NOTES

1. As of fall 1991, local graffiti writers—and especially the members of Syndicate—had added a number of new murals to the inside walls of the Inferno, and had made plans to paint still more. Despite these plans, though, Syndicate had temporarily suspended mural painting in the Inferno. A body was found at the bottom of an Inferno elevator shaft, and members feared increased police surveillance as a result. On this incident, see the *Rocky Mountain News*, October 14, 1991: 167.

2. This sense also comes from the British cultural studies tradition; as Hebdige (1988:12) says, "If I have a preference at all, then, it is that obdurate English preference for the particular, for the thing itself."

3. Among earlier studies of graffiti, see for example Reisner, 1971; Kurlansky, Naar and Mailer, 1974; and Abel and Buckley, 1977.

4. See Becker, 1967.

5. This has also meant, of course, many more hours at my desk writing than under a bridge piecing. And, in the same way that graffiti, and research on it, is deeply nocturnal, so is this manuscript; it was written almost entirely between midnight and five in the morning. Although I make no pretense of writing like James Agee, I would cite Walker Evans' comments about Agee's writing of *Let Us Now Praise Famous Men*:

> Night was his time. In Alabama he worked I don't know how late. Some parts of *Let Us Now Praise Famous Men* read as though they were written on the spot at night. Later, in a small house in Frenchtown, New Jersey, the work, I think, was largely night-written. Literally the result shows this; some of the sections read best at night, far in the night (Agee and Evans, 1960: x; see Melbin, 1987).

This book might also best be read at night—and preferably by flashlight, in the railyards.

6. See for example Ferrell, 1990, 1990a, 1990b; *Up The Creek*, June 1, 1990; Wolf, 1990, 1990a; *Rocky Mountain News*, June 20, 1990; July 8, 1990; Wood, 1990; Ellis, 1991.

7. The classic statement of this debunking imperative in sociology remains Berger, 1963.

8. Rasta's mention of "the stuff at Wax Trax" refers to "Anarchy Alley," an alley near Wax Trax record store and other "hip bin" shops in central Denver which has for some years sported street-style paintings of Marilyn Monroe and other pop culture characters.

9. Speaking for the public record, Rasta 68 and Eye Six answered the question, "Who do you consider the best graffiti artists in Denver, other than you guys?" Rasta answered "Fie"; Eye Six answered, "Z13," and added, "The originators, the innovators" (in Ferrell, 1990: 10). Z13 adds, in regard to Fie: "I wasn't really familiar with his work until I'd seen his tags around. And then I started seeing some of his spray work, and I got really impressed by his work, too. . . . He's got a real, real good style. The one thing about him, he's got really good craftsmanship and he's real tight about what he does. . . ."

10. For more on Fie, Eye Six, Jayzer, Kaos, Zone and other writers active as of Summer 1987, see Misch, 1987.

11. Rasta 68 painted a comment on these "toys" beside his "ROCK" piece on the wall of fame: a gravestone which read, "R.I.P. TOYZ."

12. For more on this, see Clegg, 1988a: 38.

13. As noted previously, another young woman, J., participates in the subculture as friend and photographer. Eye Six also recalls "Roxy," an early female writer who was known for her Old English piecing style. For a different perspective on the involvement of women with graffiti writing, see Carrington, 1989.

14. See Becker, 1982, and Danto, 1964, on art worlds.

15. As of fall 1991, Rasta 68, Ben Bargas—a former graffiti writer who went by the tag "Daze"—and other current graffiti writers were also enrolled in the Colorado Institute of Art. For more on Ben Bargas, see Lopez, 1991: 8.

16. As Eye Six says, "I kind of lead a double life. I mean, there's gallery work and then there's illegal work. . . . I was involved in Pirate, Z13 was in Core. Actually, we're the only ones that have really been able to bridge the gap between gallery and street." For more on the Spark Gallery "Graffiti Inside and Out" event—at which a large crowd of adults and children painted with brushes inside the gallery, while Syndicate members spray-painted a "SPARK" mural outside—see Dickinson, 1991: 108; and *The Denver Post*, May 29, 1991: 1F.

17. Fie refers to Craig Castleman's book, *Getting Up: Subway Graffiti in New York*, 1982.

18. Fie here refers to Martha Cooper and Henry Chalfant, *Subway Art*, 1984.

19. All of the above Ice-T quotations come from the Ice-T and Afrika Islam album, *Power*, 1988.

20. See also Tanino Liberatore and Stefano Tamburini, *Ranxerox in New York*, 1984. The "XMen" crew title used by Mir, Eoosh, Vestige, and Phaze3 similarly recalls the legendary "XMen" cartoon characters.

21. Rasta and Eye Six graciously agreed to suspend this policy when I was asked to publish an interview with them in a local music magazine. As Rasta said, "Our buddy was the interviewer, so we thought we had an advantage" (in Ferrell, 1990a: 10). As seen earlier, my research on the graffiti subculture has inevitably affected the subculture in many ways, among them the increasing involvement of its members with the media through me. For a different perspective on Eye Six's claim that "we get no profit . . . whatsoever" out of media coverage of graffiti writers' activities, see Chapter Four.

Elsewhere, anti-graffiti campaigners have utilized writers' media interests to entrap them. In Long Beach, California, sheriff's detectives posed as members of a British film crew, held "auditions" for local writers, and then arrested some of those who appeared; see *The Denver Post*, November 22, 1991: 8B.

22. Castleman, 1982, and Lachmann, 1988, provide interesting discussions of New York City "writers' corners."

23. Rasta 68 refers to this competitive process in terms of "daring people" to take their piecing further.

24. A similar emphasis on style shows up in the comments of New York City graffiti writers, as recorded in Lachmann, 1988: 237, 239, 241: "I'm famous 'cause I ain't scared of the cops and I got the style." "I get it with my style, I don't got to fight." "No clerk, no . . . schoolteacher can say if I got style. Only someone who's out there . . . [doing murals] on the subways, in the parks can know to judge what I done."

Doing Graffiti

As the previous chapter shows, Denver writers generate graffiti in a context of emerging personal and collective style. Their graffiti writing integrates the aesthetic residues of art and music with the sorts of stylistic orientations that develop out of cooperative pieces and places, "art sessions," and other subcultural activities. For the writers, then, subcultural status and identity hinge not only on the amount of subcultural participation—the hours spent piecing, tagging, and hanging with other writers—but on the aesthetic quality of that participation. Writers emphasize that the number of pieces a writer "has up" measures that writer's standing; but so does what Eye Six calls "innovation" (in Ferrell, 1990: 10), and Z13 refers to as "a good, distinct style." For Denver writers, style is as much a part of doing graffiti as is spray paint; it is the writers' essential tool.

Speaking of style as a "tool" begins to fix its place in the Denver graffiti subculture. The concept of "style" tends to float around and above us, ill-defined and esoteric, bringing to mind vague images of form or fashion. A sociology of style can overcome this problem by locating style in the distinctive texture of group identity and action, in the practice of everyday life.[1] The first part of this chapter examines the practical elements of style embedded in the day-to-day practice of graffiti writing. As will be seen, graffiti writers' construction of style has to do not only with what they think and say, but with the physical apparati, the aesthetic implements, of their graffiti writing.

The chapter's second part investigates various forms of graffiti writing, and the particular social dynamics within which they develop. Not surprisingly, graffiti writers consistently incorporate their sense of style in the many dynamics of "doing graffiti." Some subcultural activities provide opportunities for writers to develop their style—to exhibit and sharpen technical skills and creative orientations—and to negotiate these orientations with other writers. In other dimensions of graffiti writing, though, style becomes less a matter of common bond than uncertainty and threat. Such activities can serve to attack a writer's status and style within the subculture; to threaten a writer's claim to distinctive stylistic accomplishments; and to compromise the integrity of a writer's style in relation to individuals and groups outside the subculture.

Elements of Style[2]

Tags

Tags both name writers and establish their identity within Denver's graffiti subculture. While writers may come to paint or mark their tags on back walls and dumpsters—and thus leave their tags as a public display—this activity only begins to get at the meaning and importance of tags for writers. The public visibility of tags as physical residues derives from the subcultural significance of tags as stylized markers, as components of writers' social interactions and identities.

To a great extent, a writer's tag locates him within the network of graffiti writers. Some writers refer to themselves and other writers exclusively by their tags, while others intersperse tags with given names. This mix of tags and given names varies with writers' immersion in the subculture, and with the social situations in which they find themselves. Writers most deeply immersed in and committed to the subculture, those whose identities are most thoroughly shaped by participation in graffiti writing, tend to speak of themselves and others in almost every case by tags. Occasionally,

in mixed settings like gallery openings or negotiations over sanctioned murals, even these writers refer to one another by given names rather than tags, in much the same way that family members drop nicknames in public situations.

On the whole, though, writers identify themselves and their compatriots by their tags. This practice is so common that a writer's given name may not even be known by other writers—a situation that can cause problems when trying to look up a phone or apartment number, for example. Moreover, a writer's tag—as it exists, physically, on the sides of buildings or bridge abutments— may be known to other writers before the writer himself is. This is especially the case with new writers, whose tags may be seen before they are known as individuals, or who themselves may know established writers by tag but not by sight. A common introductory scene among writers, therefore, follows an interesting pattern: "Oh, yeah, how ya doin'? So you're Shoop!"[3]

Writers develop their tags in many cases as stylized references to their personal history and extra-subcultural identity. Eye Six created his tag as a rebus-like play on his last name. Rasta 68's tag makes reference to 1968, his year of birth, and to Rastafarian religion and reggae music—though, as Rasta says in a self-effacing comment, "he's not even a Rasta, he's some white dude" (in Ferrell, 1990a: 10). Voodoo developed his tag as a reference both to his pre-Denver life in Louisiana and, as seen earlier, a particular type of music: "It was something that was real Louisiana . . . and I was real into the Gothic death rock kind of scene. So, just that whole blackness and death and the fact that 'Voodoo' has to do with all that, the occult, the whole thing." Fie's tag developed in a manner somewhat more calculated, and less connected to his own history:

> When we were starting to do [graffiti], I couldn't think of a name, so I just looked through the dictionary. And I had a whole bunch of names that I picked out and none of them were right, like "Off" and all this stuff. "Fie," and I read it, you know, 'cause the dictionary was really short, "for shame."

Eye Six adds, "He said he took [it] from Shakespeare."

Writers construct tags not only as stylized personal references, but out of shared stylistic traditions and aesthetic orientations. Denver writers' practice of closing their tags with a set of numbers—Rasta 68, Eye Six, Z13, Top One, Phaze3—draws on a New York City/hip hop convention embodied in the tags of legendary kings like Tracy 168, StayHigh 149, and Phase 2. This style in turn traces back twenty years, to the infamous Taki 183, whose tag made reference to his residence on 183rd Street.[4] Writers' tags also develop out of conventions of visual style. Whether scribbling a quick tag, or executing a throw-up or mural, writers can reproduce a short tag—a tag with few letters and numbers—more quickly and efficiently than a longer tag, and use it to create a sharper and more compact image. Writers also consider the visual possibilities of the letters themselves in creating or evaluating tags. As Fie reports: "'Fie' has been really, it was really hard to work with. When I met the guy in New York, he was just like, Fie, these letters suck together, you know." Despite this, Fie has utilized the interior "I" in his tag to good stylistic advantage. In one well-known and well-respected piece, Fie transformed the "I" into a human figure which stands between and in front of the "F" and "E." In another, he dotted the "I" with an elaborately abstract house fly. Eye Six has likewise converted the "EYE" in his tag into a drawn human eye in various throw-ups and murals.

Tags which originate out of subcultural conventions in turn emerge and evolve within the dynamics of subcultural interaction. As seen in the previous chapter, Z13 derived his original tag—the "super hero" character "The Amazing Zerrox," or "Zerrox" in its shorter version—from a cartoon character he knew through *Heavy Metal* magazine. He went by this tag for several years, and in so doing established Zerrox as the founding king of Denver graffiti, but then decided to withdraw from graffiti writing for a while. In the meantime, a new writer on the scene adopted the tag "Xerox." When Z13 returned to the graffiti scene, he therefore decided to change his tag from Zerrox to Z13:

> I heard someone else was starting to use the Xerox name, too. . . .
> I decided to go with . . . I shortened it and took the Z, 'cause that
> was always something that I liked. And I took the number 13
> because I'd used that number 13 a lot of times before. Like, this
> friend of mine, back when we were younger, we had this kind of
> group and it was a kind of club like thing. And one of my
> numbers was 13. It was like a code number, so I used that; and
> also, at my work, my route number is 13. There's a couple of
> other things that that number 13 had come into play. So I
> thought I'd just take the number 13 and put it together. So then
> I came up with the Z13.

This apparently neat transition—from Zerrox to Z13, with the
new writer now known as Xerox—took on new shapes, though, as
it was negotiated within the subculture. In deference to Z13's
status, and to the fact that he was the original "owner" of the
Zerrox/Xerox tag, Eye Six and others altered the new arrangement
as they spoke it. Though Xerox intended his tag to be spoken "z-
rox," Eye Six and other writers began to speak his tag as "x-rox,"
and continued to pronounce Z13/Zerrox as "z-rox." Xerox, who in
this way came to be known among writers as "x-rox," now more
often goes by the tag "Mac."[5]

As can be glimpsed in Zerrox's evolution into Z13, and Xerox's
emergence into Mac, writers are not averse to multiple tags; as their
situations or interests change, they abandon old tags, develop new
ones, and often go by more than one tag at a time. Rasta 68, for
example, reports that Mac at one time regularly tagged "STONED"
as an allusion to marijuana—"he was going through a 'stoned'
phase"—but now is in "a new phase . . . going through Satan, so
he's been doing SATAN throw-ups. . . . Big ol' SATAN throw-
ups!"[6] Writers also change and multiply their tags as a way of
playing with their subcultural and public identity; as Rasta 68 says,
writers may "get a tag and then they outgrow that one or get
mellower." Z13 thus reports that he is "thinking of doing some
other [tags]. . . . Kind of progressing into the newer sort of thing. I
was thinking of one, I kind of like: Dik 4—D-I-K-4."

Writers also develop multiple tags, though, for a less playful reason: to burrow further into the graffiti underground when under pressure from the authorities. Since his arrest and imprisonment for graffiti "vandalism," Rasta 68 has all but ceased tagging "RASTA." On the relatively rare occasions when he does tag, he tags either "SYNDICATE," the tags of other Syndicate members, or a disguised version of his old "RASTA" tag, in order "to throw the heat off, or whatever." As he says, in this way, "maybe . . . they can't legally prove it, or . . . they don't think I'm out there again, haunting them. But I'm out there, making their life miserable." As seen previously, Fie likewise used an alternative tag—"SHOCK"— early in his career, after he had met a New York City writer who went by that tag. Later, though, he developed alternative tags due to pressure from a notorious Denver Public Schools detective. As he says:

> I had him come in and pull me out of a class. . . . And he went through my locker and stuff like that. . . . He'd find a piece of paper and shoved it over in front of my face, and he was like, "that's you. . . ." So, I stopped "FIE" after that. He was like, listen, we know it's you, and if you tell us, and you admit it and help us out with some names, you won't get in trouble. And I wasn't about to fall for that. . . . So I stopped doing that and I wrote "Image" for awhile. But I didn't like that—I liked the letters, but not too much. And then I went through a time where it just got really rampant in Denver—everyone was talking about kings and all that stuff. I was like getting pissed off and started writing "END," E-N-D.[7]

Whether developed out of stylistic playfulness or pressure from the authorities, the multiplicity of tags attests to the fluidity and adaptability of the Denver graffiti subculture. While a writer's primary tag establishes his identity in the subculture, the variety of tags which he and other writers utilize establishes—and at times confuses—the social boundaries of the subculture. For those outside the subculture, the multiplicity of tags can lead to a confusion of changing personnel with changing identities, an

illusion of many writers where there are few. As Eye Six jokes, in reference to the City of Denver's campaign against graffiti:

> That's why I had to laugh, you know. I mean, if the city was looking at it very simplistically, and every different name that was on the wall, there would be like a hundred, two hundred people doing graffiti. But it wasn't. And I mean when you get down to it, in terms of tagging, at the time of the crackdown, it was maybe five people who were fucking up the city, you know.[8]

Paint, Markers, Bags, and Pockets

In their daily interactions, Denver graffiti writers share practical knowledge essential to the process of doing graffiti. Much of their talk centers on the quality, characteristics, and availability of various spray paints; as the essential practical tool in doing graffiti, spray paint often becomes the focus of writers' conversations. While writers may disagree on color preferences or other particulars, they agree on one organizing principle: Krylon is the spray paint of choice. In fact, Krylon's status is such that its imagery and identity pervade the workings of the graffiti underground. Writers often paint images of stylized Krylon cans—as denoted by the can's five interlocking colored circles—into murals and throw-ups. Rasta 68, HL86, Mac, and other members of Syndicate cut these circles, or the red and white Krylon logo, from the cans themselves, and wear them as graffiti "dog tags." And, when the local alternative art publication *Point* (1990) runs an advertisement for the services of graffiti artists—"SPRAY ART FOR HOME OR BUSINESS, A Referral Service for many of Denver's Finer Graffiti Artists"—it is under the heading "Krylon Kreations."

Writers prefer Krylon because of characteristics that fit with the practical aesthetics of graffiti painting. In their pieces and those of others, writers value a wide range of colors—so that, for example, subtle juxtapositions of color can be achieved—as well as colors which will remain sharp and vivid as they are exposed to weather. As Voodoo notes, Krylon provides these "vibrant colors." Also, when painting illegally—and thus quickly—writers have little time

to wait for the paint to dry, especially if they intend to paint layer upon layer of color. Thus, as Fie says,

> Krylon's really good, 'cause it has the widest variety of colors, you know. I really like Rustoleum, but it's kind of harder to work with. Longer drying time and it's just a thicker paint. And it's more quality paint, but it's harder to work with. And you know, Krylon, you can do a lot of layers, dries quick, too.[9]

Moreover, in the Denver graffiti subculture as in others, writers who allow their paint to drip or run while doing a piece are seen as doing unskilled, "toy" work. When they see a drip starting, writers sometimes employ impromptu methods to forestall it—such as leaning down and blowing on it, in such a fashion as to force it to dry as it is bent back upwards. A better, pre-emptive technique is simply to use Krylon, which is known for running far less than cheaper paints. The advertisement on the side of each Krylon can, then, could well be a graffiti writers' endorsement: "The 'No Runs, No Drips' spray paint. Dries fast to a smooth, professional finish."[10]

Writers in turn prefer particular colors of Krylon for much the same reasons they prefer Krylon generally. In the midst of painting a Syndicate piece, for example, one writer returned from a paint run with the requested colors, including black. The other writers kidded him, though, because he had mistakenly bought glossy black Krylon, which tends to run and drip more than semi-flat or flat black. Writers shy away from day-glo colors as well, not only because they are more expensive, but because they are known to fade quickly when exposed to sunlight.

Writers also use cheap, off-brand spray paint—"trash paint," as they call it—but in different ways than they use Krylon. As they sketch the large outline of a piece on a wall, writers may change their minds, or make mistakes, especially if they are working in the dark. When this happens, they employ off-brand white spray paint as a sort of eraser, spraying it over those parts of the outline they wish to hide or rework. Cheap paint is also used on occasion for fill-in work, especially where large sections of undifferentiated color

are sufficient. Voodoo thus describes the mixed supply of paint he might use:

> Oh, Krylon I guess would be the standard. I mean, it's like if I'm being cheap, I buy K-Mart's and stuff. If I'm doing pieces at my apartment, I'll get the basic colors . . . then if I get something like to go out, I'll have a few cheap cans of white, you know, a good can of white color, and a few cheap cans of black and a good can of black. . . . But yeah, Krylon—I've tried doing one piece with with just cheap paint and it just didn't work.

Voodoo's final point highlights the status of off-brand paint among the writers: it can be used, but only in moderation, and for specific aspects of a piece rather than a piece in its entirety. This understanding has been underscored in the case of one of Denver's best known writers, who has been criticized by other writers not for the quality of his work, but for the poor quality of his paint. Interestingly, this understanding in turn explains a secondary phenomenon: a collection of empty, off-brand paint cans in the railyards or an alley most likely signifies the presence not of graffiti writers, but of paint sniffers, or "huffers."

When it comes to graffiti writing, though, there is more to spray paint than the paint itself. A can of spray paint has two removable parts—the plastic, color-coded top, and the spray nozzle—and both come into play as the writers paint. Since the plastic top is almost always thrown away or lost, writers must either stop, hold the can upside down, and attempt to ascertain the color from the coded fine print on the bottom; or pay attention to the color of the paint residue around the nozzle. While the plastic tops are casually lost, the spray nozzles are intentionally removed from the cans and saved. Writers remove the nozzles when carrying the cans in bags or old briefcases; otherwise, with their plastic tops missing, the cans may spray paint as they bump against the sides of the carrying case. They also remove the nozzles from cans which they discard as they are finishing a piece. First, this prevents others from coming along later and using what paint might remain in thrown away cans to "diss'" (mark over) the piece. More

importantly, this allows the writers to build a supply of nozzles, which they can later use to replace clogged or missing nozzles, or interchange for different spray effects. Short of changing nozzles, writers attempt to clean clogged nozzles in the field by removing them from the can and blowing hard through them.

Despite the legends of "racking" (stealing) paint among graffiti artists in New York City and elsewhere, most Denver graffiti artists purchase the spray paint which they use.[11] Local graffiti projects are regularly hamstrung by the lack of money to buy paint—hardly a problem if the paint were to be stolen. Similarly, talk often turns to which stores have the best prices and selection of paint—again, not a likely topic of conversation if the paint were to be stolen. (A particular large hardware store in a near west side suburb has achieved folkloric status in the subculture for its low prices on Krylon.) Z13 points out that, "I've never stolen any paint. As far as that goes, I don't think anybody in this scene has ever done that." Fie admits: "I stole one can of paint. And I must've bought—you know, I saved, I used to save my tips [nozzles], and you know I bought at least 500 cans of spray paint. . . . [You work] a part time job to pay for your crime."[12]

Along with spray paint, graffiti writers use markers—large, felt-tip ink pens which they buy at art supply stores—for two purposes. Writers carry big, wide-tip markers—"fat" or "fat-tip" markers, as they call them—for tagging on the street. As Fie says, in remembering the beginnings of his career in graffiti: "So, the summer after my freshman year, my friend and I started doing it, you know, got our fat markers and we just started tagging. . . ." While some of these markers are refillable, their lifespans are limited by the particular demands of tagging; as Rasta notes,

> You can buy ink to fill it up and it unscrews. You just fill it up and those'll last you about—well, it depends on how often you tag. 'Cause the tip is about this big and I've seen 'em where the tips are worn down to the metal. Xerox's marker, man, those guys leave about a hundred tags a night.

In the same way that the practical aesthetics of piecing intertwines with the technical capabilities of Krylon, the style of tagging flows in part from the physical construction of the markers. The markers feature not only "fat" tips, but tips that are cut on a diagonal across the end. With such a tip, a tagger can produce a type of sharp, slashing tag—a sort of street calligraphy—which would not be possible with a round-tipped marker.

Writers use a different sort of marker in creating images and designs in their piecebooks. As they work on designs and color schemes for pieces, writers attempt to emulate in their piecebooks the colors and techniques which they will later use in executing the pieces. Smaller, felt-tip design markers are available through local art stores in a wide spectrum of colors, many of which closely match Krylon colors, and are therefore used by the writers for this work. In addition, one of the most important piecing techniques is "fading"—that is, bleeding and blending colors as they are sprayed onto the wall. With their felt tips and translucent ink, these design markers are also useful for duplicating this "fading" effect in piecebook sketches. As Rasta says, "For a piecebook, designer markers are the best because you can get fades. You can make your own fades." For such work, Rasta maintains a large collection of "piece book markers" and pens, some of which he bought at a discount from another writer.

Whether heading out to piece with fifteen or twenty cans of Krylon, or tagging down an alley with a few cans or fat markers, graffiti writers must cope with the problem of transporting the tools of their trade unobtrusively. Baggy pockets, or an old overcoat in cool weather, often suffice to hide fat markers, or even a couple of cans of Krylon. Concealing enough Krylon cans to execute a piece, though, requires something more than clothing. Writers often carry small bags, small suitcases, or old attache cases. Z13 allows that he doesn't "really have one set style" of carrying paint, although he "did have a backpack that I used to carry my supplies in . . . either that or I carry a portfolio, which is kind of big and bulky, so it looks a little obvious." Another of Denver's top writers is regularly

seen with an old, black briefcase, in which he carefully arranges the night's selection of Krylon.

Pockets, overcoats, and briefcases matter because, for Denver's graffiti writers, getting around is a public event. Although typical in many ways, the "3X" piecing foray described in the previous chapter is atypical in that a car was involved. Almost without exception, Denver writers travel by foot or by bus. This mode of travel is certainly to a great extent determined by the young age and relative poverty of the writers. There exists also, though, some element of choice. Walking the central city, waiting on and riding buses, writers stay in touch with the urban culture they help to create. Moreover, foot travel provides a degree of anonymity, an urban invisibility, that automobile travel does not. Eye Six's comments capture this interplay of strategy and necessity:

> Anymore, I'm very, very suspicious whenever I do a piece. I don't want a fucking car. . . . I don't want a car anywhere near the place, because it's like that's numbers, registrations, and spottings. I walk. I walk miles if I have to. These days it's by necessity.

Piecebooks

Denver writers use as their piecebooks hard-back, leatherette-bound sketch books of good quality paper, which they purchase at local art supply stores. As the name implies, a writer's piecebook is the place where designs are developed for pieces which may later be painted in public settings. Piecebook designs are often elaborately executed, with markers, sketch pens and even airbrush used to achieve a full range of color and detail. A piecebook used in this way falls somewhere between sketchpad and archive; it becomes a sort of portable record of works which are otherwise almost certainly destined to be buffed, gone over, or otherwise lost. As such, a piecebook may also contain photographs of a writer's publicly executed pieces—photographs taken by the writer or, more often, sympathetic friends with better access to cameras and money for developing film.[13]

Piecebooks are put to a variety of other uses as well. Many writers consult their piecebook designs when finally painting a piece in public. When the piece is being done illegally, and at night, the writer thus squints back and forth between the piecebook and the wall, attempting in the dark to reproduce in bursts of Krylon the detailed contours and colors of the piecebook design. Though valued highly by the writers, piecebooks which are used in this way often suffer the effects of foot travel, soiled hands, rain, and other elements of graffiti painting.[14] To combat this, some writers have begun photocopying out of the piecebook the design which they intend to use on the street. This technique not only saves wear on the piecebook, and avoids its possible confiscation if the writer is apprehended, but provides a design which is more easily transported, concealed, and if necessary, disposed of.[15]

Piecebooks also function as part of the social life of graffiti writers. As finely executed records of pieces real and imagined, piecebooks can be shown to gallery owners, newspaper reporters, sociologists, and others outside the subculture with whom writers must establish legitimacy. When, for example, members of Syndicate were invited to deliver a guest lecture in a college art class, and at another time to meet with members of a local art gallery, some brought along their piecebooks. As a record of a writer's work, and as evidence of his skills as an artist, piecebooks serve an important function in confirming the writer's identity, in distinguishing him from others who might claim to "do graffiti."

But while piecebooks are owned and used in these ways by individual writers, they are also owned and defined by the subculture as a whole. Within the subculture, piecebooks function not only as repositories of individual style, but as common ground for collective creative production. A number of writers, especially those within the same crew, may do pieces in an individual's piecebook; and at times crew members will collaborate on pieces in one book or another. Though the property of an individual, and representative of his work, a piecebook thus comes also to represent the subculture's shared aesthetic, its developing style, and the ongoing work its members do as they prepare to piece.

Beyond serving as loci of collective style, piecebooks also serve as diaries of friendship and shared adventure within the subculture. Collaborative designs, and the designs of other writers; photographs of pieces done together; the tags and phone numbers of other writers—all give the piecebook meaning and value beyond the obvious. Thus, the last afternoon of Voodoo's return to Denver— just before he was to board a train back to Baton Rouge—he asked Eye Six to do a short piece in his piecebook, and Mac and Shoop had Voodoo tag their books.

Writing Graffiti

Tagging

The collective production of graffiti, and the sharing of stylistic and practical knowledge, can be seen in the two most common forms of doing graffiti: tagging and piecing. When graffiti writers tag, they write a practiced, stylized version of their subcultural nickname, or "tag." They also often write an alternative personal tag, the name of their crew, or even the tag of other writers in the crew. As Rasta implies, this sort of cross-tagging benefits everyone in a crew, and promotes the crew itself:

> I can go out and tag other people's names, like Amaze or Top or Eye Six or Z13, without tagging my tag. And then I can have them tag my name, so I don't have to tag to get my name up; or my friends don't have to tag either.

When Mac tags, he most commonly writes "MAC" in a style that is recognizable as his to other writers; but he also regularly writes a tag for one of his two crews—most often "3XB," occasionally "SY" or "SYN" for Syndicate. Phaze3, another of Denver's most prolific taggers, also for many years accompanied his tag with "XMen2," the name of his crew. Some writers' tags, while written in a distinctive personal style, can nevertheless be read by the general public; others are so stylized that they are recognized only by members of the subculture. Tagging alone or with others, taggers

thus participate in social, subcultural activity, both in what they write and how they write it.

Often, writers do tag together. When visiting another writer's apartment, a writer may, with his colleague's permission, tag a wall, coffee table, television, or trash can. At a writers' party, writers may likewise decide to tag in or around the gathering; at one party attended by a number of Syndicate members, one writer's old sportscoat was offered up for tagging. At the completion of a large mural, writers sign it with individual and crew tags, and may tag around it as a way of establishing the writers' or crew's ownership of it. These regular, social uses of tagging within the subculture should not be confused, however, with "going out tagging"—that is, with tagging as an activity unto itself.

On their way by foot from one place to the next, or as a sort of late night adventure driven by some confluence of anger, boredom and booze, writers tag their way down streets and alleys. Such tagging is less planned than providential, a matter of mood and opportunity. Thus, despite being one of Denver's most accomplished graffiti muralists, Eye Six at times falls back into tagging when he is "drunk and pissed off" (in Ferrell, 1990a: 10). The simplistic explanations of public officials discussed in the next chapter—that this is a dog-like marking of territory—miss the elegance and complexity of this sort of tagging. Certainly gang-affiliated taggers may tag gang names or images as a means of symbolically establishing or violating territory. And, for non-gang taggers, tagging can be a part of establishing one's identity and reputation within the graffiti subculture, although it is certainly no substitute for executing well-designed murals. What is absent, though, from these accounts of tagging's supposedly calculable results—tagging marks territory, tagging establishes status—is a sense of tagging itself; that is, of the incalculably rich experience of "going out tagging," especially with other writers.

Tagging down an alley bears little resemblance to walking casually down that same alley. On a quiet summer night, with house and apartment windows open, taggers must whisper their comments on other writers' tags which they discover, and gesture

warnings of approaching dangers. They also must be aware of, and
concerned with, the rattle of the Krylon can and the hiss of the
spraying paint. No tagger, of course, would be stupid enough to
shake the can, as the directions recommend and as one would if
painting a piece of furniture; but the gentle and occasional rattle of
the spray can ball while walking and tagging causes enough noise
for concern.

As already seen, concealing one or more spray cans causes
additional problems, especially when wearing summer clothes. For
these reasons, taggers often prefer wide-tip markers to spray cans; as
compared to spray cans, markers are quick, silent, and concealable.
As Rasta 68 says, Krylon can be a problem

> when it's two o'clock in the morning, and it's all quiet and you're
> walking down an alley and all you can hear is pssssss [the sound
> of the paint spraying]. And then you can walk down the alley and
> just have a marker and it just doesn't sound. But when you hear
> this pssssss, that sound is very distinct. You know that sound of
> pssssss, and you know nobody's out there oiling their wheels at
> night!

These same concerns lead writers to prefer, or at least claim to
prefer, tagging during Denver's cold winter months. As the writers
explain, a cold, snowy night offers all sorts of advantages, if one can
keep from freezing. Neither cops nor citizens expect taggers to be
out; windows and doors are shut tight; few people are outdoors;
and spray cans (or markers) can be concealed under overcoats or
oversized jackets.

Whether carrying cans or markers, beginning taggers must
learn to look around, to be aware of windows, balconies, lights, and
sight lines at all angles. A toy's mistake is to stop, check that the
spot seems dark enough, and begin tagging—only then to glance
back and notice for the first time the lit second-story window
behind him, or the car lights illuminating the end of the alley. And
on those rare occasions when writers dare tag in open, populated
settings, a remarkable degree of grace and guile is required. Writers
thus recall the subtlety of their arm and body movements in public

tagging, and the ploy of looking in one direction while tagging in another; and Eye Six half-kiddingly recommends a bottomless bag or box which a writer can set down, reach into, and thereby use for surreptitious tagging. Certainly part of the pleasure of tagging is the rush of excitement, the heightened awareness, that goes with learning to tag well and unobtrusively.

Tagging well also requires technical knowledge; a tagger must learn that there is more to the moment of tagging than aiming and spraying. When taggers use spray cans, a short burst is sprayed into the air or ground before tagging, to insure a steady flow of paint before contact with the wall. (This same technique is used in painting murals.) Where this step is omitted, faint beginning lines on the one hand, or drips on the other, can result. The quality of the surface also affects the quality of the tag, and especially with markers. As best possible in the dark, taggers look for a clean, flat, non-porous canvas; brick, for example, is especially problematic for tagging with markers.

The many tags which result from this subcultural activity often draw the response of other taggers, and thus spark another round of collective action. An initial night of tagging may over weeks or months evolve into a sort of conversation among taggers, as other writers respond in paint or marker to earlier tags as they find them. In most cases, later writers will simply tag near the initial tags. Less often, they will leave a short message, or even cross out earlier tags, and tag the pejorative "toy" over or near them. Tags which are written too big are also criticized by writers as evidence of an overinflated ego, and may draw written commentary.

As before, this activity cannot be reduced to simple notions of territoriality or competition. In fact, from the taggers' viewpoint, tagging near earlier tags makes sense for quite different reasons. The existence of previous tags tells the tagger that placing a tag here will get it seen, since, first, other writers obviously come this way, and, second, the property owner hasn't bothered to remove the earlier tags. To put it another way: why should I tag a clean wall, when that clean wall indicates to me either that other writers aren't

around these parts, or that the property owner immediately paints over any tags left there?

Many writers also share two convictions. They agree that, all else being equal, they would rather not tag a clean spot, out of respect for "somebody's wall" or "somebody's garage." In addition, they agree that they won't tag granite walls, sculptures, or similar surfaces, out of respect for their aesthetic qualities, and out of the practical sense that such surfaces will be quickly cleaned by the authorities. As Rasta 68 recalls, "I painted [tagged] the statue on Colfax and Broadway. . . . I caught more shit for that. My graffiti artist friends . . . gave me one response: it was uncool and tacky" (in Ferrell, 1990a: 10).[16] Such shared convictions, of course, serve further to concentrate tagging and tags in previously tagged areas.

These shared convictions as to clean walls and sculptures also begin to get at the writers' broader ethics and aesthetics of tagging, and graffiti writing in general. Fie notes, for example, that even when he was tagging heavily around Denver, he would "try to pick the spot, and make sure it wouldn't totally desecrate the place— kind of fit in, you know." When he moved to a smaller city to attend college, therefore, he "didn't tag, just because it's a really nice city. They don't have much crime. . . . It's just such a clean city, and such a beautiful city, I didn't think I wanted to tag at all." Eye Six likewise refers to the "ethics" and "standards" which have guided his tagging and piecing (and which he regrets on occasion violating), and notes that, for him, some tagging is "real questionable" in terms of "the place it's put."

Fie, Eye Six, and other writers thus tend to avoid tagging areas whose cleanliness or beauty make them aesthetically inappropriate. Instead, they concentrate on areas where tagging will, as Fie says, "fit in"—in other words, areas whose level of aesthetic degradation is such that tagging will do little additional harm. Certainly all Denver writers do not strictly follow this model; but enough do so that tags (and pieces) often cluster under aging viaducts, on abandoned buildings, or along stretches of deteriorating, unpainted wall. Eye Six points out that he won't do graffiti in downtown's Confluence Park, because "there's an aesthetic already there":

Green, growing grassland. And people, you know, they want to get away. It's in the middle of the city and they want to get away from the urban, they don't want to see no fuckin' graffiti. They want their kids to run around. . . . [Instead], I go out where the winos are, where the bums are, and where it's rotting and fucked up, and I beautify it.

Interestingly, Denver's "kings" consistently go beyond this sense of appropriate and inappropriate tagging to question the role of tagging itself. Z13 has never tagged, "was never into that," and in fact began piecing because "that's what I wanted to change, was to really put a big art form into it, instead of just the tag." Voodoo also avoids tagging—"I might have done five tags in my entire life"—and for much the same reason as Z13: "When I got into graffiti, it was just a new art form; it wasn't as much like we were tagging on the street." Even kings who have tagged voice doubts and disapproval. Despite his early fame as a tagger, Fie now feels that tagging is "totally out of hand," and adds,

Like the XMen, I didn't really respect them too much, 'cause they'd write [tag] in really weird places, and they kind of got out of hand with it . . . they were just up so much, just everywhere.

Rasta likewise criticizes those who tag indiscriminately, and emphasizes that "tags are just tags. Tags don't have nothing to do with art. . . . The Syndicate believes in that. . . ." And Eye Six holds tagging responsible for much of the city's opposition to graffiti, and admits to being "schizophrenic" about tagging in general, despite his occasional involvement in it:

There was a . . . T and T tag team . . . they're all tag. They would tag my grandfather's store; he was real concerned about it. And he knew what I did, and he came to me asking what to do. . . . And I thought that was pretty fucked up. It's like, what has this old man done? There's times I'll see this old folks' little shack, sitting there and it's been fucked up. And then I can see why people would be pissed. I mean, it's like this world's insane, and you have your own little shack, your own little abode, your own

little castle, and a tag is a personal affront on it. And in a lot of
ways, I don't think people understand. They probably take it
more personal than they should.

The discomfort of Denver's kings with tagging develops out of
two features intertwined in the role of "king." Tagging—and
especially heavy, relatively indiscriminate tagging—often
accompanies the early stages of a writer's career in the subculture.
Such tagging can be used by less skilled or experienced writers to
attain a measure of status and visibility, and thereby gain entry into
the "scene." Kings, of course, have already gained this status and
visibility, and more; they stand at a stage in their careers when such
tagging is neither necessary nor, in a sense, appropriate.[17] Thus,
when Mac made it known that he wished to join Syndicate,
Syndicate's "kings" considered his tagging not a point of status, but
a potential problem. Moreover, kings have gained and solidified
their subcultural status less because of their tagging than their
piecing—that is, because of their recognized skills as artists. In this
sense also they have moved beyond tagging, and come to define
themselves and graffiti writing generally by the aesthetics of piecing.

Piecing

The painting of large, illegal murals or "pieces"—"piecing" or
"painting," as it is known in the subculture—develops, like tagging,
along various lines of interaction and cooperation. As already seen,
writers together draw on hip hop and other cultural resources in
evolving lettering styles and images for their pieces. They in turn
employ their piecebooks to create the specific images and designs
for large murals, often sketching and planning in cooperation with
other writers.

As could be gathered from the "3X" piecing episode described
in the previous chapter, the actual painting of a mural incorporates
a hodgepodge of social activity. Writers phone other writers, and set
meeting times and places, as they attempt to round up the night's
crew. Together, they evaluate the supply of paint left from previous
work, and, if more or different paint is needed, pool money and

find transportation for a "paint run." Once an adequate supply of paint is gathered, writers organize their paint by color or type, and load it into the sorts of old briefcases or bags described earlier. On the way to do the mural the writers also purchase enough cheap beer or Yukon Jack for the night's work, although such purchases may be limited by the amount of money remaining or the amount of beer the group is willing to haul on foot.

As the hours-long process of piecing begins, tasks, roles, and innovations intertwine. Since most pieces are designed to be taller than the writers' reach, one or more writers often try to scrounge some sort of urban debris on which to stand while painting. Though all manner of objects are used—beverage cases, concrete blocks, discarded furniture—wooden pallets are generally thought to make the best ladders, especially when leaned against the wall so that the strongest cross-boards face outward. Writers also pick up pieces of broken glass or plexiglass, sheet metal, or other debris to use as straight-edges in their painting. Later, one or another writer will take a break from painting to smoke a cigarette or drink a beer, and keep watch for police, street people, paint sniffers, and other potential intruders.

Before they begin spray painting the piece, writers prefer to "prime" or "prep" the wall—or, as Voodoo says, to "latex the wall"—with white or light-colored house paint. While writers may omit this step due to lack of paint or time, they would rather not. To begin with, prepping the wall makes sense economically; applying a coat of cheap house paint means that an old, deteriorating wall won't absorb as much expensive spray paint. Watching Voodoo spray paint on a wall which had, of necessity, not been prepped, Eye Six commented, "Look at the shit. He's having to hold his can right next to the wall," because the wall was absorbing so much paint. As Z13 says, using house paint to prime a wall, or even fill in larger areas of a piece, is in the long run "conservative of the paint."

For the writers, though, priming the wall is a matter not just of economics, but aesthetics. The house paint provides a consistent texture and monochromatic background for the piece. Especially

when applied in such a way as to create a large square or rectangle, it helps to define the piece's frame of reference, to set the piece off from a lengthy expanse of wall. The white or light-colored background also contrasts nicely with the piece's outer boundaries, which are most often spray painted black. Finally, a primed wall allows the writers to spray paint sharper, cleaner lines within the piece than would be possible on an unprimed, spongy old wall. When Voodoo finished the piece on which he had "to hold his can right next to the wall," due to lack of primer, the other writers present commented on the remarkable style and composition of the piece. But Voodoo could only complain, "There's not one sharp line in the whole thing."[18]

As the house paint begins to dry, the writers use light Krylon colors to sketch the piece's outline on the wall. If the piece has been designed in a piecebook, the writers prop the book open and glance at the design while outlining. If a figure is to be incorporated—Bart Simpson, or a B-boy, for example—the writer most skilled in this area will begin this sketch as well. As the piece progresses, other writers known to be especially good at fading (blending and shadowing colors at their borders) or detailing (painting intricate interior designs) begin their work. "Toys"—who, if present, will have probably helped with the house paint—fill in larger, single-color sections designated by the more skilled writers, or help "erase" mistakes with "trash paint."

All the while, the writers keep up a discussion as to the practical and aesthetic progress of the piece. They argue over the accuracy with which the images are being translated from the piecebook to the wall, and ask for help with perspective and scale ("Spot my dimensions for me"). They discuss the appropriateness of blending and juxtaposing particular colors, and of adding star-bursts, thick borders, birds, and other stylized conventions. They curse the strange disappearance of paint cans ("Now where the fuck is that Jade Green?"), and worry over the amount of paint remaining, which they judge by the feel of the cans. And as their pointer fingers wear out from holding down the spray nozzle for hours on end, they paint larger areas—areas which don't require as precise a

touch—by wrapping all four fingers around the Krylon can and spraying with their thumbs.

Increasingly, writers also include stenciled images in their illegal pieces. Z13 and Eye Six are both accomplished stencil artists who have exhibited their stencil works in local galleries; Voodoo also combines stencil with other media, and has produced stencil art for clubs and shows. For these writers, stencil art and graffiti connect by way of the spray can, as Eye Six makes clear:

> The way I got into graffiti was stencil stuff. I had been doing straight stencil painting for people, and then I started seeing graffiti, and I said, well shit, I use spray paint, I'm going to try my hand at it.

As seen in the previous chapter, one of Syndicate's first collective pieces thus included a number of Z13 handgun stencils. Z13, who has "recently started to use just a few" stencils in his pieces, also incorporated stencil effects in his railyards "HOMEBOY" piece. Using "something that I had found near a railroad car, as we were walking down there," Z13 produced "a bunch of dots . . . circles as an effect inside the lettering."[19] Voodoo likewise blended stenciled shadow lettering—"all stencils, so it was real crisp"—into a nearby piece which featured a full moon, mausoleum, skeleton, snake, and other dark images.

These stencil techniques push at piecing's aesthetic boundaries. In a subculture where writers value free-hand virtuosity in piecing, some see stencil work as inappropriate, a way of hedging on personal style and technique. Z13 notes that some of Eye Six's early "stencil pieces" were therefore diss'd (marked over) by other writers, and Eye Six adds,

> They hate it. It's cheating, you know. Which was real discouraging when I first got into it, because I thought people would get into it. And anytime I would do a stencil piece, everybody would fuck it up. And, since they've met me, they've come to like . . . they accept my eccentricities a little bit more, but it's still taboo.

This conflict over stencil techniques gets at a more basic disagreement as to the use of "straight-edges" in piecing in order to achieve sharper, more precise lines. Drawing on New York City/hip hop graffiti traditions, some Denver writers have rejected the use of straight-edges, and thus embraced an aesthetic which devalues straight lines in pieces. But as Z13 notes:

> I think some of the people don't like [stencils], but a lot of them use it, as far as straight-edges. They might not use an actual stencil as a symbol or whatever, but as far as like using the straight-edge to get a good, clean line, a lot of them are using that. So, therefore, that's a stencil, too.

As this conflict among Denver writers is negotiated, so too is an emerging aesthetic. As kings like Z13 and Eye Six continue to incorporate stencil techniques in their pieces, they begin to develop a graffiti/stencil style distinctive to the Denver scene.[20]

If illegal piecing draws on previously manufactured stencils, carefully executed piecebook designs, and other prearranged elements, though, it also incorporates a large measure of adaptation and improvisation. In this sense, the stencil which Z13 found and then used in his "HOMEBOY" piece is an appropriate symbol, capturing as it does the fluid, emergent nature of piecing. Illegal piecing is less a planned event than a process—a process defined by the vulnerability of the situations in which it occurs. As hour after hour of piecing goes by, writers are vulnerable to interruptions by police, paint sniffers, or other passersby. Even without these interruptions, writers may begin to lose interest in the piece— especially if a good bit of beer or pot is involved—or change their minds as to its content, style, or dimensions. And, as is often the case, they may be forced to change a piece as they begin to run out of particular colors. Voodoo comments on this emergent process:

> Yeah, I always work it out beforehand. My graffiti piece was on a certain page in the [piece]book, but when we started to do it, the

color scheme didn't match the color scheme that was on the page, because I didn't have all the colors to make it as big as the piece was going to be. So I just had to compromise, you know—it turned out a lot better than what the picture looked like.

But most of the pieces, like the "IMPS" piece, this piece was just totally spontaneous. . . . And I thought, well, I'll just go in here [the Bomb Shelter], so this was just figures and the altar again and the roses and stuff. And at first, this was just a big bubbling thing of goo, and then I turned it into a person, so it was just a bunch of ad lib. Just off the top of my head, the colors that I had.

As seen in the previous chapter, a planned "3XB" likewise became, in the process of piecing, a "3X" piece; an intended "SPARK" piece nearby evolved into what the writers now call "the SPA piece;" and "FORTY"—planned as a tribute to the forty-ounce malt liquor bottle—emerged as a "FOR" piece.

In the process of piecing, writers thus produce pieces that deviate from piecebook designs; that take on unexpected colors, dimensions, and meanings; and that may never quite reach completion. Such spontaneous adaptations—and the writers' ready acceptance of them—reveal an essential dynamic: the process of piecing is both a means to an end and an end in itself. Writers certainly care about the content of their pieces, often designing them as tributes to their crews or individual writers within them. Syndicate, for example, has produced murals honoring Eye Six, Rasta 68, and even the U.N.L.V. basketball team which won the Final Four in Denver; and Voodoo has painted a "Hit the Road, Jack" tribute to Jack Kerouac.[21] Writers work long, dangerous hours on such murals, and in turn gain subcultural status when they are well done.

They also work together on murals, though, simply for the pleasure of it. Crew members often get together to hang out at an apartment or bar, or to attend an alternative gallery opening or party; but piecing is the process which most clearly confirms the

crew's identity, its reason for existence. Drinking, talking, smoking cigarettes, painting, those together in the alleyway or railyard share a kind of wild pleasure. At large and illegal in the city, they attain a moment of unfettered collective creativity. As Eye Six says, "It's like a band. You can sit in your room and pluck your accoustic guitar and that's fine for you, but if you really want to collaborate and get the energies flowing and exchange ideas and motivate, put out the loudest beat, you gotta be in a band" (in Ferrell, 1990: 11). In this sense, piecing produces not only graffiti as spray painted art, but graffiti as performance art—performance art unique in the artists' hope that no one save themselves witnesses it.[22]

When they talk about piecing, Denver writers emphasize this experiential dimension, noting time and again the intense excitement of piecing as an end in itself. Like tagging, piecing produces moments of illicit pleasure that transcend any rational calculation of its results. Commenting on the factors that first drew him into illegal piecing, Z13 notes "the excitement of doing it, at night and undercover. That's kind of the thrill in it." Voodoo is even more explicit:

> Right before you hit the wall, you get that rush. And right when you hit the wall, you know that you're breaking the law and that gives that extra adrenalin flow. And that's what really got me going. It's like, it's kind of almost like a drug. . . . Yeah, it's like being a jewel thief. It's not like you're really breaking the law, it's like a jewel thief, it's real kind of a romantic criminal act.

Looking forward to his return to the Denver scene, he adds: "I miss the magic, the breaking law part of it. It's probably the biggest rush of all."[23]

While the "rush" of piecing fades as the night ends and the crew disperses, the resulting piece, of course, remains as part of the city's emerging visual landscape. Even when the night's piecing leaves behind an unfinished mural, writers may subsequently return to check on it and do "touch up" work. If the piece stands in a relatively safe place—an obscure spot in the railyards, for example—writers at times even risk returning by day, to take

advantage of the visual clarity which daylight offers. At any rate, word of the new piece soon spreads throughout the subculture, and other writers go by to view and critique it. If they like the piece, they often write short, complimentary messages, along with their tags, nearby.

To nonwriters who wander by, the new piece surely presents itself as a bewildering display of color and style. Where the day before there stood an expanse of clean if decaying wall, there now stands a wildly stylized mural, perhaps ten by thirty feet in size. If the piece is like most in Denver, its letters will be so wildly stylized as to make it inaccessible to those passersby outside the scene. If they know how and where to look, though—usually somewhere near the bottom of the piece—they may find a "key" to the piece: a tagged word or phrase, often in quotation marks, which reproduces the words or phrases in the piece. In other pieces, no amount of attentiveness is likely to decipher the content; in these, the writers' stylistic tricks—upside down or mirror-image letters, or even pseudo-letters—have reached a point of remarkable sophistication and abstraction. To be a member of the Denver graffiti scene, then, is to know not only how a piece is to be read, but how it is not to be read.[24]

Throwing Up

Throwing up is not, as Rasta 68 jokes, "when you get really sick of seeing all the tags and you throw up all over the side of a building" (in Ferrell, 1990a: 10). Instead, throw-ups occupy, both technically and aesthetically, the middle ground between tags and pieces. Writers "throw up" graffiti when they spray paint an enlarged, two-dimensional version of an individual or crew tag—typically three or four feet square—on an alley wall or abandoned building. In some cases, as in some of Mac's "SY" (Syndicate) or Top's "TOP!" throw-ups, the work consists simply of a two-dimensional outline of stylized letters. More often, the writer fills in this outline with one or two layers of paint, thus creating piece-like lettering on a smaller and less elaborate scale. When a simple outline is executed, a throw-up can be done in a few seconds with one can of paint. If

the outline is filled in, two or three cans of paint will complete the work in a few minutes. As Rasta says, "You get down with like a thirty minute piece that's not that elaborate, but it's way more elaborate than a tag. An outline and maybe three colors of paint" (in Ferrell, 1990: 10). For writers, throw-ups develop out of an economy of paint, time, and style.

The subcultural status of throw-ups likewise falls between that of tags and pieces. The status and visibility which writers gain from throw-ups—especially throw-ups which are particularly stylish or precise—certainly surpass that which tagging confers, but don't compare to the prestige which follows from well-executed pieces. Fie's status as one of the top "kings" of the Denver scene, for example, results primarily from his brilliant pieces, but is enhanced by his throw-ups. Fie's throw-ups—a recognizable, two-color, bubble-style "FIE!"—are not only consistently and precisely executed, but visible throughout central Denver. As Fie says,

> I tagged and I started doing pieces and then I stopped tagging, you know. And then I wanted . . . I didn't want to stop tagging completely so I thought, well, throw-ups. And there weren't any throw-ups in Denver at that point, so I started doing throw-ups. And it was just like one month—I just went around and I . . . just did them all in a really brief period.

Voodoo adds that Fie began throwing up "just to make sure his name was up and that they weren't tags," and notes that when he spotted one Fie throw-up, "it was like, oh my God, that's Fie. . . . That's why I think he's the undisputed king because his pieces are quality, plus he gets around." For writers, throwing up thus draws on both the repetitive visibility of tagging and the stylistic sophistication of piecing.

Other Denver writers have also produced distinctive throw-up styles. Voodoo has done only "a couple of throw-ups," but in these combined his recognizable use of "roses and vines" with an odd twist: "VOUSDOUS," a pseudo-French rendition of his tag. As noted earlier, one of Eye Six's often photographed throw-ups locates a painted eye above a lettered "SIX" and vaguely Oriental

lettering. And Phaze3 has developed a brief, distinctive throw-up—
"3!"—which he has reproduced hundreds of times in the alleys of
central Denver.

For these and other writers, the cost, time, creativity, and risk
of throwing up falls somewhere between hurried tagging and hours-
long piecing. In this sense, throwing up constitutes at the same time
a particular subcultural activity and a residual category. Z13 notes
that,

> Sometimes when you're just in the mood to do something, or if
> you don't have enough time or enough paint . . . you can only do
> a certain amount of work. It's usually something that's not all
> that great, that you don't want to brag about, or bring all your
> buddies out and, "Yeah, I did this, look at this," you know. But
> then again, sometimes you can do a quality throw-up; it just
> depends on the mood and how things are flowing at the time.

Or, as Eye Six explains, "a throw-up is just whatever's not a tag and
not a piece."

Biting

As already seen, graffiti writing is an essentially stylish process,
developing out of a subculture which blends shared aesthetic
conventions with an appreciation of individual "innovation" and
creativity. Whether painting quick throw-ups, collaborating on all-
night pieces, or tagging down back alleys, writers continually
negotiate the boundaries of personal and collective style. "Biting"
denotes a situation in which these boundaries are called into
question, in which the authenticity and legitimacy of a writer's style
becomes a point of contention among other writers in the scene.

When writers accuse another writer of "biting," they consider
him to have inappropriately taken and used distinctive images or
stylistic touches, either from other writers in the scene or from
sources outside the scene. Within the Denver scene, the
innovations of "kings" like Z13 and Voodoo have not only set the
standards for the scene's development, but in some cases been

directly bitten by other writers who have taken these innovations and incorporated them in their pieces. Z13—who defines biting as "trying to use somebody else's work that's already been done, or copying their style"—explains that in his case

> There was somebody, back when we were doing the [original] wall of fame, they were using green goblins. I don't know who it was, but they were using kind of the same type superhero character [The Amazing Zerrox] that I was doing. . . . They were just a toy and it wasn't any quality work, I think, so I wasn't really worried about it.

Rasta likewise explains biting as "whenever you take somebody else's style . . . they use it and claim they did it," and notes that after Voodoo established his "organic," vines and roses style of piecing, Phaze3 and other writers bit it—they "stole all the roses."

Writers also talk about the appropriation of popular culture imagery in terms of biting. Eye Six jokingly criticizes some of Mac's early pieces which "bit" the Ninja Turtles—in other words, pieces in which Mac included slightly altered images of the turtles. In this sense, Phaze3 has also bitten a variety of pop culture characters, painting a scowling Bart Simpson character at the top of his "IN YOUR FACE" piece, and including a Calvin character (of the cartoon strip Calvin and Hobbes) in another piece described below. As might be expected, Denver writers also bite the imagery, language, and style of hip hop culture. Phaze3 talks about "biting" his "What is crime?" poem on the second Wall of Fame, in that he took a lyric from Ice-T and altered it to fit graffiti writing. And Rasta says, in reference to biting, "O.K., look at the characters. Everybody draws like a black dude—like [they draw] a B-boy."

To accuse a writer of biting the style of another writer, or of biting popular culture imagery, is to call into question the writer's willingness or ability to innovate. As these accusations push individual writers towards greater innovation, they also begin more broadly to demarcate the subcultural boundaries between personal and collective style. While membership in the subculture implies that a writer will understand the shared codes and conventions of

graffiti writing, it also implies that he will understand the limits of this shared style as well, and develop a personal style not directly appropriated from other writers' innovations. "Biting" can therefore further imply "stealing" another writer's distinctive style; as Rasta says, other writers "stole all the roses" from Voodoo. In this way, accusations of "biting" not only delimit individual and collective style, but also get at issues of the authorship and ownership of style. Here writers employ the notion of "biting" in much the same way that conventional art worlds negotiate and utilize more formal notions of forgery or copyright violation. For graffiti writers, as for literary writers and sculptors, style matters; and such notions reinforce, in the breach, its primacy.

Going Over

A writer on occasion decides to "go over" another writer's piece— that is, to paint his piece so that it partly or completely covers the existing piece. The act of "going over" has to do, therefore, not simply with painting a new piece over an old one, but with the relationships between the current writer, the previous writer, and the broader subculture. As with tagging, though, this interplay of painted images cannot be reduced to simple notions of interpersonal hostility or aggressive territoriality. Instead, "going over" must be made sense of within a context of subcultural status and style.

At one time or another, all writers who piece regularly will have a piece gone over. The likelihood of this happening, though, depends in part on the status of the writer within the subculture. Writers within the same crew are less likely to go over each other's pieces than the pieces of writers outside the crew. In addition, writers are less likely to go over the pieces of writers commonly acknowledged as "kings" within the subculture. This deference is due not to any sort of violent intimidation on the part of the kings, but to the quality of their work. As Rasta says, a writer "go[es] over another piece to do something better, to challenge the person you just went over" on the level of technique and style. Since kings are

understood to be the masters of technique and style, their pieces are for the most part protected.

This process of going over varies not only with the general status of the writers involved, but with the characteristics of particular pieces. As seen previously, many of Denver's kings at one time pieced inside the railyards building which they dubbed the "Bomb Shelter," and continue to piece at locations near its bulldozed ruins. On a stretch of abandoned wall just east of the Bomb Shelter's remains, Phaze3 thus painted a piece in tribute. The core of the piece was a large, stylized "SUBVERT," with a silhouette of the Denver skyline behind it. Beside this Phaze3 painted a Calvin cartoon figure with a "III" (for Phaze3) belt buckle, and holding an activated black bomb. He also added a stylized scroll which read:

Dedicated
to: Painters of
the "Bomb Shelter"
Fie, VooDoo
EyeSix, XTC
Baünz, Xerox, Nish
Japan, Eoosh
& Mir

Some time later, when Eye Six (and Mac) began a piece on this wall, Eye Six decided to go over the cartoon character and the scroll, but not the "SUBVERT" and skyline. His explanation was straightforward: "If you want to write an essay, do it on paper." In other words, he distinguished between what he saw as the piece itself (the "SUBVERT" and skyline), and what he saw as the superfluous writing attending to it (the scroll). As of early 1991, Phaze3's "SUBVERT" and Eye Six's new piece remained, along with other pieces added since.[25]

Eye Six's decision to go over part of Phaze3's piece occurred within another context, as well: the limited space in which graffiti writers work. This notion of limited space might at first seem odd for artists who take the city as a whole for their canvas. In reality,

though, a variety of factors limits the locations in which writers can piece. The city's legal clampdown on graffiti has had the direct effect of driving writers away from more visible locations—such as the original "wall of fame," along the Cherry Creek bicycle path downtown—and into the relative invisibility of the railyards and the alleys. The clampdown has in turn indirectly affected the locations writers choose by making them more wary of sightlines, pedestrian traffic, and other risks which might lead to detection and apprehension.[26] Writers' aesthetic and ethical concerns as to which sorts of surfaces are appropriate for piecing serve to further diminish the number of possible locations. And, as with tagging, writers prefer to piece in areas that are frequented by other writers, and therefore provide the opportunity for their pieces to be seen and appreciated. In the process of piecing, then, the number of available locations is in fact relatively small. The wall on which Phaze3 pieced stands as a case in point. Although hundreds of feet long, most of the wall is all too visible from a major downtown viaduct, and therefore a risky place to piece. Only a small portion of the wall angles away from the viaduct and toward the old Bomb Shelter site. On this part of the wall, previous pieces took up much of the space, and Phaze3's large piece a good bit of the remainder. When he decided to go over, then, Eye Six did so within subculturally real limits of safety and space.

Superseding any of these considerations, though, is the nature of piecing itself. As already seen, writers piece not to establish permanent works of art, but to participate in an ongoing process of shared creativity and pleasure, of subcultural give and take. They readily acknowledge that their pieces won't last long, vulnerable as they are to being "buffed" by city and neighborhood clean-up crews, painted over by property owners, gone over or "dissed" by other writers, or otherwise obliterated. Thus, when one of Eye Six's pieces was gone over by Mac, his friend and collaborator, Eye Six "gave him some shit about it," but otherwise wasn't particularly bothered; after all, he said, "the piece had been up a while." Moreover, as Rasta 68 argues, "there is no respect in graffiti," anyway, since

> If I go up and paint on a wall . . . paint on your nice white garage door up the street and I do a piece on there and I think it looks cool but you don't, and then you paint over it, then I look at it like you just disrespected my art. But, I've just disrespected your white garage door, and so . . . how can you talk about respect in graffiti?

For writers, then, going over is less an act of overt aggression or confrontation than a routine part of the inherently risky process of doing graffiti.

Dissin'

"Dissin'" incorporates the sort of direct, confrontational hostility between writers that going over does not. As with much of the argot and style of graffiti, the term "dissin'" comes from the world of hip hop. A street abbreviation of "disrespecting," the term denotes an intentional insult or affront, as in Public Enemy's (1988) "And every real man that tries to approach, come the closer he comes, he gets dissed like a roach," or Ice-T and Afrika Islam's (1988) "They get money for hype-type publicity, they don't think twice, about dissin' me!" In the graffiti subculture, "dissin'" thus refers to a writer's (or nonwriter's) vandalization of another writer's work, most often by crossing out the work with spray paint or marker, or by writing derogatory comments over or beside it.

While dissin' may result from a personal confict between writers, or from a nonwriter's distaste for graffiti, it most often has to do with a conflict over the status of writers or crews within the graffiti subculture. Dissin' is most commonly used to rebut the efforts of writers seen as "toys." Throughout Denver, established writers have crossed out the pieces, as well as the tags, of writers they consider "toys," at times adding commentary like "toy" or "will someone tell him he can't paint! TOY." Crews that "get up" through prolific tagging, but don't establish their status by doing stylish pieces, may suffer the same fate. Some Denver writers consider the XMen to be such a crew, known more for tagging than piecing. As Rasta 68 says, "Xmen . . . never, hardly ever did any

pieces. They caught a lot of flack—people crossing out their tags, their names."

As a subculturally significant sign of disrespect, dissin' thus carries connotations which going over does not; it signifies occasional conflicts and disagreements among writers who otherwise operate within shared values and styles. When someone marked over a number of highly regarded pieces in the Towering Inferno, Phaze3 spoke for the subculture by writing on an Inferno wall, "Whoever is dissen everyone show your face and I'll beat it in!!—PhazeIII." And when another disser crossed out "Rasta" and "Bast" tags on a set of walls some miles away, Kash wrote back, "Disn mutha fucka! to: toy: you wanna x [diss]? cant sign your name!! I smell pussy! lets battle fuca. Why you disn, toy?" These largely symbolic conflicts, though, should not be overread so that dissin' is sensationalized as evidence of a violent "war" between writers or crews. As Rasta says, although "I'd rather have [my work] gone over than crossed out . . . it wasn't worth going and getting into a fight over."

The subcultural dynamics of dissin' can be seen in a case which involved Mac, Japan, Top, and an unknown "disser." Mac and Japan painted two pieces behind a gas station on Capitol Hill, and tagged them so as to indicate that these were 3XB pieces. Within a day or two, Mac's piece had been dissed. Over the piece, someone had scrawled "Fuck off! So what! Fuck you!" Moreover, Mac's name was crossed over in the crew signature which he had written beside the piece: "Motha fuckin' Mac & the Third Beez." Soon after this, Top, a Syndicate writer, happened by the dissed piece. Since Mac is a member of Syndicate as well as 3XB, Top responded. Down the wall a few feet, Top wrote: "Great job Mac and Japan. Top!One." Next to the dissed piece, he wrote: "2-D stupid son of a bitch who dogged! Fuck U. 3XBz iz down with us. Fuck You! Syndicate." Top's response constitutes a defense of Mac's and 3XB's status, but even more a sort of subcultural counterattack, a dissin' of the disser—the "stupid son of a bitch who dogged." His response also shows that, like tagging, dissin'

operates as a form of symbolic interaction, an ongoing secondhand conversation among writers about status and style.[27]

Signpainting

As we have seen, members of the Denver scene do graffiti for one another. When they tag, piece, and throw up—and even when they go over or diss'—writers engage in an ongoing process of subcultural communication, an interior dialogue played out on the exteriors of the city. At times, though, Denver writers also paint for those outside the subculture. The previous chapter noted that Denver's kings have painted murals for AIDS awareness and Stay in School campaigns, music video shows, and various other public and private ventures. They also paint murals with some regularity for local businesspeople, homeowners, and others who are able to contact them through networks of friends, artists, and alternative gallery owners and patrons. Along with innumerable pieces commissioned for private bedrooms and back fences, Top has painted a sign for ImiJimi, a local skateboard shop; Mac and Rasta have produced a commemorative mural for R.I.P. (Radical Information Project) Bookstore; and Rasta has painted murals for companies including Atlas Metals and Bron Tapes Inc., behind whose building he was previously arrested for graffiti vandalism!

Such work offers a number of benefits for local writers, not the least of which is increased visibility and legitimacy in the community—as Rasta says, "free advertising for me." In addition, the writers are paid for such work, either in cash, or in the provision of spray paint for the project. Writers put cash payments to good use—since their circumstances place many of them in perpetual need of money—and take great pleasure in using their artistic skills to earn money. Even when the payment is only in paint, writers still benefit, as they supplement their personal supply with those cans not used in the project.

Despite this, many local writers express discomfort with the work, and some refer to it pejoratively as "signpainting." This discomfort develops out of the disjunctions between graffiti writing, as practiced in the railyards and alleys, and "signpainting." As Eye

Six says, in graffiti writing, "You choose your own vision, you choose your own location, you don't ask anybody's permission, you don't expect any monetary reward, you go in the hole and do your deal" (in Ferrell, 1990a: 10); in signpainting, of course, the employer provides both a location and a "monetary reward." Most troubling to the writers, though, is the employer's provision of a "vision"—that is, the employer's requirement that writers compromise the imagery and style of their graffiti writing to fit the project's requirements in regard to content and legibility. Rasta notes that, for him, signpainting means

> you're hired, you're going to do what you need to do to get the money. And you're going to do what you need to do to make them happy, so they'll tell all their friends. Kind of like a restaurant—you want to make cooking and make them want to come back, or them to tell their friends.

And Eye Six adds:

> I've had commissions and everything, but still, it's throw away, you know? In a way, graffiti's not permanent and I understand that, but if you're doing a commission for somebody I want it to be treated like art, like any other art form. And if they're telling you what to write, like "Do a piece on AIDS, do a piece on whatever," then that's not really art, it's advertising, it's throw-away (in Ferrell, 1990a: 11).[28]

Though useful for financial viability and community visibility, signpainting thus puts writers in situations of economic and aesthetic dependency, and in so doing undercuts their understanding and practice of graffiti writing. Hired for their skills and reputations as graffiti writers, the writers are in many cases asked to compromise the one thing that defines them as writers: their style. These contradictions parallel those experienced by members of another subculture which also rode the boundaries between deviance and art: the "dance musicians" on whom Becker (1963: 86; see 79–100) first reported some four decades ago. Like

Eye Six's belief in the artistic autonomy of graffiti writing, the musician's belief that "under no circumstances should any outsider be allowed to tell him what to play or how to play it" collides with the realities of commercial compromise and aesthetic accessibility.

Drinking, Smoking, and Huffing: A Footnote

In the process of doing graffiti, many Denver writers do drugs as well. Piecing forays in the railyards, "art sessions" at writers' apartments, and most other subcultural activities consistently incorporate some mix of cigarettes, pot, beer, and liquor. A number of Denver writers smoke cigarettes—some to the point of chain-smoking—and shamelessly cadge smokes from one another while they walk or piece. Most drink beer and malt liquor regularly, and supplement their Budweiser, Midnight Dragon, and St. Ides with Yukon Jack or cheap vodka, as their budgets allow. And almost all share and enjoy smoking marijuana, despite the limitations imposed by its price and occasional unavailability.

While piecing, tagging, or simply walking inner city streets and alleys, writers also come into contact with "paintheads" or "huffers"—that is, those who get high by inhaling spray paint fumes. As seen previously, huffers who discover writers in the process of piecing or tagging will attempt to ingratiate themselves in hopes of getting spray cans from them. Even when writers are not piecing or tagging, they are often carrying cans of Krylon in old backpacks or briefcases, and can thus become targets for paintheads who discover this. Eye Six, for example, recalls meeting a young man while walking through downtown Denver. When the man discovered that Eye Six was carrying paint, he began to beg him for some of it. Finally, Eye Six gave in, and watched as the man sprayed paint into a Kleenex and snorted the fumes. Out of this experience, and similar encounters while piecing, Eye Six has come to realize that Denver writers serve as the "patron saints of huffers."[29]

Drinking, pot and cigarette smoking, paint sniffing—does all of this imply that graffiti writing is somehow wrapped up with a sort of drug-induced decadence? Does it further indicate that graffiti writing and drug abuse are linked through some pattern of

criminal causality? Clearly, no. To begin with, though writers are at times caught in situations where they serve as huffers' "patron saints," they look on huffing not as an attraction, but a nuisance. Writers consider huffers not only fools out to "fry their brains," but urban vultures whose paint scavenging gets in the way of the writers' work, transforming a pleasant night of piecing into a sort of night of the living paintheads. Beyond this, Denver writers have so little interest in sniffing fumes themselves that many of them wear filter masks while spray painting, whether indoors or out. As Z13 says, huffing is

> not what we do. . . . Obviously, we sniff some fumes, but that's not intentional. It's not like we go out spraying, just to do that. I wear masks when I do work in my studio . . . because it's unhealthy, and I want to live as long as I can. That's one way to end your life real quick.[30]

Even the drug use in which Denver writers do engage hardly sets them apart from countless other non-graffiti writing kids their age. Beer drinking and pot smoking neither cause nor are caused by graffiti writing. The link between drug use and graffiti writing is not causal, but casual; Denver writers drink beer and smoke pot while doing graffiti in much the same way that others drink and smoke while watching football, playing cards, or having sex. Thus, drug use among Denver graffiti writers does not set them apart as a deviant or criminal subculture; if anything, it narrows the gap between their experience and that of other kids, situating them firmly among a large segment of urban youth culture. And while too much beer or pot may on occasion alter the tone of a writer's conversation, or inhibit the completion of a piece, such events do not define graffiti writing. They simply serve as footnotes to the elegant and complex process of doing graffiti.[31]

NOTES

1. On style and the sociology of style, see, for example, Clarke, 1976; Hebdige, 1979; York, 1980/1983; Cosgrove, 1984; Ewen, 1988; and Ferrell, 1990c, 1991.

2. This heading intentionally plays on Strunk and White's classic writer's manual, *The Elements of Style*, 1959. Literary writers utilize stylistic devices in constructing texts, and negotiate the legitimacy of texts in reference to shared stylistic conventions; graffiti writers do likewise in producing graffiti. Elements of style underlie the text on the library shelf as well as the text on the alley wall.

3. Lachmann (1988: 241) reveals the same sort of emergent dynamic in a quotation from a New York City writer: "We would see some fine [subway] cars go by . . . knowing there were masters out there we'd never seen. We knew them as artists before [we] got to know them as men."

4. See Cooper and Chalfant, 1984: 14–17; Hager, 1984: 13–18. The popular Hollywood film *Turk 182!* (1985) played off Taki 183 and this name/number tag convention. Graffiti writers have in turn incorporated the fictional "Turk 182" into the culture of the graffiti underground. One occasionally sees "Turk 182" tags around Denver and other cities; and, during the summer of 1991, I photographed a "TURK 182" piece in Amsterdam. In graffiti writing as in other collective activity, the interplay of media imagery and everyday social practices continues. See Howorth, 1989: 562, for more on *Turk 182!* and other "audio visual resources" related to graffiti writing.

5. When doing "gallery material" or other artwork outside the graffiti scene, Z13 also goes by "Z" or "Z" in combination with his given name. Rasta 68 also on occasion refers to Z13 as "ThriftyZ," in joking reference to what Rasta perceives as Z13's careful ways with money.

6. Phaze3 also tags "STASH," apparently in reference to marijuana.

7. Fie likewise reports that another Denver writer now "uses a bunch of stuff [tags] . . . 'cause he got caught . . . by the police."

8. The phenomenon of multiple tags contributes to the authorities' difficulty in arresting and prosecuting a writer on the basis of a "known" tag found on a back wall. The tag may in fact *not* be accurately "known," and may have been placed there by someone other than its owner. Thus, at

the 1990 Metro Wide Graffiti Summit, Denver Assistant City Attorney Jim Thomas complained that "when we know who's doing it, well, knowing who's doing it doesn't prove it beyond a reasonable doubt, which is our burden if and when we take it to court."

This issue has also surfaced outside Denver. In late 1990, for example, Los Angeles police arrested Daniel Ramos for tagging "CHAKA" throughout Southern California, and charged him with 48 counts of misdemeanor vandalism and trespass. His friends, though, argued that "up to 15 different writers spray painted Chaka up and down Southern California over the past three years as a lark" (in Tranquada, 1991: 5B). He was later sentenced to one year in jail, and ordered to undergo psychological counseling, pay restitution, and work 1,560 hours cleaning graffiti.

Denver writers also employ multiple tags as a way of "pranking" the media, and hiding even their subcultural identity from reporters. Thus, when a local newspaper reporter quoted at length "an 18-year-old man known in graffiti circles as Shakespeare" (Gottlieb, 1989a: 10B), Denver writers knew that their friend was certainly *not* known in "graffiti circles" as "Shakespeare."

9. Z13 likewise notes that Krylon is "top of the line," but adds that he also uses True Test and other brands that offer "different colors."

10. See Cooper and Chalfant's (1984: 38) photographs of New York City writers' spray painted apologies for drips and "cheap paint."

11. On racking in New York City and elsewhere, see for example Castleman, 1982: 46–48; Atlanta and Alexander, 1989: 165; Hager, 1984: 19; and Lachmann, 1988: 236.

12. Voodoo echoes Fie's comments: "I'm not much of a paint thief . . . I prefer to just save my money and pay for it." And Eye Six responds to allegations that Denver writers steal paint as follows: "That's horseshit. That's never done. Not in Denver—never."

13. As Voodoo notes:

I've got about twenty books, like my art books and stuff. Before I started doing graffiti they were just thoughts and poems and just the pictures that I'm doing for canvas pieces, and shit like that. But now, they've got picture postcards, and the next page you'll see graffiti, the next page you'll see a poem, and next you'll see a picture of graffiti.

14. Recently Eye Six got into a fight while carrying his piecebook. The piecebook took the worst of it, with ripped and footprinted pages, and a cover torn off.

15. Z13 is one of the few Denver writers who doesn't use a piecebook as such, although he does "have some sketch books that I've worked on over the years." He often does piece designs "on a single sheet of paper . . . and I'll take that out with me" when piecing, thereby gaining the advantage that other writers gain from photocopying designs out of their piecebooks.

16. The intersection of Colfax and Broadway, it will be remembered, was the location of the "writers' corner" described earlier.

17. On the dynamics of deviant and criminal careers, see of course Becker, 1963, and Goffman, 1961. See also, for example, the articles gathered in the "Into and Out of Deviant Careers" section of *Social Problems*, 1983—especially Adler and Adler, 1983, and Shover, 1983—and Luckenbill and Best, 1981, on problems with the deviant "career" notion. Lachmann, 1988, explicitly applies this "career" notion to graffiti writers and writing.

18. When Z13 used house paint to paint some large faces on a downtown wall, he added a subcultural joke to the piece: a "cartoon balloon" that had one face saying, "house paint!"

19. This piece is also mentioned in Howard, 1988: 12, who describes the found stencil as a "plastic seat back."

20. The ambiguous status of stencils in the Denver scene can be seen in the tagged response to an image stenciled near a number of highly thought of pieces by Rasta, Fie, and others. Along the edge of the stencil someone has tagged, "Who dat stencil"—a question which communicates, both by its placement and its content, a mix of curiosity, uncertainty, and disapproval. By 1991–92, though, the members of Syndicate were more heavily involved in stencil art and stencil graffiti than ever. See also Eye Six's discussion of stencil versus freehand techniques in Ferrell, 1990: 10; Huber and Bailly, 1986, on stencil graffiti in Paris; Robinson, 1990, on stencil graffiti in New York City; and Sheesley and Bragg, 1991, on Sandino stencil graffiti in Nicaragua.

21. The three Syndicate murals were legal pieces, painted near Rasta's place of employment at the time; and the U.N.L.V. piece was painted,

with great confidence, *before* U.N.L.V. won the championship. Interestingly, Eye Six shares Voodoo's appreciation of Kerouac; see the previous chapter.

22. Denver street artist DeDe LaRue reports, "I work at night, mostly around nine or ten, and I've learned to create a number of vaguely diversionary tactics. That's part of the fun, and the whole thing takes only minutes. The actual execution is practically performance art" (in Chotzinoff, 1988: 9).

23. Fie provides a similar account of his beginnings as a tagger: "When I was in high school, you know, it was just walking the streets really late at night. It was just my favorite thing to do, 'cause I'm a real nocturnal person." Piecing and tagging are thus grounded in the sorts of criminal pleasures which Katz, 1988, describes. The final chapter explores the significance of these pleasures further.

24. Rasta, for example, has designed and painted a remarkable illegal piece in which upside down, mirror-image letters form the word "SET." For a description of tagging, piecing, and other phenomena in the Seattle graffiti underground, see Brewer and Miller, 1990.

25. Eye Six later noted: "Also, I knew I could do better than what was up. His choice to bite Calvin was a sad one, and his execution was sorry as well. Had it been a good piece I wouldn't have even thought of going over it."

26. The city's campaign against graffiti writing will be examined in the following chapter. As Fie says, since the city's clampdown, "Everywhere I've pieced, I've really checked it out. I've gone there and seen what the traffic is, all the escape routes and all that stuff."

27. A poem which Pak3 wrote—on a wall under the 15th Street viaduct, near a popular graffiti writing spot—also captures the dynamics of dissin':

> Sup Joel!
> eye for an eye
> x for an x
> you x me and
> you'll be next
> Don't Dig dis
> Pak3

And in one unusual case, Phaze3 left a "DOPEY" outline he had done on a railyard wall, only to return and find that it had been filled in (badly) by a toy writer. He thus dissed the piece by tagging "PhazeIII" across it, and by painting on top of it a "3!" throw-up in which he wrote, "I'm the only Dopeman!! Next time use your own outline!!"

28. Eye Six reports that, for a "Stay In School" piece he was asked to create, the instructions were, "We want a piece that's graffiti style but not illegible." Similarly, New York City kings like Dondi report that they use wild style, a highly stylized lettering scheme, when doing pieces for other writers, but "straight letters" when writing for "the public" (Cooper and Chalfant, 1984: 70–71).

29. For more on huffing in Denver, see Schrader and Gottlieb, 1990. See also Gammage, 1990.

30. In the best tradition of postmodern referentiality, the "night of the living paintheads" phrase plays on Public Enemy's "Night of the Living Baseheads" (1988), a rap song which in turn plays on George Romero's film *Night of the Living Dead* (1968) to diss' free base drug dealers and users: "Like comatose walkin' around . . . the fiends are fiendin'." See also Atlanta and Alexander, 1989: 160–161, who argue for a deeper social and aesthetic connection between graffiti and drugs than that described here.

31. Katz's (1988: 204–205) analysis of drug and alcohol use in relation to the careers of stickup men thus applies as well to Denver graffiti writers: ". . . a close look at their lives shows a relationship much more complex than is suggested by theories of the criminogenic powers of addiction."

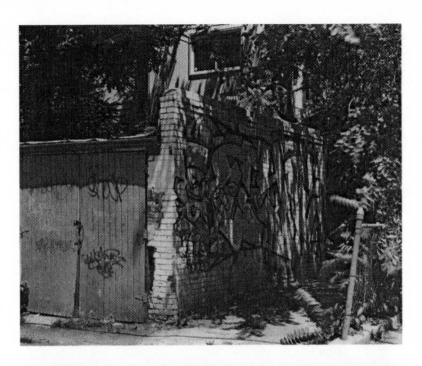

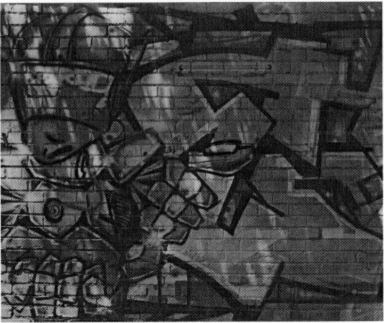

Top: Eye Six and Mac, "EYE" piece in the Capitol Hill neighborhood. Tags by Shoop, Phaze3, the XMen, and others decorate the adjoining door.

Bottom: Detail of "EYE" piece (shown above).

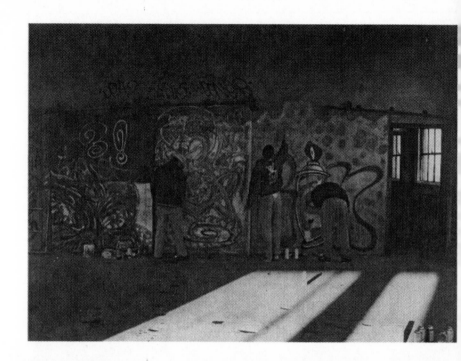

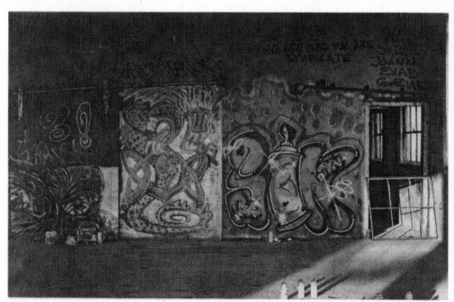

Top: Rasta 68, HL86, and Mac at work on a "SIN" piece in the Towering Inferno. (See pages 21–22 on the Towering Inferno.)

Bottom: The finished "SIN" piece. Note the stylized spray can forming the "I" in "SIN" and the smaller "SYN" and "LOVE" lettering in the piece.

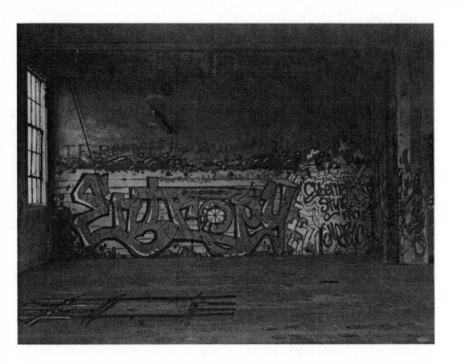

Top: Phaze3, "ENTROPY" piece in the Towering Inferno.

Bottom: Fie, "FIE" piece in the Railyards. The piece has been dissed by overwritten tags such as "we are no toys!" (See pages 90–92 on dissin' and pages 35 and 90 on toys.)

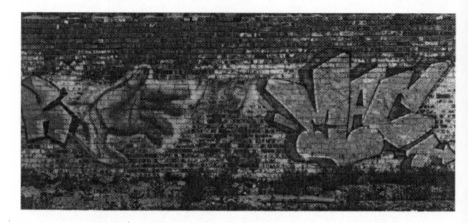

Eye Six, "HAND" sketch, and Mac throw-up on an outside wall of the Towering Inferno. (See pages 83–85 on throw-ups.)

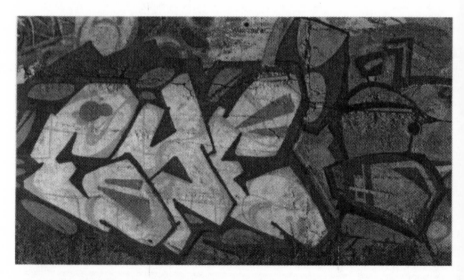

Unfinished "EYE" piece by Eye Six and Mac in the Railyards. Note the stylized spray can bordering the right side of the piece.

Left: A surviving 1988 Fie throw-up in the Railyards.

Right: Untitled piece by The Kid in a stairwell of the Towering Inferno. The piece reads "Rollin once again, fuck the damn police." The lettering on the figure's back was added later.

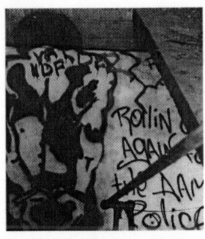

Bottom: Mac, "JOANN!" throw-up in the Railyards. In reference to its coloring, Mac describes this work as a "silver up."

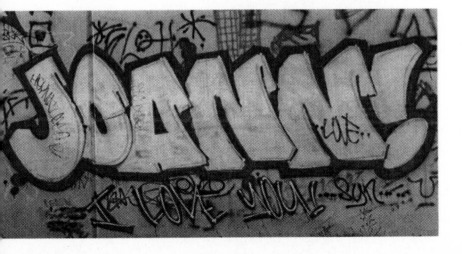

Top: "MOON DANCE" piece by J. in the Railyards. The "syn:sks" tag belongs to a neighboring piece.
Bottom: Voodoo, "HIT THE ROAD JACK" piece in the Railyards. The piece was painted as a tribute to Jack Kerouac, an earlier denizen of Denver's Railyards.

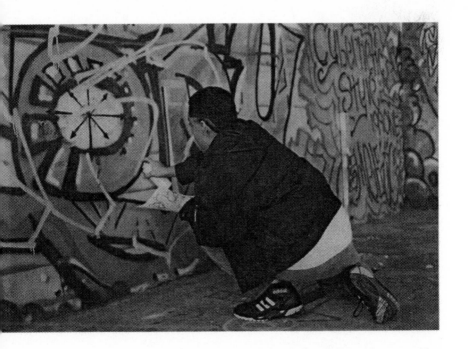

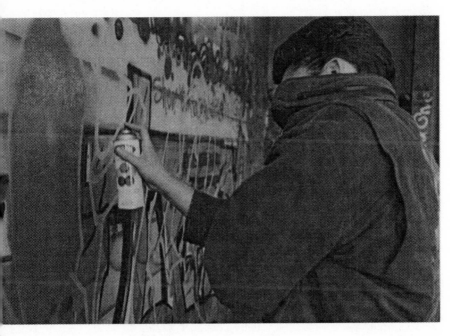

Top: Mac, Rasta 68, and HL86, at work on a "VICK" piece in the Towering Inferno. Note the sketch being used as a guide for the piece.

Bottom: At work on the "VICK" piece. The coat is pulled over the writer's face not to mask his identity, but to protect him from paint fumes.

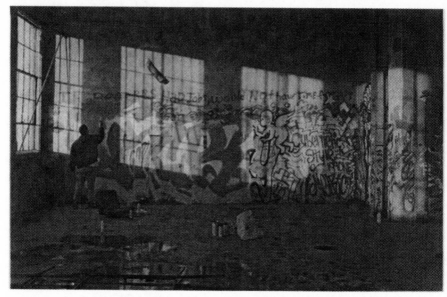

At work on the "VICK" piece. In executing the piece, Mac, Rasta 68, and HL86 are going over Phaze3's "ENTROPY" piece, seen in a previous photo. (See pages 87–90 on going over.)

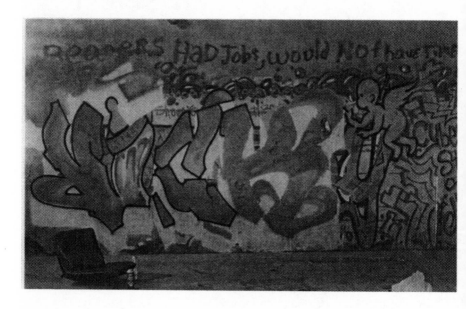

Unfinished "VICK" piece. Note the stylized baby bottle that forms the "I" in the piece, as well as the angel watching over it.

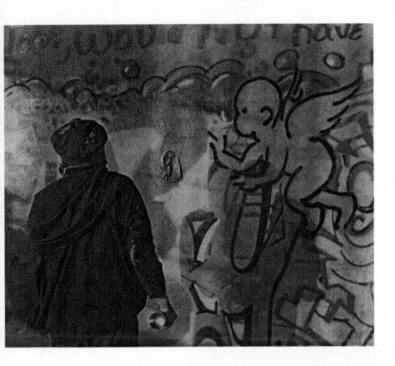

Above: Detail of the "VICK" piece in progress.

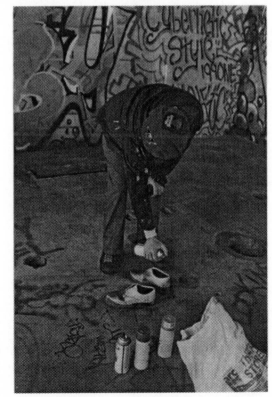

Right: A writer spray paints a pair of shoes in the Towering Inferno. In the subculture shoes, shirts, jackets, furniture, and other items regularly fall victim to the spray can and marker.

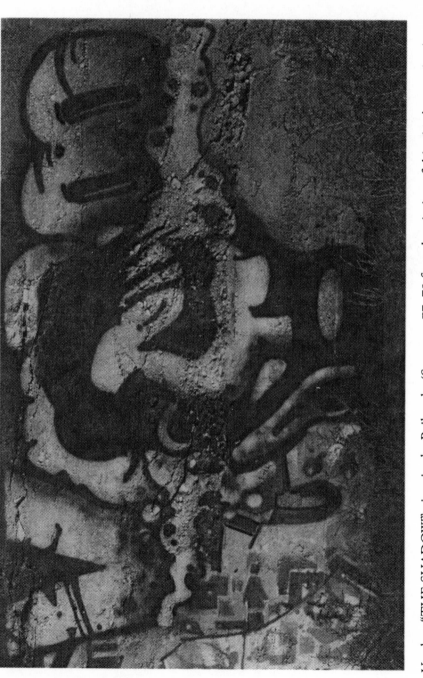

Voodoo, "THE SHADOW" piece in the Railyards. (See pages 77–78 for a description of this piece's execution.)

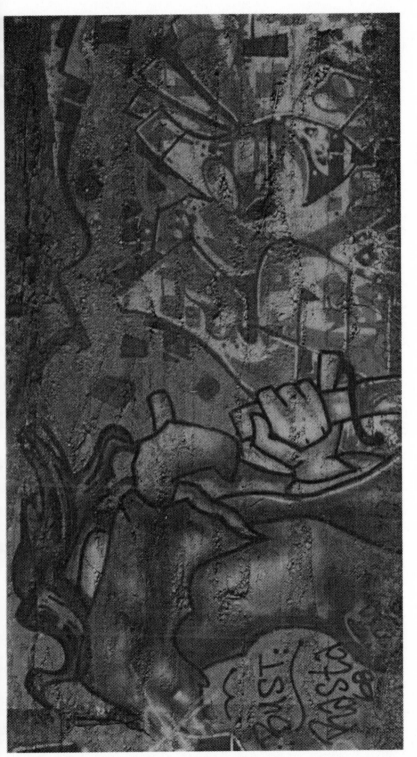

Eye Six and Mac's "SPA (and Banshee)" piece in the Railyards. The ":Bust: Rasta 68" tag identifies a neighboring piece.

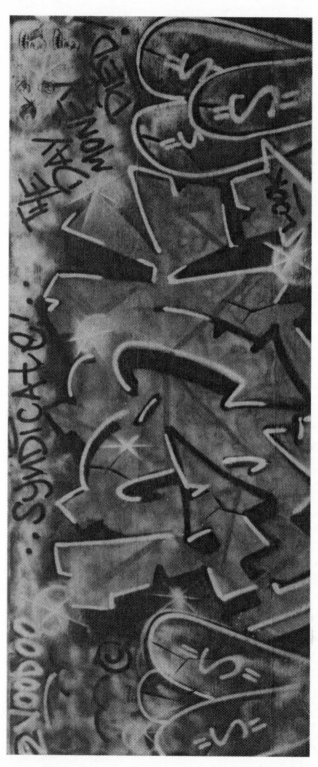

"LOOK" piece by Rasta 68 in the Railyards. As the lettering in the upper left corner indicates, Rasta painted the piece for Voodoo as commentary on their ongoing disagreement about the artistic versus monetary value of graffiti; thus Rasta's comment, "the day money died!" Note the stencils by Evad in the upper right corner, including both a clown, an affectionate term writers use in referring to themselves, and a king, a term referring to a top writer. (See pages 31–35 and 75–76 on kings, and pages 79–80 on stencils.)

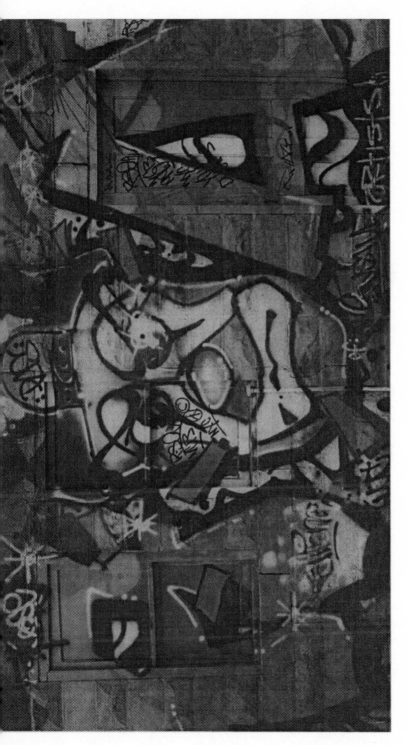

Mac, Mask, and Fase, "AIA" piece in the Capitol Hill neighborhood. A piece painted by writers from different crews, "AIA" denotes a temporary "Alliance of Insane Artists," as the lettering across the bottom of the piece indicates. (See page 8 on crews.)

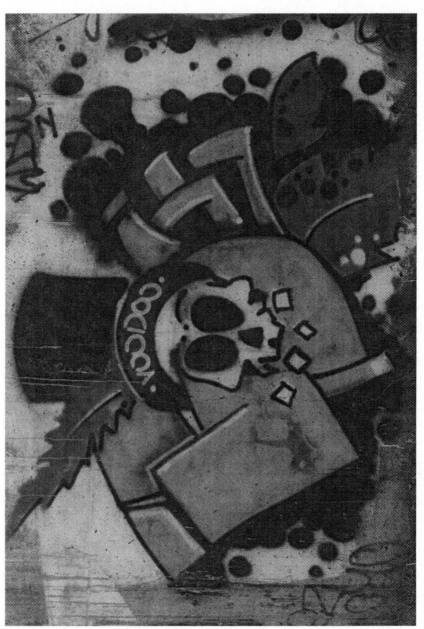

Untitled piece by Voodoo in the Railyards.

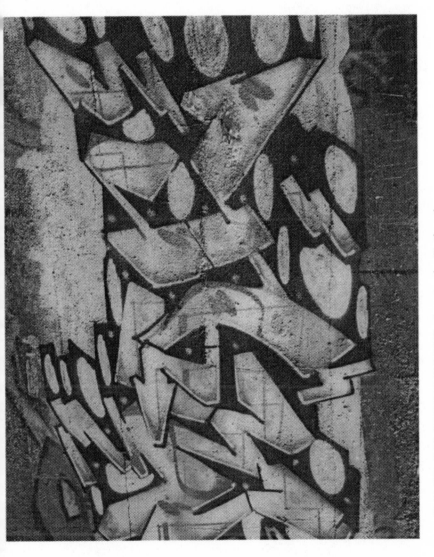

Mac, "MAC'S COMPUTER ROCK" piece in the Railyards.

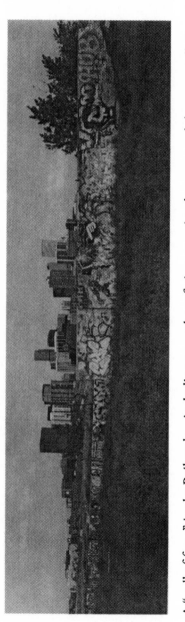

A "wall of fame" in the Railyards—including a number of pieces previously seen—and the same wall six months later with one new piece in the larger section on the right and several stretching to the left. (See pages 35–36, 49–50, and 102–105 on walls of fame.)

The Clampdown: Graffiti As Crime

We will teach our twisted speech to the young believers,
We will train our blue-eyed men to be young believers.

The Clash, "Clampdown" (1979)

In the process of doing graffiti, Denver writers move in and out of activities which diverge from conventional conceptions of legality and morality. As writers tag and piece down the railyards and back alleys of central Denver, their footsteps and Krylon cans at times take them across the legal boundaries of vandalism and trespass. The beer drinking and pot smoking which often accompany graffiti writing accentuate the illegality of these moments, putting the writers crossways with statutes prohibiting marijuana possession, drunkenness in public, and for some, underage drinking. Set against a panorama of urban violence and corruption, though, these activities constitute a rather short list of minor offenses—a list which, in Denver, does not even include the theft of paint. Denver writers can also balance this list of transgressions against their contributions to the city, including participation in AIDS awareness projects and Stay In School campaigns.[1]

During the early years of the Denver graffiti scene, public and official responses to graffiti writing fit the relative insignificance of the crime. Z13 recalls working on one of his early pieces behind Mammoth Gardens in central Denver, the "Vanish Man—'cause he just kind of faded away." As he "started to continue down this wall" to begin a Judy Jetson character and "the face of a Black man,"

two policemen on foot, they were walking down the street. They saw me down this alley and they came down and, you know, they caught me red-handed. They didn't arrest me for doing that, though. It was because I had, I think it was a warrant for unpaid parking tickets that I had out. . . . As a matter of fact, they even said that they liked what I was doing. It's like, "yeah, that looks pretty nice," you know. There was no mention at all of what I was doing or anything.

Eye Six likewise remembers an occasion when "I was walking down the street just doing [a] stencil on the street":

And these cops drove by and, I mean, just flat-assed caught me with the stencil, and they saw the big piece of paper and the [spray paint] can. . . . And they were laughing as they drove by, you know, and I just kept walking and ditched it. And it was just at that point in time, it was just like extra paper work [for the police].

Z13 and Eye Six also worked on the original "wall of fame" along the Cherry Creek Bike Path during the day, in full view of appreciative joggers and bicyclists. As Eye Six says, "I'd work on it at my leisure, and it took me about twelve hours. And I would say about seventy people had seen me by the time I was done with it. People would watch, and they really seemed interested."[2]

In late 1987 and early 1988, though, Denver writers began to encounter changes which would put leisurely public graffiti performances to an end. Rasta remembers that,

[It] first started in April of '88. . . . I saw the front page of *The Denver Post* on a newsstand, and I saw [a photograph of] a Fie piece right there on a shed, and I looked, and I'm like, "They're crackin' down on graffiti. . . ." It showed the Mayor in front of the May D and F Tower (in Ferrell, 1990: 10).[3]

By this time Voodoo had left Denver, but heard through a friend that "all the stuff on the Cherry Creek bike trail had gotten painted

over." Not sure that he believed the story, he returned to Denver, and

> after I got off the train I went straight from the train station to the Wall of Fame. And I came up over and looked and it was like, "oh!," it was all gone. It was kind of a cold welcoming—I wondered what this was going to be like. And then me and my friend . . . dropped some acid and we got on our bikes and we started riding down the Cherry Creek bike path. And I said, "Hey, I got to show you all these pieces down here." And we went all the way down the Cherry Creek bike trail and there was not tag one. So I was like, "God!"

The front page articles and whitewashed walls which Rasta and Voodoo saw were but two faces of a broader enterprise: Denver's political and corporate clampdown on graffiti writing. And if visual encounters like these generated a certain amount of indirect consternation among the writers, other encounters with the emerging anti-graffiti campaign produced directly negative results. Rasta and The Kid were arrested while piecing behind a building in central Denver; as Rasta says, "We both went to jail, and I was there for five days with no bail and I had to do 120 hours of community service" (in Ferrell, 1990: 10). Fie also "felt it right away." When "it was just starting to get crazy and they just started their program," he was pulled from class and threatened by a Denver Public School detective, and soon thereafter arrested by the "graffiti task force" while tagging downtown. As an undercover detective grabbed for Fie and "flashed his badge," Fie

> tossed his arm away. I started running, 'cause this old guy, he's not going to catch me. . . . So I ran through Civic Center Park . . . and behind the garbage area of the [Denver Art] Museum. And I threw my pen. . . . I was all panting. And then I hear this clump, ca-klunk, ca-klunk, and I look up, and it's the mounted police. And they make me get out and they put me against the dumpster and then three special detective cars come and another police car. . . . What happened is this lady had seen me run away from this old man with my bag and she thought I

had stolen the bag from him, and she had a cellular phone in her car. So she called the police . . . and told them where I was. So they were just really pissed and they shoved me around and put the cuffs on over the wrists and stuff.

Mac, Zhar Zhay, Nag and other writers were arrested as well.[4]

The clampdown, though, changed more about the Denver graffiti subculture than the arrest records of some individual members. It also altered the urban ecology and social dynamics of the scene, and thus helped shape the subculture's evolution in the late 1980s and early 1990s. The obliteration of the original "wall of fame" along the downtown Cherry Creek Bike Path, for example, meant not only the loss of early masterpieces by kings like Z13, Rasta, Eye Six, and Voodoo, but, at least temporarily, the social and physical dislocation of the subculture. As Voodoo says, "With the Wall of Fame, it was like you could go out there and everyone sprayed there. So, it was different. It was like each person could show you two or three pieces." And even though the writers soon began to organize new "walls of fame," these new locations of necessity lacked the public visibility of the original. Eye Six notes that, because of the clampdown, "we were almost pushed into real obscure places where all we're basically doing is painting for other writers and puttin' up wallpaper for winos and bums" (in Ferrell, 1990: 11).[5]

The clampdown also affected writers' participation in particular forms of graffiti writing, and the dynamics of collective writing generally. Under increasing pressure from the clampdown, Fie, Rasta and other writers began to disguise their identities with alternative tags, and even to withdraw from some types of writing. Fie remembers: "I stopped tagging . . . after I got caught. I did it a little bit afterwards, but not much. And then I started doing throw-ups. . . . Twelve hours in jail, I just had to really think about when and why I was tagging." Facing the possibility of lengthy jail time if arrested a second time, Rasta pulled back from both tagging and illegal piecing. The undermining of a well-known king like Rasta in turn damaged the larger subculture, as Voodoo points out:

Rasta was responsible for a lot of pieces, 'cause he built up a lot. And since he's not [illegally] piecing anymore because of the clampdown, I don't know. . . . He'd go up all over the place. He had pieces, he was real inspiring.

If the clampdown's authors had hoped for these sorts of subcultural consequences, though, they must surely have been unpleasantly surprised by others. As will be seen, the clampdown has had the long-term effect of promoting the social and criminal careers of Denver writers—even of those, like Rasta, most directly victimized by it—and thus accelerating the collective production of graffiti.[6]

While Denver writers appreciate the clampdown's ironic contributions to their work, they also understand the political and economic contexts out of which it was constructed. Referring to his early encounter with the police, Z13 points out, "See, that was before; if it had happened now, they would have busted me," and sets the context for the erasing of his and others' pieces along the original wall of fame:

That wall along the creek there—of course, the reason there's so much interest in that is because they're redeveloping that whole area. . . . Back when we did the wall of fame, it was just like, just previous, before they started working in that area, so it was still okay. But then once they started doing some work out there, all that had to go.

Eye Six sees the clampdown on graffiti as part of Denver Mayor Federico Peña's response to a recall movement that was flourishing at the time:

Well, put it in context. . . . Are you aware that that was exactly when the heat was worst on him about the recall? It's like a smokescreen. And I mean, I really, if by trying to strip my mind of any paranoia, you always get back to that. I think that was definitely the issue. Lots of control—I got to control something.

Joe Kennedy, owner of the gallery which hosted Denver's first "spray art" show, likewise locates the clampdown inside the politics

of the recall: "The mayor was facing a recall election and . . . his
first public policy reaction to that, as far as anybody could tell, was
to declare war on graffiti. . . . It was the perfect scapegoat." Even an
editorial cartoon which the conservative *Denver Post* ran at the time
of the clampdown's announcement asked readers to "name the
place the mayor would like most to be cleansed of ugly scrawls and
signatures" (Keefe, 1988), and offered as options public buildings,
overpasses, historic landmarks—and the recall petitions. To
exacerbate these tensions, Voodoo at the time painted along the
Cherry Creek Bike Path a "Recall Peña" piece, accompanied by the
following poem:

> Graffiti was never a problem before.
> Now Peña thinks it's some kind of war.
> Someone should tell him he's really a bore.
> He can't clean the streets, much less do more.

As Kennedy says, "the mayor liked to jog around in there, and
that's where this 'Recall Peña' piece was, so [the wall of fame] was
sort of doomed."[7] But perhaps Rasta 68 most succinctly captures
the writers' view of Peña's role in the clampdown: "He's just a
peckerhead" (in Ferrell, 1990: 10).

Moral Entrepreneurs and Moral Enterprise: The Denver Anti-Graffiti Campaign

> It is an interesting fact that most scientific research and
> speculation on deviance concerns itself with the people who
> break the rules rather than with those who make and enforce
> them. If we are to achieve a full understanding of deviant
> behavior, we must get these two foci of inquiry into balance.
>
> Becker (1963: 163)

The City and County of Denver, of course, does not see its
clampdown on graffiti writing in quite this way. As executive
director of Keep Denver Beautiful (formerly Clean Denver), Valerie
Purser has served as the city's point person in the anti-graffiti

campaign. She argues that the campaign developed out of a survey of neighborhood associations which Clean Denver conducted in 1987. According to a local newspaper, the survey showed that "65 percent of Denver residents deemed graffiti a major problem in Denver and in their own neighborhoods" (*Up The Creek*, August 5, 1988: 4); Purser adds that "graffiti was the most important issue in many of the neighborhoods—not all of them, mind you." At the same time, according to Purser, "the mayor, unbeknownst to me, was very, very much wanting to see the graffiti problem be reduced, if you will, because it was a real problem for him," in that

> this mayor has cared about his neighborhoods, and he's also cared about issues such as graffiti that affect the quality of life in our city. And, while he may be criticized for a lot of things, he's tried very, very hard to have people have a sense of ownership.

Out of this remarkable marriage of citizen concern and political compassion, Purser and others argue, the city's anti-graffiti campaign was born.

If Purser was unaware of the mayor's concern over graffiti, though, it was not because he had failed to publicize his feelings previously. In fact, soon after he was elected mayor in 1983, Peña called for a "crackdown" on graffiti in the Capitol Hill area of central Denver and along the Cherry Creek Bike Path. Citing the need for tougher city laws and "more aggressive" police patrols, Peña complained that "it's really getting out of hand. Here we are making efforts to beautify and improve the city, and people are painting on buildings left and right. It's outrageous" (in the *Rocky Mountain News*, February 22, 1984: 8). By the summer of 1984, Peña had "increased police patrols in graffiti-littered neighborhoods," and lent his support and campaign slogan—"Imagine a Great City"—to a "Graffiti Paint-a-thon" program sponsored by the local United Way and Brothers Redevelopment. Dubbed by Peña "Imagine a Great City—Without Graffiti," the program utilized young volunteers to paint over graffiti and develop "youth awareness." Despite support from Peña in the form of "attending high school assemblies and . . . promoting the issue to local

businesses and the media," the program was discontinued after summer 1986 due to the kids' lack of interest (Bremer, 1984: 9; see Gottlieb, 1989: 1B).

As "Imagine A Great City—Without Graffiti" faded from the scene that summer, a private citizen decided to take up the cause. Declining to call the city's graffiti removal crew, Diane Tate armed herself with whitewash and paintbrushes and "declared war on the graffitists who have decorated the walls along Cherry Creek." Her one-woman campaign drew a distinctly negative response from a group of alleged writers, who dumped a bucket of water on her head while she whitewashed a wall. Other responses were more positive. The Executive Director of the Platte River Greenway Foundation allowed that he could "appreciate her frustration." City officials called her efforts "wonderful," and announced plans to restore the area (Bawmann, 1986: 11; *Up the Creek*, 1986: 4). By the summer of 1987 a "graffiti subcommittee" had been put in place within the city's Public Works Department "to look into the costs and come up with solutions" for graffiti along Cherry Creek and elsewhere (Misch, 1987: 1). That December, though, an editorial in *The Denver Post* complained that "there has been a marked increase in signature graffiti [tagging] in Denver in the last six months," and that

> the Denver Department of Public Works is stuck in neutral, considering hiring an advertising agency to educate the media and the public about graffiti. And a representative of the Denver city attorney's office says she hasn't spoken to anyone there who has prosecuted a graffiti case (Johnson, 1987: 7B)

The next month, *Denver Magazine*'s (1988: 34) annual listing of "50 Dynamite Denverites" included a profile of Valerie Purser. Noting her cable television show and role as "chairman" of an organization promoting the Denver Center for the Performing Arts, the magazine described her as a "public relations consultant for Denver's Clean Air Campaign, [who] plans a 1988 campaign against litter, graffiti and ugly gateway entrances to the city."

In April, 1988, the campaign began. As Rasta well remembers, *The Denver Post* announced the clampdown with a front page article and two photographs—one of Fie's "END" piece in the railyards, the other of Mayor Peña's viewing a "Roxie" tag on a downtown landmark.[8] Quoting Peña, District Court Judge David Ramirez, and Diana Bolter, president of a downtown business organization, the *Post* outlined a "new crackdown" which would force convicted "offenders" to perform public service work and pay for graffiti cleanup costs. In addition, the new campaign would include an "education program" and police work with the Denver Public Schools to "discourage vandalism" and "identify culprits," a new graffiti-removal manual for property owners, and an attempt "to develop more legitimate outlets for those who want to paint truly artistic murals on walls" (Digby, 1988: 1). Despite some initially shaky support for the campaign—including a *Post* columnist who praised the "ambition, scope and execution" (Kisling, 1988: 7B) of local graffiti murals, and the above-mentioned graffiti/recall cartoon—the *Rocky Mountain News* was able to claim, in a late April front page article, a police list "of more than 50 names of graffiti creators and their 'tags'" (Flynn, 1988: 1).[9] That summer, Peña and the Denver City Council declared an "Off the Wall Week" to promote graffiti removal, and the campaign sponsored an "artway" on which local writers could legally paint.[10]

1989 opened with a directive from Denver's Chief of Police "ordering a crackdown on graffiti," and a subsequent announcement that "after five years of failed attempts to eradicate the city's graffiti problem, Denver officials are gearing up for the largest anti-graffiti campaign yet" (Briggs, 1989: 2B; Gottlieb, 1989: 1B). Developed at the request of Capitol Hill business and home owners, the "new" campaign simply reworked much of the existing program, but added to it a twenty-four hour graffiti "hotline," rewards for information on graffiti writers, and increased coordination among city and state legal and judicial bodies. During the year, Peña allocated an additional $60,000, and the campaign hired a schools liaison, purchased clean-up equipment, and

promoted an "Adopt-A-Spot" program in which neighborhood residents agreed to monitor and clean a piece of public property. By the end of the year one local publication claimed that "the city's graffiti problem is apparently being held in check by Denver Police and a city program enacted last year. Calls to the Graffiti Hotline have declined significantly in recent months," but admitted that "opinions vary as to whether waning publicity or efforts by the program are responsible for the decline" (Ross, 1989: 5).[11]

As the clampdown has moved into the 1990s these programs have continued. With Purser leaving the campaign at the end of 1990, and Peña declining to run for re-election in 1991, though, the campaign has reached a turning point of sorts. As Purser says, "Who knows what a new administration [will do]; even if it's someone the mayor endorses, they're different. We're all unique. And so, who knows what their soapbox is going to be." Moreover, as Purser admits,

> There were a lot of mistakes that happened as we were trying to develop this anti-graffiti campaign. . . . I've lived and breathed graffiti for the city since 1987 to the point that I'm a little crazy with it. It was kind of like, I mean, is there any answer to this . . . ? The city is putting $350,000 behind eradicating graffiti off of public and private property. . . . The city is, probably the best way to say it is re-evaluating the direction it needs to go in. . . . I don't know where Keep Denver Beautiful's anti-graffiti campaign will go, because it has now been fragmented. You have the office of the Manager of Public Works doing a component of it. And people looking into ordinances and so forth. You have Public Works Solid Waste Management overseeing the clean-up activity. And then you have Keep Denver Beautiful over here kind of going, well, if we're supposed to do education, what is that role?

Whatever future direction the city's campaign may take, though, it is clear that its direction to this point has been shaped not just by the politics of city government, but by the economics of ownership and enterprise. From the first, the clampdown has been

structured by and for the city's business interests and property owners. At a 1990 "Metro Wide Graffiti Summit," Purser announced, "From back at the beginning when we started, we started out with business. In your own community, business needs to be willing, and they are willing, to help." And, as a Clean Denver (1988a) pamphlet notes, if you join the anti-graffiti campaign, "you'll be joining forces with an enthusiastic and formidable group of corporate sponsors, including US West Communications, Kwal Paints, and Public Service Company of Colorado." The magnitude of this "sponsorship" is reflected in the number of local CEOs who sit on Keep Denver Beautiful's volunteer board, and in the campaign's reports that twenty-four dollars in corporate donations are used in its programs for every dollar of city money.[12]

The campaign's intermingling of business and politics is both ideological and practical, a matter both of perspective and participation. As head of the anti-graffiti campaign, Valerie Purser has emphasized time and again the campaign's concern with obliterating graffiti in the interest of business and property owners. At the Metro Wide Graffiti Summit, she pointed out that "we'll be looking at the economic impact of graffiti," and later added: "This [anti-graffiti] program is about property rights, and about people's rights . . . how it does affect the economy and business moving into different areas." Other anti-graffiti campaigners have developed and publicized similar rationales. Denver City Council President Cathy Donahue points out that graffiti "ceases to be art when it costs you, the homeowner, the business owner, thousands of dollars and hours to take it off." Don Turner, of the downtown Denver Partnership, notes that he doesn't "even want to get into that discussion" about whether or not graffiti is art, "because I'm a property manager, and it's a pain in the neck wherever it's going on." And Barton Wong, a leader of the anti-graffiti campaign in neighboring Aurora, complains that graffiti is problematic for residents because "it lowers their property values."[13] Within this ideological framework, Mayor Peña thus spoke to "corporate leaders who are here in this room" at the Metro Wide Graffiti Summit, and asked for support

of the graffiti clampdown from the highest levels of their organizations.

Corporate leaders, though, had been forthcoming with their support long before Peña's request at the 1990 Summit. If John Huss, the Benjamin Moore Paint Company representative attending the Summit, heard Peña's request, he must surely have thought of the hundreds of gallons of paint which the company had already donated to the campaign—paint subsequently handed out to neighborhood residents for graffiti cover-up. As noted previously, Kwal Paints—along with US West Communications, and Public Service Company of Colorado—are also corporate sponsors of the campaign.[14] In addition, First Interstate Bank, the Denver Board of Realtors, and local 7-Elevens are involved in the campaign; Gates Rubber Company contributed to the cleaning of graffiti in and around Confluence Park; the Colorado Institute of Art held a "Graffiti Clean Up Day" in conjunction with Keep Denver Beautiful, and created an anti-graffiti poster for distribution to schools and businesses; and Keep Denver Beautiful has coordinated its activities with the GLAD Bag-A-Thon program.[15]

The Metro Wide Graffiti Summit itself nicely exposed the confluence of corporate and political power, the mutual political and economic opportunism, behind the campaign. Co-sponsored by Keep Denver Beautiful and US West Communications (with assistance from local television stations and the Colorado Institute of Art), and held at US West's downtown Denver headquarters, the Summit was an exercise in political/economic coordination. As Valerie Purser remembers:

> Like Public Service and US West met with us because they're vandalized [by graffiti] quite frequently. . . . And so they threw money in behind the program and it was basically money to do eradication and some education. Which is what US West did that day, was to sponsor, let's come together and look for some solution. I didn't like that Summit. I didn't think that the Summit gave enough of an opportunity to really break it apart. It was like, it had to be done. US West wanted it to be done.

At this event which US West "wanted . . . done," speakers from the City of Denver included not only Mayor Peña, but Deputy Mayor and Manager of Public Works Bill Roberts; Deputy Public Works Director Ruth Rodriguez; Council President Cathy Donahue; Manager of Public Safety Manuel Martinez; Assistant City Attorney Jim Thomas; and various other city bureaucrats and police officers. Corporate interests were addressed by representatives of US West, Benjamin Moore Paints, 7-Eleven Stores, Public Service Company, the Denver Partnership—and by Roger Pfeiffenberger, whose Bench Advertising Company has suffered from graffiti writers' tagging its commercial bus stop benches. Roger Pfeiffenberger's wife, Robin Pfeiffenberger, serves as Education Coordinator for Keep Denver Beautiful.

At the Summit, Deputy Public Works Director Rodriguez argued, in regard to graffiti removal products:

> . . . we need to get product availability, and if it's not here, that's how we tap the business community and say, "It's a product here. Get it here at a reasonable price. Get it here in a quantity that we can use, and don't put us, the City, in the distribution business." Put it in a private market where it needs to be. . . .

This "private market" for graffiti removal products was, in fact, present at the conference itself. While speakers decried the destructive effects of graffiti, a "trade fair" went on in the lobby. Late in the day, Purser thus expressed her hope that "you had the opportunity . . . to visit some of the trade fair participants," who were in turn listed and thanked in the conference program. The participants included Mobile Power Wash, Rainbow Power Mobile Wash Company, Raymond Restoration, G.E. Silicone, High Country Wash on Wheels, Pro Coat Systems, and Benjamin Moore Paint Company.[16]

At the Summit Ruth Rodriguez also argued that "we have got to be as organized as block by block. I mean, it's a campaign; block by block in terms of where the critical areas are." Central Denver's Capitol Hill neighborhood—whose alleys sport innumerable tags, and occasional throw-ups and murals—best exemplifies this "block

by block" approach, as well as the political and economic entanglements behind it. A primary force in the Capitol Hill clampdown has been the neighborhood newspaper, *Life on Capitol Hill.* Published until mid–1990 by a local realtor, the newspaper continues to be distributed throughout the Hill "Courtesy of Our Advertisers." Relishing its regular attacks on "graffitidiots," and its reports on the "Capitol Hill graffiti war" (*Life on Capitol Hill,* June 2, 1989: 1), the newspaper has aggressively publicized and promoted the Adopt-A-Spot program and the Graffiti hotline. Capitol Hill United Neighborhoods (CHUN)—a "neighborhood association" which views the neighborhood in terms of business development and property ownership—has also actively supported the clampdown. CHUN has, for example, distributed Clean Denver anti-graffiti fliers under its auspices, and worked with Keep Denver Beautiful and a neighborhood hardware store and restaurants to paint over graffiti.[17]

Beyond these coordinated activities, CHUN is directly connected to the Keep Denver Beautiful campaign through two key individuals. CHUN board member Tom Linker was appointed by City Council President (and Capitol Hill council representative) Cathy Donahue to a position on the Keep Denver Beautiful Advisory Board. Linker and Keep Denver Beautiful in turn organized an "angry standing room only" meeting of about seventy people at the Capitol Hill Community Center; the meeting featured Cathy Donahue, speakers from CHUN and the Denver Police Department, and "cries from the audience of 'lock 'em up for a long time'" (*Life on Capitol Hill,* March 3, 1989: 1; see 3). Linker subsequently spoke at the Metro Wide Graffiti Summit, in whose program he was listed as a cochair of Keep Denver Beautiful's "graffiti committee."[18]

Denver Police Officer Ed Thomas provides the other critical link. A member of CHUN's board of directors for many years, Thomas was elected President of CHUN in 1990 and re-elected "by acclamation" in 1991 (*Life on Capitol Hill,* February 1, 1991: 1; see January 19, 1990: 1). The complex, cozy relationship between Thomas, CHUN, Keep Denver Beautiful, and the broader

clampdown on graffiti can be seen in Thomas' remarks at the Metro Wide Graffiti Summit:

> One of the people that was really instrumental in starting a lot of this should be on the panel, and is instead sitting in the front row. It's Tom Linker. A lot of these things started in his condominium on East 14th Avenue. . . . How a lot of this kind of thing happened is we had a neighborhood meeting at Tom's house with Cathy Donahue, myself, some other city representatives, and a lot of the neighbors to finally, I guess they were kind of at the point where they were just fed up. I mean, they were fed up with this nonsense in their alleys, on the streets, on the buildings and everything. . . . So, I was there with Val Purser and a couple of other people from the City and during the time we were talking about a lot of the graffiti.

This sort of "neighborhood meeting" underscores, in the case of the graffiti clampdown, the more general claims made in local publications that "CHUN enjoys strong ties to city government," and that "CHUN's positions are generally regarded by Denver's elected leaders and department heads as the will of the people of Capitol Hill" (Iler, 1990: 8).[19]

CHUN's entanglement in the anti-graffiti campaign highlights a larger dynamic as well. The aggressive and politically profitable anti-graffiti stances of Federico Peña and Val Purser, the dedication of local anti-graffiti activists like Tom Linker, the careful organization and coordination of economic and political power, all point to a single conclusion: the Denver anti-graffiti campaign—and indeed the status of graffiti as a local problem—results less from the nature of graffiti than from the enterprise of those who stand to benefit from its obliteration. Clearly, the Denver graffiti clampdown has been orchestrated by those "in the upper levels of the social structure" that Becker (1963: 147, 149; see 147–163) labels "moral entrepreneurs"—entrepreneurs who, in the process of constructing an anti-graffiti campaign, have at the same time constructed graffiti writing as crime. As Becker has argued, the "moral crusades" which such entrepreneurs undertake lead not only

to new definitions and perceptions of the acts which they criminalize, but to the establishment and growth of formal rules and formal organizations as part of this criminalization. As Becker (1963), Turner and Surace (1956), Cohen (1972/1980), Hall et al. (1978), Cosgrove (1984), Ben-Yehuda (1990), and others have demonstrated in empirical studies of mods and rockers, muggers, zoot suiters, and drug users, these crusades are rooted not only in abstract notions of the public good, but in the concrete realities of political and economic power.[20]

Federico Peña and Valerie Purser stand out as Denver's most active anti-graffiti entrepreneurs, its most effective anti-graffiti crusaders. Drawing on their leadership roles within the anti-graffiti campaign, and their media and public relations skills, they have seduced other political and business leaders into their vision of the graffiti "problem," and thus into their enterprise against it. At the Metro Wide Graffiti Summit, for example, Michael Martin—"sales manager, government and educational services marketing unit" of US West—served as moderator for the "Business and Corporate Support" panel, and "co-host." In his opening remarks, he described his first encounter with Peña's anti-graffiti campaign:

> About a year or so ago, I was out at Washington Park listening to the mayor give his State of the City address. And he was real emphatic that he was going to start a war on graffiti. And at that point, I was, I guess my sensitization to graffiti was somewhat lower than it is now, because I can remember thinking that, well, you know, was graffiti that big of a problem? But once you hear the word and start concentrating on the word, it's amazing. You cannot look in any direction without seeing it.

He then discussed his first "contact with Val Purser"—a contact that furthered the sort of conversion experience, the addictive pull, that Peña's speech had begun:

> Now I'm sure all of you have met Val. Anyone that walks into her office is going to come out a believer. Wouldn't you agree, for those of you that have met her? I mean, she is probably the

best salesperson for getting both the business community, the community at large, anyone involved in cleaning up graffiti. Well, I spent fifteen minutes talking to Val on the phone and I was hooked. I came back to US West and said, yeah, we do have a graffiti problem in Denver.

Later in the conference, Deputy Public Works Director Ruth Rodriguez described a similarly inverted process within the Public Works Department itself. For Public Works employees, as for Michael Martin, the perception of a graffiti "problem" has not led to a campaign against it; instead, the campaign against graffiti has taught its participants to perceive graffiti as a problem:

I took some people in our department. It was like, you have to raise people's consciousness about it. There's this real feeling about what you tell people about it, more of it will happen. So you can't talk about it. Well, we're going to have to talk about it in order to get it dealt with, and we have to be able to see it. Our people didn't.

Moral entrepreneurs, though, cannot be satisfied with simply altering the perceptions of corporate executives and city workers. As Becker (1963: 153, 155) has argued, they must also construct the "appropriate enforcement machinery" to accompany their campaign, and work with the "rule enforcers" who will operate this machinery for them. As Cohen, Turner and Surace, and Hall et al. have so clearly shown, they must also construct a machinery of language and ideology—a machinery whose imagery and symbols will create "moral panic" (Cohen, 1972/1980) around the issue, and mobilize public response to it.

Strategies of Enforcement and Control: The Clampdown

As early as February 1984, Mayor Peña argued that "we ought to have some pretty stiff penalties" for graffiti writers, and asked the city attorney to "draft a proposal beefing up the ordinance" covering the defacement of public property to include "stiffer

penalties for violators" (*Rocky Mountain News*, February 22, 1984: 8). The Peña administration's attempts to criminalize graffiti writing in this narrow sense—through the passage of harsher legal restrictions—have, however, been largely unsuccessful. At the Metro Wide Graffiti Summit, Deputy Mayor and Manager of Public Works Bill Roberts complained:

> I attempted to concern our [city] council not too long ago to pass a law having to do with tightening up the laws to make sure that those who did put paint on property, that there were penalties, a greater penalty. And I was approached by some, some number of people who meant well, and said that I was all wrong, and that there really was [*sic*] some great painters out there, some Rembrandts and other folks who were waiting to be discovered, and that I really shouldn't do that, and that we should let them be discovered. . . . And they made a convincing argument and worked real hard and I didn't get the bill tightened up.

In addition, the city council in 1985 attempted to put into place an ordinance prohibiting minors from purchasing spray paint. Not surprisingly, the ordinance died under the pressure of business interests; "ridiculed by merchants and viewed as impossible to enforce," it was "never brought up for a vote" (Gottlieb, 1989: 1B, 10B). A city councilwoman's plan in 1991 to resurrect this ordinance to ban paint met a similar fate.[21] As Valerie Purser notes, despite the Peña adminstration's efforts, in the end "there weren't any new ordinances put together . . . any new regulations."

What the city could not accomplish, though, the state could. In 1989, the state legislature passed—as part of House Bill No. 1335, "an act concerning the war on gangs and gang-related crimes" (*Session Laws*, 1989)—harsh new penalties for gang-related graffiti. First-time offenders now face up to a year in jail and a $1,000 fine, second-time offenders a mandatory one-year jail sentence.[22] Written with an eye towards Bloods, Crips, NSM (North Side Mafia), skinheads, and other gangs and gang graffiti in Denver and other Colorado cities, this law has come to pose a threat to non-gang writers like Rasta 68, Eye Six, Mac, and others. Since they

belong to writers' crews like Syndicate and 3XB, and often tag or piece together, the writers believe—and, more importantly, the authorities believe—that the new legal provisions can be applied to them. As Eye Six says:

> In terms of gangs and graffiti, I think the state law [is] you're caught one time doing graffiti, gang-wise, you get in trouble. Second time, you can spend one year in jail. And if you get down to it, you narrow it down . . . they define the gang as any group commonly known to each other, wears uniforms, goes by different names, and are engaging as a group in a crime. Therefore, you can call a crew or a group of graffiti artists a gang. So I mean, when you get down to it, if they wanted to be real hardcore they could throw a graffiti crew in jail. And supposedly, this is all in the guise of a crackdown on gangs.

Evidently, the authorities do intend to be "real hardcore." Valerie Purser comments:

> Because of the new gang regulations, and because of the fact that graffiti is just lumped under, I mean, you say graffiti, it means many different things to people. . . . So it's easier for them as police officers to put it under, you know, a gang problem. And in a sense they are a gang. They're not a gang in the sense of selling drugs, but they are a gang. They are an organized group. . . . So it's easier and it sticks better and the language is better understood within the judicial system when they do it that way.

And, as Denver County Court Judge Crew noted at the Metro Wide Graffiti Summit, the penalty he assigns a convicted writer will be "more severe because he's a gang member."

Although this drastic new provision has as yet been utilized primarily as a legal scare tactic—a threat as to what *could* happen to a writer arrested a first or second time—other legal sanctions have been widely applied. The city has utilized zoning ordinances to force property owners to remove unsanctioned graffiti and, as will be seen, to force even the removal of graffiti-style pieces commissioned by the state health department![23] To punish

convicted writers, the city has relied most heavily on community service sentencing which forces writers into supervised graffiti clean-up programs like the one in which Rasta performed 120 hours of work. In one of his earliest public pronouncements on graffiti, Mayor Peña argued that once writers are caught doing graffiti, "we ought to make them help clean it" (in the *Rocky Mountain News*, February 22, 1984: 8), and, indeed, city officials and the local media have consistently presented this sort of public service sentencing as one of the foundations of the subsequent anti-graffiti campaign.[24]

The city coordinates a variety of legal and judicial operations in running this program. Once a writer is convicted, city attorneys ask the judge to impose a sentence which includes mandatory clean-up. If the judge agrees, the city then inducts the writer into the program. As City Council President Cathy Donahue commented at the Metro Wide Graffiti Summit:

> We want to put these kids back out on the street, painting over their graffiti, and we have a gentleman, Randy West, who goes to the courts and gets these youngsters as they are sentenced, and their sentence is they have to perform so many hours of community service, and he has the paint, and he supervises them and he takes them out to the alleys and streets and they have to repaint as part of their punishment.

The Denver Sheriff's Department in turn provides officers to guard the convicts while they paint alley walls and dumpsters.[25] And as they finish painting each dumpster, the writers tape to it a paper sign which reads:

WET PAINT
Your dumpster has been repainted by
convicted graffiti vandals
under the supervision of
Denver Public Works
and
Keep Denver Beautiful

A project of Denver's OFF THE WALL Anti-Graffiti Program.
For more information call—575-3600

Randy West—variously identified as "Rev. Randy West, director of the Juvenile Offenders Program," and "Randy West, Juvenile Probation Coordinator"—thus argues that the program provides "an opportunity for [the writers] to break the cycle, for us to restate some values to them, for us to try and change the direction of the energy, the output that it takes to do this vandalism." He adds that "youth who have been through the offenders program decry graffiti for fear of having to clean it up through community service" (*In the Public Eye*, 1989; Ross, 1989: 5).[26]

Clearly, though, there is more to the community service/clean-up program than its alleged deterrent effects. As their comments reveal, the program appeals to anti-graffiti campaigners for its retributive qualities; it serves as a sort of legally sanctioned "degradation ceremony" (Garfinkel, 1956) designed to humiliate and publicly disgrace convicted writers. At the Metro Wide Graffiti Summit, for example, Deputy Public Works Director Ruth Rodriguez noted that the program is meant "to get [convicted writers] back into the community that they have disabled, intimidated, or whatever, and have them work side-by-side with someone that they have actually vandalized their home," and Assistant City Attorney Jim Thomas pointed out that the program is intended to "require the individuals to clean up the mess that they have created." Thus, in central Denver's Congress Park neighborhood, "a group of juvenile graffiti offenders" was forced to "assist" neighborhood residents "in 'powerwashing' buildings, homes and garages" (*Congress Park Newsletter*, no date).

Most revealing are the thoughts of Denver Police officer and CHUN President Ed Thomas. At the Metro Wide conference, Thomas noted his intention to make graffiti writing "an unpopular kind of sport or activity," and added,

The way I was proceeding to do that is through the enforcement. Kind of putting a couple of new colors in their paint box. Instead of having them go to, uh, put all the graffiti on the building, it

would be nice if they spent two, three, four hundred hours scraping it off. And publicizing the fact that this is the kind of activity that they were doing, because of their graffiti. . . . But what I would like to see as far as improvement . . . is the overall emphasis on the violators and perpetrators themselves, and the advertising of the fact that these are the things that they're doing. . . .

Thomas, though, wants even more than 400 hours of "advertised" humiliation; he also looks forward to a certain degree of violent intimidation. As he said in the local media, "you get those taggers out there cleaning up their messes with some ticked-off inmates from the city jail, and they're going to have an awful long bus ride back to the jail at the end of the day" (in Gottlieb, 1989: 10B).[27]

For local anti-graffiti campaigners, then, the clean-up program incorporates a nicely twisted blend of punishment, rehabilitation, and degradation. It draws on a sort of politically perverted Protestant work ethic, forcing convicted graffiti writers into clean-up work presented as both castigation and salvation, condemnation and calling. As such, the program is reminiscent of the violent degradation ceremonies enforced on young Black and Hispanic zoot suiters in the 1940s—the "ritualistic stripping of zoot suiters" which Cosgrove (1984: 43) records—but even more so of the sorts of "work schemes" and public embarrassments faced by youthful Mods and Rockers in English resort towns of the 1960s. As Cohen (1972/1980: 90, 120–121, 130, 95) documents, authorities and residents in these towns favored "visible restitution" in the form of "enforced work scheme[s] for convicted Mods and Rockers," as well as various forms of "public ridicule." Cohen thus concludes that these sorts of responses

> involve the control agents in "the dramatization of evil." Deviants must not only be labelled but also be seen to be labelled; they must be involved in some sort of ceremony of public degradation. The public and visible nature of this event is essential if the deviant's transition to folk devil status is to be successfully managed. This staging requirement fits in well with

the common police belief that a good way to deal with adolescents, particularly in crowd situations, is to "show them up" or "deflate their egos." Formal as well as folk punishments involving public ridicule have been a feature of most systems of social control.

In developing the clean-up program and other strategies of enforcement and control, Denver anti-graffiti campaigners have worked to reorient the perspectives of police officers and judges, and to coordinate the anti-graffiti operations of the criminal justice system. After Val Purser, Cathy Donahue, Tom Linker, Ed Thomas, and other city officials met at Linker's Capitol Hill condominium, they moved to a higher level of orchestration. As Thomas recalls:

> We decided to set up a couple of different meetings with all of the different entities in the City and County that would facilitate ... enforcement. We had a meeting in the mayor's office with Clean Denver and the mayor, the police chief, the head of the Denver Sheriff's Department, the Manager of Safety's Office to tie in all of the different ends of this, as far as enforcement, as far as the arrest procedure and the court procedures, the involvement with the City Attorney's Office, and the Sheriff's Department.[28]

Anti-graffiti campaigners have supplemented meetings like this one with direct judicial and police pressure. Cathy Donahue reports that

> we went to the judges, well, we had this big sort of summit meeting with all kinds of city employees, police, the judges, and we said, "Look, when you do catch these guys and they do get into the judicial system, you know, [you] give them the twenty-five dollar fine. We don't want you to do that."

Assistant City Attorney Jim Thomas notes also that the city has "asked the police department to identify to us if this is a major player in the graffiti scene, so we can let the judge know that," and

that the city then "let[s] the judge tell that this is not a trivial
offense as far as the city is concerned, and that there must be
consequences for the act of the defendant." And Valerie Purser adds
that, while graffiti was not previously a priority in the judicial
system, the campaign has served to "reeducate the people in the
judicial system":

> we [went] into the judges' chambers when they had their meeting
> and said we really need your help. If we're going to make an
> impact, we need you to make this stick and not just slap them on
> the hands. . . .[29]

In concert with these sorts of interpersonal pressures, Denver
campaigners have also been able, in Purser's words, to "streamline
graffiti under one court"—that is, to consistently channel graffiti
cases to a judge who could be trusted to do more than "slap them
on the hands." Purser thus notes that, in the case of Rasta 68, the
judge "made it stick in the worst way." A local newspaper likewise
reports that "a juvenile court judge recently assigned a graffiti-
inclined youth 200 hours of community service to be spent
cleaning up his messes as well as the graffiti of others" (*Up the
Creek*, August 5, 1988: 4). And Progreso Gallery owner Joe
Kennedy adds, "They had a judge who's specifically set up to
handle these cases. I witnessed his actions, his antics on videotape,
and he was a real idiot, basically. He had no concept. . . ."[30]

Anti-graffiti campaigners have utilized similar strategies in
orienting the Denver police force to the clampdown. Prior to the
clampdown, it will be remembered, Denver police officers
complimented Z13 on his graffiti murals, and drove by laughing
while Eye Six walked along with spray paint and stencil. As Valerie
Purser says, when police officers

> can be out catching a rapist or someone that is doing bodily harm
> to someone, they're going to spend more time and energies
> following through with that versus going out and following some
> little guy that's maybe doing $100,000 worth of damage, mind
> you, but that's not how they see it.

For Purser and others, then, the task has been to change "how they see it." To accomplish this, the Denver campaign has not only worked with the Chief of Police and others atop the police bureaucracy, but conducted "roll call training" with police officers to teach them proper procedures for "flagging" graffiti cases in their reports.

Initially these efforts did not generate the results that anti-graffiti campaigners wished. Denver Manager of Public Safety Manuel Martinez admits that it was at first "difficult to convince" police officers that they should take graffiti seriously. This problem was surely exacerbated by the creation, in 1988, of an anti-graffiti bicycle patrol. Two police technicians from the Community Services Division were assigned to bicycle up and down the Cherry Creek Bike Path—during daylight hours. Needless to say, they failed to catch any graffiti writers; they did, however, succeed in citing one individual for throwing rocks at the Cherry Creek ducks, and in becoming "the laughing stock of the graffiti underground" (Garnaas, 1988: 1, 20; Gottlieb, 1989: 10B).

As new perspectives on graffiti have been institutionalized within the police department, though, policy developments have followed. The mayor's office meeting with the Chief of Police and other top-level law enforcement officials resulted in new, stricter enforcement procedures which, according to Ed Thomas, cover

> the types of things that are necessary for the investigation, the duties and roles of the initial investigating officer, the detective that's going to be handling the graffiti, the crime lab that was going to go out and film the graffiti, which they had never done before.

Thus, in January 1989, Police Chief Art Zavaras issued directives incorporating these new procedures in an overall police "crackdown on graffiti"—a crackdown which Zavaras characterized as an attempt to save Denver from a "nightmare of painted obscenities and satanic symbols" (Briggs, 1989: 2B). With the subsequent increase in arrests—seven between February 28 and March 30, 1989, for example—Cathy Donahue could take pleasure in

reporting to the Metro Wide Graffit Summit that "the police have stepped up their enforcement and their program to handle this greatly."[31]

An incident early in the anti-graffiti campaign revealed the extremes to which this "stepped up" enforcement policy would be taken. Two weeks after Mayor Peña announced the graffiti clampdown, a curiously constructed article appeared on the front page of the *Rocky Mountain News*. Entitled "Graffiti growing like mushrooms in secret places," the article described in lurid language an alleged "Writers Heaven," a downtown plaza "where at least 100 vandals armed with spray paint or marking pens have left their marks in a netherworld of graffiti. . . ." The article went on to quote Lou Lopez, "a retired Denver police lieutenant now working for the Denver Public Schools, [who] came across Writers Heaven after penetrating the 'inner circle' of the city's graffiti scribblers" (Flynn, 1988: 1, 11). As it moved to an inside page, though, the article took an odd turn, sandwiching information about an upcoming "graffiti exhibit" at Joe Kennedy's Progreso Gallery between criticism from the plaza's marketing director and comments from Valerie Purser.

Joe Kennedy now believes that the article was part of a set-up for what was to come. During the previous week—while he was preparing the "Denver Throw Down/Spray Art" show which the article labelled a "graffiti exhibit"—Kennedy was visited by Lou Lopez and a local probation officer. According to Kennedy, Lopez threatened that he would "get" the participating artists, and promised Kennedy that "we're going to let it be known that you're promoting this stuff." By the show's opening night—the night after the *Rocky Mountain News* article appeared—Kennedy was "pretty apprehensive," as well he may have been. While a large crowd viewed the spray art panels, Denver Police Officer Jerry Arellano circulated undercover. When he had seen enough, Arellano headed for the door—but not before grabbing a display album containing two hundred of Julia Davis' photographs of Denver graffiti. After some discussion—and what Kennedy took to be a threat to close down the show—Davis and Kennedy accompanied Arellano and

the album to the police station. Once there, Kennedy recalls, the officer in charge

> told me to sit down and shut up, and he was going to take Julia in this other room and interrogate her and the book. And so they did, and they separated, they got Julia and the book, while we waited in the lobby. . . . They let her out about two hours later after photographing all the photographs that she had, and asking her things, and she wouldn't answer.

Despite the Colorado Lawyers for the Arts' opinion that the photo album constituted "art on display [with] all its attendent First Amendment rights" (in Clegg, 1988: 32), Davis and Kennedy chose not to pursue the incident further. Davis, who with Eye Six had curated the show, left the country the following week. Kennedy decided not to "exercise any legal recourse," since there "really wasn't that much to gain by it and a lot to lose in terms of the city being more repressive." The local media, though, were not finished with the incident. Art critics for the daily and alternative newspapers, for example, argued that "the mayor's 'troops' overreacted," that "the mayor's recently declared war on graffiti may have taken an illegal far-right turn," and that Mayor Peña had therefore earned "this critic's Imagine a Great Ninny award" (Heath, 1988: 8W; Clegg, 1988: 32). Valerie Purser thus acknowledges that the anti-graffiti campaign's increasingly positive publicity "went back down" because of the seizure. A subsequent attempt to rehabilitate the campaign's media image wrote a laughable postscript to the incident. A *Denver Post* article a few months later quoted Denver police officers' claims that they had been "collecting intelligence information [on graffiti] for most of the summer." The article then noted: "Most of that intelligence has been collected in a police photo album, a catalog with more than 200 snapshots of graffiti artistry" (Garnaas, 1988: 1). Indeed.[32]

To supplement their own methods of "collecting intelligence information," Denver police and the anti-graffiti campaign have enlisted the aid of local residents. The "Graffiti Stoppers" program, an offshoot of the established "Crime Stoppers" program, offers

residents rewards of up to $1,000 or $2,000 for information on graffiti "vandalism"—or, as it is more often phrased in the local media, "turning in graffiti vandals" (Asakawa, 1989: 8; Gottlieb, 1989: 10B). Funded by business contributions and other private donations, the program has been publicized in daily and neighborhood newspapers, and has, according to Manny Alvarez of the Crime Stoppers Program, drawn citizen response. In conjunction with Keep Denver Beautiful, the Denver Police Department has also set up a "hotline" for the "sharing of information" between the department and local residents.[33]

Although the Graffiti Stoppers program has apparently not generated any convictions for graffiti writing, it has produced at least one incident of vigilante entrepreneurship. In late February, 1989, Keep Denver Beautiful and CHUN held a public meeting at which the program was publicized. The next day, two teenagers showing a local reporter a graffiti-covered alley were assaulted by three men, one of whom told them, "I'm gonna get a thousand bucks for your ass." Valerie Purser notes that one of the men subsequently called the Keep Denver Beautiful office, asking "Are we gonna get a reward? Are we gonna get a reward?" As Purser says, "They had been at the public meeting the night before, where the program was announced, and people were pumped up and emotional about it" (in Asakawa, 1989: 8). A few weeks later, local street artist DeDe Larue announced that she was "disturbed by the 'heavy-duty vigilante' mentality surfacing. 'I am concerned that someone is going to get hurt'" (Kreck, 1989: 1C).[34]

Local residents have also been recruited to clean and paint over graffiti. The "Adopt-A-Spot" program institutionalizes the coat-of-paint approach to graffiti prevention which Diane Tate applied along Cherry Creek in the summer of 1986. Adopt-A-Spot volunteers watch for graffiti's appearance on designated traffic signal boxes, dumpsters, or alley walls, and then paint over what graffiti they find with house paint provided by Keep Denver Beautiful. In so doing, according to Deputy Public Works Director Ruth Rodriguez, they "start to take responsibility, block by block, for what their community looks like" (Metro Wide Graffiti

Summit). Responsibility for the paint itself, though, has been left to Benjamin Moore Paint Company, Kwal Paint Company, and other corporate sponsors, who have donated paint and equipment to the program.[35] These corporate connections surface on the official "Graffiti Adopt-A-Spot" application form, which asks volunteers to choose which "public spot" they will adopt: "traffic signal box, City Dumpster(s), U.S. Mail Box, [or] Phone Booth or U.S. West Property" (Keep Denver Beautiful, no date).

With the active assistance of *Life on Capitol Hill*, the Adopt-A-Spot program has most successfully recruited volunteers in the Capitol Hill area of Denver. *Life on Capitol Hill* has served as the program's primary promoter, publishing the Adopt-A-Spot application form, providing phone numbers for this and other anti-graffiti programs, and "rush[ing]" one hundred copies of the application form to the Sixth Avenue Merchants Association.[36] As a result, the newspaper was able in April 1989 to report that "almost two hundred spots have been adopted on Capitol Hill alone, and the fight is on" (Filley, 1989a: 3). In Capitol Hill and elsewhere in Denver, this fight for environmental control has been augmented by the use of high-pressure washers and similar sorts of cleaning technology. Denver's Parks and Recreation Department, for example, has put together a two-person team which travels the city in a "small pink truck" cleaning "parks, monuments, structures, [and] retaining walls" (Jerry Tennyson, Metro Wide Graffiti Summit). Tom Linker and other anti-graffiti activists are likewise attempting to purchase this type of equipment for use by Capitol Hill residents.[37]

The anti-graffiti campaign has also attempted to create a broader base of support and involvement through educational and recreational programs—programs designed at the same time to dissuade kids from involvement with graffiti. Robin Pfeiffenberger began working as a volunteer with Keep Denver Beautiful, but as Val Purser noted at the Metro Wide Graffiti Summit, "kind of created herself a position" as Education Coordinator. As such, she believes that education is the "ultimate weapon" in the fight against kids' involvement with graffiti, and travels to local elementary

schools to "catch them at an early age." She takes with her a group
of characters dubbed "The Clean Team," an anti-graffiti ensemble
whose skits include Robin in the role of a living, and ultimately
graffiti-free, wall! As he reported to the Metro Wide Graffiti
Summit, Michael Simmons of the city's Commission on Youth
likewise works to involve kids in programs designed to
"reinforce . . . values" and "change the mindset of young people so
that they don't do these types of things." And while older students
may miss out on the living wall and other such programs, they do
see an anti-graffiti poster designed by the Colorado Institute of Art
and distributed to all Colorado high schools. Despite these efforts,
though, Valerie Purser worries that the city still "need[s] to develop
a broader educational campaign," since "there is no major
education campaign right now."[38]

Denver anti-graffiti campaigners also hope to develop programs
to reconfigure the "mindsets" of those already convicted of graffiti
writing. Early in the campaign, Valerie Purser was reported to be at
work on "a program to channel graffiti artists into productive art
classes with therapists" (Flynn, 1988: 11). Later, she proposed that
the campaign might acquire useful information from a
psychological analysis of writers' motivations:

> And then you get some trained psychologists in there that say,
> now, what this really means and how we need to take this
> information back home when we're putting programs together,
> and I'm not a psychologist, but you know, you get some
> psychiatrists or psychologists that say, you know, this is what,
> now, you just heard this young man talk.

Ruth Rodriguez further proposes that convicted graffiti writers
work with "role models" from the community while serving out
their community service sentences in the clean-up program.[39]

Although these programs of soft control have not yet been put
into place, one concerted attempt has been made, in Valerie
Purser's words, to "guide [graffiti writers] into the area that they'll
feel good about," and at the same time "create a warm fuzzy" for
the city of Denver. The summer of 1988 saw Mayor Peña

publicizing a legal outlet for local graffiti writers: an "artway." Like similar projects in San Francisco and elsewhere, this "artway" was in fact a construction site walkway to be painted by graffiti writers, in this case along the 14th Street side of the city's new downtown convention center.[40] Part of the city's emphasis on "authorized public art projects to channel talented artists away from destructive graffiti vandalism" (Clean Denver, 1988: 5), the artway was described in one local press report as both an "experimental attempt to stop the spread of wall art on public buildings" and as a "note of tolerance in an otherwise hard-line crackdown" (Newcomer, 1988: 8). Eye Six thus described the project as "a p.r. scheme: 'Well, we've punished the poor children enough, now we'll throw them a bone'" (in Ferrell, 1990: 11), and Mayor Peña agreed:

> We want to send two messages with this. One, there is a legal alternative to illegal graffiti for these artists. And two, we are cracking down on illegal graffiti and we're cracking down hard (in Graf, 1988: 1B).

From the beginning, then, the artway embodied a sticky contradiction, hanging between the intimation of tolerance and the intention of control.

This contradiction was played out in the execution of the artway itself. Local graffiti writers were offered temporary studio space at a midtown Public Works facility, provided with plywood panels and spray paint made available by the convention center contractor (Hensel-Phelps) and the Colorado Paint and Coatings Association, and assured by a city administrator that "we don't want to do any censorship" (in Chotzinoff, 1988a: 8). According to Rasta 68 and others, though, the panels were "not even plywood, it was particle board, shit wood" (in Ferrell, 1990: 10); and since the spray paint was "cheap-assed paint," many of the writers were forced to dip into their own stocks of Krylon in order to complete the panels.[41]

Worse, certain of the panels which the writers did complete never made it to the artway—in particular, Rasta's "STOP WAR" piece, and Voodoo's two-panel piece on AIDS. At the time, Valerie

Purser claimed that the panels' disappearance was "unfortunate" and "a mistake" (in Chotzinoff, 1988b: 10), and later argued that "it wasn't the city that lost them, it was Hensel-Phelps that lost them." Others saw the lost panels as less an unfortunate mistake than intentional censorship. Rasta alleges that "they did censor it," since "it's obvious they aren't into having that kind of subject matter up there" (in Ferrell, 1990: 11; Chotzinoff, 1988b: 10). Voodoo likewise argues that "they didn't want those pieces up there—it 'just happened' to be the two pieces to stop war and AIDS," and explains by describing his "AIDS" piece:

> I knew they wouldn't bring that one back, 'cause it was, *Westword* called it a study in black plague motif. It was all real yellow and bruisy and it had the meat car with the bodies in it and the guy holding the car, "We'll throw out your dead." A big kettle that said, "Many of you will die," and it was just really spooky.[42]

Fie thus believes that "they looked at them and they just didn't want them in, so they had them stolen."

The pieces that did make it to the artway were mounted badly, left unprotected from the elements, and juxtaposed with panels fingerpainted by local children. These mistakes, in conjunction with tagging by writers displeased with the project, left the artway looking, in Fie's words, "mangled, violated . . . really shitty."[43] Fie therefore considers the entire undertaking "a fiasco." Valerie Purser labels the artway "a disaster," a project that "backfired on us terribly." But perhaps Joe Kennedy—whose Progreso Gallery hosted organizational meetings for the artway, and who helped coordinate its completion—provides the best evaluation. At the beginning of the project, Kennedy found himself "hopeful, naive really, in thinking that the city is trying to make some gesture of respect, or trying to educate itself." He also wanted to believe the city's "implicit promise" that the artway would be, as one city official said, "only the beginning" in developing a permanent "graffiti art zone" (in Chotzinoff, 1988a: 8) in the city—a promise that was not kept. By the end, he was left "really angry." As he says,

"We talked about all the things that could go wrong and they managed to make every one of them happen."

Image and Ideology in the Criminalization of Graffiti

Denver anti-graffiti campaigners have relied on visits from The Clean Team, stylish poster art, and various social and service activities in teaching kids to see graffiti as a losing game. They have advocated the involvement of therapists, psychologists, and community role models in an attempt to reorient the motivations and desires of graffiti writers, and have tried to "guide" writers away from graffiti through the artway and clean-up projects. As seen earlier, campaign directors like Federico Peña and Valerie Purser have also been successful in persuading corporate and civic leaders that, in Michael Martin's words, "we do have a graffiti problem in Denver." In conjunction with the local media, Denver campaigners have also moved beyond the indoctrination of these specific groups to a larger task: the reconfiguration of the general public's perception of graffiti and graffiti writers.

This manipulation of perception and understanding—this creation of "moral panic" (Cohen, 1972/1980)—stands as a central task of any moral crusade, of any attempt to criminalize groups and their activities. Moral crusaders and moral entrepreneurs must not only attack their targeted groups; they must also attack the public's limited awareness of those groups if they are to create legitimacy and support for their campaigns. In the 1930s, the criminalization of marijuana in the United States is accompanied by "an effort to arouse the public to the danger confronting it by means of 'an educational campaign describing the drug, its identification, and evil effects'" (Becker, 1963: 140). In the 1940s, "overt hostile crowd behavior" against zoot-suiters is "preceded by the development of an unambiguously unfavorable symbol" in Los Angeles newspapers (Turner and Surace, 1956: 14). In the mid-1960s, lurid accounts of rape and assault in national publications and official reports set the context for a clampdown on the Hell's Angels—and in the process establish the identity of a motorcycle

gang which at that point is "virtually nonexistent" (Thompson, 1967: 42). At almost the same time, authorities' attacks on British mods and rockers are legitimated through the media's "exaggeration and distortion" of events, and deployment of "emotive symbols" (Cohen, 1972/1980: 31, 54). In the 1970s, the "reciprocal relations" between the criminal justice system and the mass media in Great Britain produce the perception that mugging is "a frightening new strain of crime" (Hall et al., 1978: 74, 71). And throughout the 1980s, an increasingly intrusive and authoritarian "war on drugs" in the United States is legitimated by mediated stories of drug-related violence and fried-egg brains.[44]

In the late 1980s and early 1990s, Denver anti-graffiti campaigners have likewise used an assortment of discomforting images, factual distortions, and symbolic references to locate graffiti in specific contexts of perception and understanding. As with marijuana users and youthful motorcyclists, this ideological onslaught has been essential to the creation of moral panic around graffiti and graffiti writers. Once constructed, this moral panic has served as a source of campaign support and legitimation, and also as a useful control strategy—a sort of epistemic clampdown, a narrowing and restricting of the range of explanations for graffiti. And as the troubadours of pop criminology, The Clash, well understood, these ideological controls—"we will teach our twisted speech to the young believers"—in turn intertwine with the sorts of control strategies just examined, and thus serve as the epistemic underpinnings for the more general clampdown.

Though the Denver clampdown is predicated on the interests of local political and business elites, their concerns are of course not presented to the public as such. Instead, anti-graffiti campaigners and the local media create moral panic by publicizing their concerns as concerns of the community as a whole. An intentional confusion of business interest and public interest is perpetrated and, in a sort of magical reversal, perspectives which business and political leaders wish to impart *to* the community are presented as coming *from* the community. Political and economic problems with graffiti are reconstructed as social problems which threaten all

Denver residents, rich and poor, powerful and powerless. And, ultimately, property values are translated into social values, and property rights transformed into human rights.

Denver campaigners lay the groundwork for this sort of moral panic by first selling the notion that neighborhoods as a whole are disgusted with graffiti, that people in general are outraged by it. Valerie Purser argues in the local newspapers that "This isn't just the city. The community feels it's wrong" (in Paige, 1989: 7B). *Life On Capitol Hill* (Slivka, 1989: 5) reports on the anti-graffiti efforts of "Mrs. A. J. Bailey and her neighbors," and quotes Mrs. Bailey: "We find graffiti offensive. It's our neighborhood, but these teenagers or whatever come along and write their insignias. We're taking back the neighborhood." The *Denver Graffiti Removal Manual* (Clean Denver, 1988: 5) states under "Graffiti Facts": "Residents of graffiti vandalized neighborhoods experience disgust and frustration as they witness this environmental liability changing the face of their once well-groomed community."[45] This "fact" is of course not a fact at all, but an ideological construct, based not on sound social research but on the values of the business and political forces behind the campaign. And, as Mrs. Bailey's thoughts so well reveal, it intentionally omits graffiti writers and aficionados, teenagers, street kids, homeless persons, gang members, and other outsiders from its mythical population. Constructed by anti-graffiti campaigners, these "residents" and their attitudes are as empirically dislocated as "the moral majority," "the American way," and other political creations which float within the mythology of majority will.

The illusion of an outraged citizenry sets the context for a second image essential to the construction of graffiti as a social problem and to the creation of moral panic around it: the vision of a spreading, growing menace. The *Denver Graffiti Removal Manual* (Clean Denver, 1988: 5) claims that

> Graffiti vandalism is becoming a rapidly increasing problem no longer limited to big cities like Los Angeles, New York and Chicago. Graffiti vandalism has spread across this country and

now scars buildings, roadways, parks and recreation areas of large
and small communities.

A pamphlet distributed to the public by Clean Denver (1988a)
adds that, in Denver, "What started as a few isolated scribblings has
escalated into a webwork of scars—spinning out of control all over
the city." As Denver graffiti "spin[s] out of control," of course, it
begins to make sense that residents of neighborhoods throughout
the city will be increasingly repelled and disgusted by this
"webwork of scars."[46]

To accentuate this picture of an outrageous, cancerous menace,
anti-graffiti campaigners must paint a portrait of the sort of person
who would threaten "well-groomed communities" with graffiti—a
portrait of the villain, the "folk devil" (Cohen, 1972/1980), the
"graffiti vandal." The *Denver Graffiti Removal Manual* (Clean
Denver, 1988: 5) attributes graffiti to "a lack of caring, lack of
respect for one's community," and characterizes it as a "public
display stating an aggression or message to the community at large."
Similarly, the program for the 1990 Metro Wide Graffiti Summit
explains to participants that graffiti expresses "the desire to strike
back at society" (Keep Denver Beautiful, 1990). Valerie Purser
argues that graffiti writing originates in the same need to "feel that
you're a part of something" that leads to being "involved in a gang
that's selling crack and cocaine." And *Life on Capitol Hill* (March 3,
1989: 1) reports on the "inflated egos of many 'taggers'."[47]

In Denver, this psycho-pathological portrait of the graffiti
writer has been elaborated through the deployment of derogatory
images and catch phrases by local politicians and the local media.
At the 1990 Metro Wide Graffiti Summit, Denver Deputy Mayor
and Manager of Public Works Bill Roberts told a story about dogs
urinating on trees to mark their territory, and noted that,

> as I look at that behavior in those lower animals and I look at the
> people who go around in our cities with paint cans and other
> things marking territory, it causes me to wonder perhaps if
> they're not operating at a, at a level in the, in the animal chain
> not too far removed from that that we observe in lower animals.

Denver City Councilwoman and Council President Cathy Donahue added that "I sort of agree with Bill's story about the dogs," and later referred to "senseless . . . dog markings."

Larger audiences also benefit from these sorts of derogations. Denver's *Life on Capitol Hill* consistently refers to graffiti writers as "graffitidiots." In one case during 1989, the paper ran a photo of a Capitol Hill dumpster painted by local street artist DeDe LaRue. On it, LaRue had painted one of her trademark flamingos, and above the flamingo the wry plea, "Please don't kill me." The paper headlined the photo, in bold letters, "Graffitidiots Driven to Begging" (June 2, 1989: 1). The paper also uses "graffiti creeps" regularly; one 1989 article on anti-graffiti efforts carried the headline, "Capitol Hill Neighbors Outlast Graffiti Creeps" (Slivka, 1989: 5; see *Life on Capitol Hill,* Dec. 1, 1989: 1). A popular local columnist and talk show host likewise refers in his column to graffiti writers as "gauche graffiti goons" and "spray-can cretins" who "slink around in the dark of night, unashamedly polluting Denver" (Paige, 1989: 7B), and adds on a local television program, "Most of us got over that type of drawing when we were three or four years old—we were drawing on our parents' wall—we went on to better things" (*In the Public Eye,* 1989).

Although they happily employ these floridly negative images, anti-graffiti campaigners' preferred *generic* characterization of those engaged in graffiti is always "graffiti vandals," in place of the less loaded "graffiti writers" or the more positive "graffiti artists." As Valerie Purser notes,

> "The major focus is on education, and changing how people view things." And the first step is to downplay the media's use of the term "graffiti art," she adds. "It's not like we're going after artists. We're talking about ugly words and signatures. These people just want to regain their neighborhoods." (in Asakawa, 1989: 8)

In public meetings, in print, over the airwaves, campaigners use "graffiti vandals" so commonly, and so carefully, that it takes on a sort of chant-like quality.

Not surprisingly, campaigners also employ the derivative phrase, "graffiti vandalism," to describe all forms of graffiti, whether murals, throw-ups, or tags. The effect, of course, is to lock graffiti into the context of vandalism, to tie it to activities like window smashing and cemetery desecration, and to deny graffiti any special status as creative or artistic activity. This effect is furthered through media reports structured so as to blur the distinction between graffiti and other forms of vandalism and crime. In July 1988, for example, the *Rocky Mountain News* (Pugh, 1988: 26) ran a story under the headline "Castle Rock breaks out in graffiti." The story began with a description of graffiti "vandals" and "vandalism" in Castle Rock, a Denver suburb; moved to the statement that "the graffiti spree isn't Castle Rock's first incident of vandalism this year;" and concluded with a description of a "window-smashing rampage." Similarly, a 1991 article in the *Rocky Mountain News* described a neighborhood group's efforts in "driving out the drug dealers," but ended with the note, "Neighbors plan to whitewash the graffiti" (Herrick, 1991: 7).[48]

To maximize the sense of threat and violation, verbs such as "attack," "destroy," and "rob" are subsequently paired with "graffiti vandal" and "graffiti vandalism." In a public service announcement aired on local television, for example, Mayor Federico Peña claims that "each day the citizens of Denver are being robbed, robbed by graffiti vandalism on their public and private property" (*In the Public Eye*, 1989). Council President Cathy Donahue likewise announces to the Metro Wide Graffiti Summit that when you do graffiti, "you are robbing somebody, in my view." And Clean Denver's *Denver Graffiti Removal Manual* proclaims that "for years graffiti vandals have attacked public and private buildings . . ." (Clean Denver, 1988: 1). Significantly, such phrasing implies not only violent assault, but an aggressive intentionality on the part of the "graffiti vandal," who doesn't "write" or "paint," but "attacks" and "robs."

These attacks and robberies in turn must create "victims," whose existence in anti-graffiti publicity helps cement graffiti's fearful image. The July 1988 Public Service Company of Colorado

Update—"a monthly information report to customers" enclosed with their utility bills—thus reports not only on graffiti "attacks" by an "uncaring few," but on the "victims of graffiti vandalism." At the Metro Wide Graffiti Summit, Valerie Purser talks about "the victims and what are their rights and what can be done to assist them," and Ruth Rodriguez speaks about plans for "victim assistance." Later, Purser specified the nature of these victims: "We're talking about victims, the victims, which are the property owners." An interesting variation on this theme of graffiti "attacks" and graffiti "victims" is the notion of graffiti writers victimizing themselves, of graffiti writing as a sort of social suicide. The president of Denver's Mad Dads—a neighborhood anti-gang, anti-crime group—thus commented in the local press that gang members who do graffiti "are destroying their own neighborhoods. They've got to live here too. It's almost like committing suicide" (quoted in Pugh, 1990: 8).

For anti-graffiti campaigners, then, graffiti attacks and victimizes those on whose walls it is written; but it also allegedly victimizes the general population by instilling a sense of fear, threat, and intimidation. According to the campaigners, this threat operates on three levels. First, and most direct, is the individual's fear of violent, psychotic graffiti vandals ready to retaliate for any actions taken against them. Privately—and without any supporting evidence—Valerie Purser notes that her leadership of the anti-graffiti campaign

> was a little frightening, 'cause you never know what these guys are going to do. You know, they look you up in the phone book, and they say, o.k., we're going to come and get you, you know. And so that, I didn't want that. So, I mean I'm really happy to be moving on.

Publicly, the same sorts of claims are made, again without the benefit of supporting information. At the Metro Wide Graffiti Summit, Purser reiterated her fear of retaliation from local writers, and Ray Krupa, an anti-graffiti neighborhood activist, noted that he had not faced retaliation—yet. Most courageous, though, was

Mayor Peña, who demanded that the war on graffiti must continue, despite the "problem of threats."

Even in the absence of these direct if imaginary threats from writers, graffiti itself is presented as generating a sort of free-floating fear in the general population. Cathy Donahue thus admits that "I don't know of anybody that has really been threatened," but adds that "I'm sure that there has been some feeling of threat. . . . People that live close to the spots where the gangs do their graffiti . . . are certainly afraid." In a radio spot aired locally and nationally, Valerie Purser claims that graffiti "makes people feel unsafe" (Wood, 1990), and in a local newspaper article adds:

> When someone gets something on their garage door that may be from a tagger (someone who paints just their nickname), it still instills fear into the community about what this means. People think, "Is someone going to come and hurt me?" (in Wolf, 1990a: 8).

At the Metro Wide Graffiti Summit, Ruth Rodriguez claims further that graffiti is designed "to intimidate the community," and can therefore "intimidate and scare eveybody to death." Denver campaigners, of course, present no evidence by which the veracity of these claims might be judged. And even if residues of fear and anxiety were discovered in the general population, they would surely trace less to graffiti and graffiti writers than to the sensationally negative images of them disseminated by the anti-graffiti campaign.[49]

Anti-graffiti campaigners generate a third level of threat by linking graffiti writing to issues of ecological destruction and decay. Denver's Keep Denver Beautiful is affiliated with the national Keep America Beautiful organization, and thus oversees local campaigns against litter and urban "ugliness" as well as graffiti. Because of this, reports in the local media often discuss graffiti in the context of other Keep Denver Beautiful concerns, and in so doing situate graffiti among the many threats to the urban environment. Beyond this, anti-graffiti campaigners and the local media intentionally present graffiti as an ecological threat—and often, as the primary

ecological threat—in a city notorious for its suffocating "brown cloud" and its location a few miles downwind from a nuclear weapons plant. In launching the 1988 clampdown on graffiti, Mayor Peña alleged that "graffiti represents a signature of disregard, not only for the rights of property owners, but for the appearance of our city and the cleanliness of our environment" (in Digby, 1988: 1). A week later, a *Denver Post* editorial (April 13, 1988: 6C) blended this perspective with the fear and intimidation viewpoint already developed:

> the greenbelt would feel far less safe if every flat surface along it were marred by spray-painted defiance, as the subway cars in New York City have been. . . . No one has the right to debase our surroundings with paint, any more than with any other kind of pollution.

Most remarkable, though, was an article in the local weekly *Up the Creek* (August 5, 1988: 4) later that year. A discussion of litter, dog feces, and graffiti, "an escalating form of eye trash," the article was headlined "Graffiti Worst Trash Problem for Denver."

Anti-graffiti campaigners take this imagery of threat and victimization to its hyperbolic extreme with their linking of graffiti writing and rape. The *Rocky Mountain News* publishes an article on the "rescue" of an abandoned local elementary school building from gang graffiti, a building that "should be a respected landmark in the heart of the city." The author notes that "to 21-year-old Sam Orosco," a former gang member, "the abuse of the school was like the rape of a friend" (Wright, 1990: 7). *Life on Capitol Hill* (July 7, 1989: 3) features, under the headline "Graffiti Not Art," a letter to the editor from one Charles A. Hillestad, a Capitol Hill resident. In it, Hillestad trots out the usual denigrations, referring to graffiti writing as "cowardly, damp scribblings," the "malicious trashing" of homes and businesses, and a "direct attack on others through their possessions." He predicts that future research "will show a strong correlation between more serious crime and graffiti." And he adds:

Graffiti is much closer to rape than it is to art. While I would
never directly equal [sic] graffiti with rape, the latter crime being
far more heinous than the vandalism and desecration caused by
graffiti, nonetheless I strongly suspect it arises from the very same
baser emotions ... an antisocial desire on the part of these
delinquents to take something that doesn't belong to them and
make it their own or destroy it.

Beyond newspaper reporters' and letter writers' efforts to
associate graffiti with rape are the direct efforts of anti-graffiti
campaigners themselves. Privately, Valerie Purser argues for the
same sort of "correlation" as does Charles Hillestad:

I think the statement it says about the neighborhood is that
nobody's watching, nobody's caring, and so therefore people that
want to do maybe theft, or maybe rape or maybe whatever, what
kind of neighborhood, then they say, nobody's watching here, I
can get away with it because nobody's watching. So I believe
there is a correlation between the crime.

Publicly, she makes the connection more succinctly and more
powerfully. "In the Public Eye," a graffiti documentary produced
and aired by local public television station KBDI in 1989, includes
interview segments with Purser. Early in the documentary, and
before she has been identified to the viewer, Purser is included in a
segment of comments from the general public on graffiti. Her
comment: "We feel like we've been raped." It is difficult to say
whether such tactics are more offensive to rape victims or graffiti
writers; it is not difficult to see that such tactics are designed to
locate graffiti in the worst possible context.

The placement of graffiti in a threatening, violent context is
furthered through the imagery of anarchy and chaos. This imagery
is utilized both to represent the sort of social decay which graffiti
purportedly evidences, and to symbolize the further disorder and
decay which will result if graffiti is left unchecked. Such imagery
thus characterizes graffiti as both causing and caused by the

breakdown of social order, and taps into public anxieties about street crime, youth cultures, and other phenomena represented as part of this social collapse. In utilizing these images, anti-graffiti campaigners attempt to create a sort of Durkheimian nightmare around graffiti, a social vision in which graffiti becomes an anomic bomb exploding the basic values of middle-class society.[50]

Anti-graffiti activist Tom Linker thus refers in *Life On Capitol Hill* (March 3, 1989: 3) to the "destruction of the central core of this city" through "graffiti vandalism," and at the Metro Wide Graffiti Summit tells the audience that graffiti "destroys everything and mutilates not only private and public business, but also the entire neighborhood, and demoralizes and intimidates everyone involved." At the same public conference, Assistant City Attorney Jim Thomas points out that graffiti writers are "involved in destroying the city," and Don Turner, a member of the Denver Partnership and property manager for the principal downtown shopping district (the 16th Street Mall), argues that graffiti "gives a perception of gang activity and chaos in the streets." Speaking to a larger audience, one *Denver Post* editorial writer argues, under the headline "Graffiti Can Destroy A City," that "graffiti are connected to art as robbery is connected to banking," and that "graffiti mark a zone of apathy, anarchy and decay" (Johnson, 1987: 7B). Another refers to graffiti as "the immovable litter [that] breeds an atmosphere of urban lawlessness" (April 13, 1988: 6C).[51]

Together, these images—marauding vandals, rape, chaos, destruction—cue a public interpretation of graffiti as inherently threatening and violent. Moreover, they banish graffiti and graffiti writers from an idealized urban community, setting them in conflict with community values and concerns. Moral campaigners cement this polarization, this alienation of graffiti writers from membership in the collective city, by encasing public discussions of graffiti in the terminology of war. In the same way that they transform those engaged in graffiti from artists to aggressive vandals to rapists, anti-graffiti campaigners transform their self-interested response to graffiti into a community crusade, a holy war fought from street to alley.

Broad characterizations of the anti-graffiti campaign consistently incorporate terminology such as the "war on graffiti" and the "Capitol Hill graffiti war." As already seen, *Life on Capitol Hill* publicizes the Adopt-A-Spot program by announcing that "almost two hundred spots have been adopted on Capitol Hill alone, and the fight is on" (Filley, 1989a: 3). A pamphlet distributed by Clean Denver (1988a) uses the language of war, or perhaps of street violence; it talks not of "stopping" or "arresting" graffiti writers, but of "bringing down the graffiti vandals responsible." Such characterizations are of course reminiscent of other "wars" waged by moral entrepreneurs in Denver and elsewhere, including the "war on drugs" and the "war on gangs."[52] And like the daily reports from these other wars, the particulars of this war on graffiti are cast in intentionally bellicose language. Writing in *Life on Capitol Hill,* Slivka (1989: 5) adopts the voice of the war correspondent, noting that "reports from the front are encouraging as the graffiti battle wears on."

As seen previously, Slivka goes on to quote Mrs. A. J. Bailey's assertion that "We're taking back the neighborhood." This sort of imagery—of graffiti vandals taking over buildings, streets, and neighborhoods, and concerned citizens launching counter-offensives to take them back—recurs throughout the campaign. The chairman of a neighborhood coalition is quoted as having "spat out a pledge" that "we're going to take back" a neighborhood school from gang graffiti (Wright, 1990: 7). A front page *Rocky Mountain News* article characterizes downtown condominium owners as "hoping to reclaim their plaza" from "a netherworld of graffiti" (Flynn, 1988: 1). Embedded in these "take back" characterizations are not only the broad orientations of a graffiti "war," but a specific message which furthers the tensions and hostilities which that war produces. The message is that the mere presence of graffiti denotes a transfer of power from neighborhood residents to graffiti vandals, and thus a failure on the part of residents to maintain control over their lives and property. As a *Rocky Mountain News* (June 20, 1990: 46) editorial says: "A neighborhood stricken with graffiti is a neighborhood in which the

residents have lost—or are at risk of losing—control." If the intent is to polarize graffiti writers from the neighborhoods in which they operate and to create moral panic about them, a more effective message could hardly be imagined. The homeowner who wanders into her back alley to find there a fresh tag has learned to understand that tag in terms of personal threat and violation.

Denver anti-graffiti campaigners thus employ deliberately derogatory language in constructing images of graffiti and graffiti writers for the public. Certainly particular phrases may spring forth in the heat of a public debate, or under the pressure of a publication deadline; but the consistency and frequency with which others are employed points to their intentional use as ideological and linguistic devices. Taken individually, each functions as a sort of marker, a stigma attached to particular topics or public discussions. Taken as a whole, these devices perform a critical function in the moral campaign against graffiti: they serve to locate graffiti in a specific *epistemic* context. They function to establish an interpretive framework, a paradigm through which the public can perceive and understand graffiti, and to shift public perception and understanding toward particular sorts of fear and condemnation. The perception of graffiti as a growing menace, a vermin that carries the plague of personal, social, and environmental disorder, of course legitimates the existence of the anti-graffiti campaign itself. The perception of graffiti writers as aggressive, subhuman vandals who rape and destroy their victims in turn justifies the campaign's legal and political clampdown on graffiti writers and graffiti writing. Spectacularly derogatory images are important, then, not so much as evidence of mean-spiritedness on the part of Denver's moral campaigners—although they appear to indicate that as well—but as basic tools for creating and sustaining the moral panic without which they could not operate.

Unintended Consequences: The Amplification of Crime

Denver anti-graffiti campaigners have employed a remarkable range
of control strategies in their effort to stop graffiti writing: stricter
enforcement and sentencing procedures; citizen programs like
Graffiti Stoppers and Adopt-A-Spot; The Clean Team and the
Artway; ongoing media and public relations campaigns; and even
bicycle patrols and photo book confiscations. These programs have
required not only increasing coordination among city agencies, and
between the city campaign and its corporate sponsors, but large
expenditures as well. The yearly cost of Denver anti-graffiti
eradication efforts, for example, is estimated at between $350,000
and $1,000,000.[53] As already seen, this complex, expensive
campaign has resulted in the arrest of a number of writers, and in
the temporary disengagement of writers like Fie and Rasta 68 from
certain forms of graffiti writing.

The larger effect, though, has been precisely the opposite of
what Denver's anti-graffiti campaigners have intended. In using
local media and their own public relations machinery to create
moral panic around graffiti, anti-graffiti campaigners have at the
same time unintentionally increased local writers' public visibility.
The onslaught of news accounts dealing with graffiti writers and
writing, graffiti arrests, and the variety of legal and illegal graffiti
projects—in conjunction with counter-reports sympathetic to the
writers in alternative publications like *Westword, Muse,* and *Clot*—
has added greatly to the public "fame" of Denver's kings, and
elevated their status and visibility within the graffiti underground,
the alternative art community, and the local music scene.

This heightened visibility has translated into an increased
demand for graffiti writers' services. Over the past few years writers
like Rasta 68, Eye Six, and Top One have secured more and more
commissioned work from individuals, media producers, bookstores,
skateboard shops, and other groups—work which the writers
directly attribute to the publicity, negative or positive, which the
anti-graffiti campaign has been good enough to generate for them.
Eye Six notes that,

in the long run it was good for us because of the publicity. That's when the pictures started showing up—when [Valerie Purser] started bitching, and I'd say that about even the clampdown. When the newspapers started reporting, people started learning about it and wanting to buy it and that kind of thing (in Ferrell, 1990a: 11).

Rasta 68 echoes Eye Six's sense of bad publicity's good effects:

Everyone wanted to get some on their property, or wanted a little piece of the action. Any publicity is good publicity. That's what my friend Eye Six told me when I was getting all upset about the articles in the tabloids (in Ferrell, 1990a: 11).

Eye Six thus concludes that,

in terms of monetary compensation, the crackdown has really been a benefit. I mean, in a way, it's about the best thing that they could have done. Because shortly thereafter, people . . . still, two years later, are seeking out these people that were involved in this. . . . I mean, I've gotten from the crackdown, 100% of my art sales, 100% higher.

Z13 concurs, noting that the negative publicity surrounding the Progreso/Denver Throw Down show "was o.k., too, because that got us more media attention than it probably would if they had left it alone—so, therefore, they were kind of working against themselves."[54] He goes on to point out a second unintended consequence of public attacks on graffiti writing: the recruitment of new writers. As he says, the more the campaign clamps down on graffiti, "the more attention it gets. And therefore, the more people want to do it, too. Some new kid probably says, 'o.k., yeah, I can do that, too; I'll get in on that, too.'" The new waves of writers that have continued to join the underground *during* the clampdown certainly seem to confirm Z13's perception.

This seemingly odd, unintended relationship—a clampdown on graffiti generating more activity within the graffiti subculture—results not only from media exposure, but from the nature of

graffiti writing itself. As seen in the previous chapter, writers piece and tag as much to achieve the excitement, the "adrenalin rush" of illicit creativity, as to leave lasting marks or images. Graffiti writing occurs, then, in a context which challenges, defies, and even celebrates the illegality of the act—a context which can only be exacerbated by the harsh efforts of anti-graffiti campaigners. Local writers report that "a highly publicized campaign adds to the thrill of their 'outlaw lifestyle,'" and one writer allows that "he 'knows for sure' that the hard-core taggers . . . will view the city's crackdown as a challenge to become more active" (Gottlieb, 1989: 1B; 1989a: 10B). DeDe LaRue likewise points out that "you can't stop graffiti. That's what it's all about, it's covert. Resistance makes you try harder" (in Chotzinoff, 1988: 9), and adds that writers see the anti-graffiti campaign as an "irresistible challenge":

> Doing graffiti is a real adrenalin rush. That provides a lot of the pull and draw to the taggers. The city doesn't understand that the more they publicize the crackdown, the more active the taggers will become (in Gottlieb, 1989a: 10B).

Even Valerie Purser admits that "there's still that element out there that go, 'catch me if you can.' It's like thumbing our nose."[55]

The appeal of tagging grows, then, as the city's clampdown increases the excitement and challenge which accompanies it. To the extent that tagging develops out of anger and resentment—Eye Six, it will be remembered, returns to tagging when he is "drunk and pissed off" (in Ferrell, 1990a: 10)—the city's shrill campaign further motivates writers to tag, as its legal and ideological attacks continue to "piss them off." Moreover, Denver writers emphasize that, as the clampdown has made hours-long mural painting more and more risky, some writers have reduced their mural work and turned their energies, and resentments, to tagging. Eye Six notes that throw-ups "caught on after they cracked down on murals—I mean, there hadn't ever been throw-ups," and points out the ironic connection between tagging and the anti-graffiti campaign:

> The reason there was a crackdown was because of tagging. . . .
> That was the main reason that the city cracked down. O.K., so
> they crack down, and they make it hard for you to spend two
> hours, three hours. A good piece, like a mural, takes hours to
> do—which, you're not going to stay. The only thing you can do
> right now and get away with it is tagging, which is what they're
> trying to stop.

In this way, the anti-graffiti campaign has caused an increase not
only in graffiti writing generally, but in the very sort of graffiti most
offensive to the campaigners themselves.

Indeed, a tour of central Denver seven years after Mayor Peña's
first attacks on local graffiti, and three years after the inauguration
of the hard line anti-graffiti campaign, reveals that graffiti writing
has if anything increased. But the campaign, of course, has not only
contributed to the writing of graffiti; it has also fostered vigilante
attacks, art gallery seizures, and a remarkable degree of ill will and
misunderstanding on all sides. And while the anti-graffiti campaign
has certainly promoted the political and economic careers of the
moral entrepreneurs behind it, it has at the same time accelerated
graffiti writers' artistic and criminal careers, propelling them into
oddly overlapping cycles of notoriety and fame, stigmatization and
punishment. Born of political opportunism and economic self-
interest, the Denver anti-graffiti campaign survives as a sort of
criminal circus, an ill-tempered diversion from the serious problems
pressing down on the city. But even when Denver's moral
entrepreneurs abandon the anti-graffiti campaign for their next
moral crusade, its residues will remain, in back alleys and
downtown railyards, in corporate boardrooms and city courtrooms,
and in twisted fabrications of image and ideology.[56]

NOTES

1. In another act of public service, three local writers painted an anti-
drug mural over gang graffiti—a mural which elicited "praise from people
driving by" (Soergel, 1989: 12).

2. As of 1987, DeDe LaRue was also still able to paint her flamingos and other animals on dumpsters "in broad daylight"; moreover, "once, she stepped back to admire a finished piece and was startled by a sudden noise. A crowd had gathered behind her and was applauding." At this same time, the DNA crew painted a mural in tribute to two police officers killed on duty. Officer Pete Ricker commented, "I think it's neat. What they've done is tasteful. If they just keep it underground, everybody'll be happy" (in Misch, 1987: 1, 35–36).

3. For the article to which Rasta refers, see Digby, 1988: 1.

4. Jayzer and a "companion" were arrested in the summer of 1987 while working on a mural in honor of the companion's deceased father (see Misch, 1987). Later arrests are noted in, for example, the *Rocky Mountain News*, March 14, 1989: 26; Gottlieb, 1989: 10B; Gottlieb, 1989a: 10B; and Kreck, 1989: 1C. For more on Rasta's arrest and sentencing, see Chotzinoff, 1988b: 10.

5. The "bomb shelter" was also lost to local writers at about this same time. As Voodoo recalls, upon his return to Denver,

I walked out in the railyards and I was tripping, but I was like, man, this doesn't even look like the same railyards. . . . I didn't see the bomb shelter or anything. I was like, man, everything's gone!

See the previous two chapters on these and other socially significant locations, and on subsequent "walls of fame."

6. Thus, as in other areas of social life, the apparently psychological responses of individuals like Fie and Rasta in fact turn out to be culturally/subculturally specific responses to identifiable social forces.

7. *Westword* (June 29, 1988: 17) reproduced the poem, and voted this piece the "Best Graffiti" in Denver. A 1984 *Rocky Mountain News* article (February 22, 1984: 8) noted that Mayor Peña thought the graffiti problem "particularly bad along the Cherry Creek bike path," which Peña utilizes "for his daily six-mile run."

8. A measure of the anti-graffiti campaign's effectivess is the fact that, three years later, Fie's "END" piece still looked out over the railyards.

9. At the Metro Wide Graffiti Summit two years later, Ed Thomas likwise claimed

A lot of these people have been identified as far as being graffiti kind of vandals. I mean, they knew their handle that they used when they did the painting. They also knew who these people were.

10. See Public Service *Update*, July 1988; Clean Denver pamphlet, 1988a; and *Up the Creek*, August 5, 1988: 4–5 on the "Off the Wall" campaign. The "artway" will be discussed subsequently.

11. See issues of *Life on Capitol Hill*, circa March/April 1989, for examples of the "Adopt-A-Spot" promotion.

12. See Asakawa, 1989: 8; Ross, 1989: 5.

13. The quotations from Cathy Donahue, Don Turner and Barton Wong are all taken from the Metro Wide Graffiti Summit.

14. See for example Kreck, 1989: 1C; Filley, 1989a: 3. And as Bal Chavez of Public Service said at the Metro Wide Graffiti Summit: "We had pulled our anti-graffiti program right directly into our maintenance program, and not viewed [it] as a separate cost center."

15. See Kelly, 1990: 6; *Life on Capitol Hill*, August 18, 1989: 2; September 7, 1990: 10; Metro Wide Graffiti Summit transcript.

16. See also Gottlieb, 1990: 6B.

17. See *Life on Capitol Hill*, November 2, 1990: 5; and Iler, 1990: 8–9, on CHUN's economic and political orientations. A neighborhood business association, Colfax on the Hill, is also involved in the clampdown. As Colfax on the Hill's Executive Director wrote in *Life on Capitol Hill* (Amble, 1989: 1): "Graffiti remains a problem for [sic] not only on Colfax and its neighboring businesses, but also for greater Capitol Hill. More aggressive owner paint-out action, tagger arrests and punishment are needed to control this pervasive, offensive and costly problem." *Life on Capitol Hill's* involvement with the clampdown will be explored further in subsequent sections of this chapter.

18. CHUN presented Linker a "Good Neighbor" award in January, 1991, for his "efforts to clean-up the graffiti in Capitol Hill and throughout the city of Denver. Tom has been an inspiration to the Keep Denver Beautiful Committee" (*Life on Capitol Hill*, January 4, 1991: 2). An award was also presented to Alice Marsh and Marsh and Associates, in part for their support of anti-graffiti efforts.

19. *Life on Capitol Hill* (see January 18, 1991: 8) bestowed on Thomas its "Man of the Year" award for 1991.

20. See also Cohen and Young, 1981; Comack, 1990. Anti-graffiti campaigns in Denver and elsewhere can perhaps be understood not only as the products of moral enterprise, designed to criminalize and suppress graffiti writing, but also as organized attempts to construct graffiti writing as a social problem. For more on this "constructionist" perspective on social problems and the mass media, see for example Spector and Kitsuse, 1987; Gamson, 1988; Best, 1989; Goode, 1989; and Rafter, 1990.

21. On the 1991 attempt to prohibit the sale of spray paint and wide markers to minors, see Carnahan, 1991: 6; Shiflett, 1991: 71; *Rocky Mountain News*, April 17, 1991: 16. New York City authorities and others have also attempted to regulate or criminalize the sale of spray paint; these efforts have also been abandoned due to the concerns of local business interests—see Castleman, 1982: 135–174.

22. See Section 10, 18–4–509, Defacing property (2):

Any person who defaces or causes, aids in, or permits the defacing of public or private property without the consent of the owner by painting, drawing, or writing, by use of paint, spray paint, ink, or by any other method of defacement commits a class 2 misdemeanor. A second or subsequent conviction under this subsection (2) shall carry a one-year jail sentence (*Session Laws,* 1989).

See also Gottlieb, 1989b: 6B; Ross, 1989: 5; Roberts, 1989: 1; Roberts, 1989a: 5B; Cooper, 1989: 5B; Cooper, 1989a: 3B; Wong, Metro Wide Graffiti Summit transcript.

23. See Zoning Administrator Dorothy Nepa's comments at the Metro Wide Graffiti Summit. Zoning ordinances have been utilized similarly in Aurora, one of Denver's largest suburbs; see Barton Wong's comments at the Metro Wide Graffiti Summit.

24. See for example Digby, 1988: 1; Gottlieb, 1989: 10B.

25. See Briggs, 1989: 2B; see also Assistant City Attorney Jim Thomas' comments at the Metro Wide Graffiti Summit.

26. Val Purser admits that, though the program is presented as one for "convicted graffiti vandals," it in fact largely utilizes convicted gang members, and even adults serving drunk driving (DUI) convictions. As she says:

You can't take a writer if you catch them and a gang member and put them together and expect to change their behavioral attitudes. So I got very frustrated with it, because [Rasta] had to go out under our Juvenile Offenders Program, the only program that we had that was organized, that would oversee them cleaning up the graffiti. And he wanted to go out and paint over, which I thought would be alright, but then who was going to take the responsibility to go out and see, yes, he did it and it took him five hours? You see, so it's Catch–22, and it's not a successful campaign. And it's not. Right now, they're now using, like guys from DUI, in the adults, and then now they're using the juveniles one day a week and the program is just basically, the operation side of it that I used to oversee, we broke out. . . . And while they may have done graffiti, it's gang. It's all gang. It's all gang—sure it is. It's all gang.

Though misleading, the inclusion of adults convicted of drunken driving in this public punishment program for graffiti writers is perhaps not surprising, since the program itself recalls the sorts of public humiliations at times enforced on those convicted of drunken driving and similar offenses elsewhere.

Denver's Urban Conservation Corps—a "gut-testing, work-study program for underskilled people ages 18 to 23"—also works on "vital public service projects" like removing graffiti; see Charland, 1990: 100.

27. Joe Kennedy thus describes the clean-up program as both "real repressive" and "real stupid."

28. At the Metro Wide Graffiti Summit, Barton Wong outlined a similar orchestration procedure in neighboring Aurora. There, a meeting like the one in Denver included representatives of various city departments, Public Service Company, public transportation agencies, and the Aurora Public Schools. Wong also reported that the city hopes to include local newspapers, the postal service, and the Colorado Department of Highways in its anti-graffiti campaign. An Aurora newspaper also reported an anti-graffiti meeting between "city department representatives" and officials from Public Service Company, US West, Bench Ad Advertising, and the Aurora Public Schools; see *Community Accent*, October 1990: 25.

29. The *Denver Post* (Gottlieb, 1989: 10B) also reported that the campaign "hopes to accomplish" its sentencing objectives by "flagging graffiti cases so judges know how to sentence the perpetrators."

30. New York City authorities have likewise created a special Car Appearance and Security Taskforce, increased "surveillance by a force of roving Property Protection agents," and set up a Transit Adjudication Bureau, which "permits more effective enforcement and collection of fines than was possible through the overburdened criminal courts" (Vuchic and Bata, 1989: 40).

31. See Kreck, 1989: 1C; Gottlieb, 1989: 10B; *Rocky Mountain News*, March 14, 1989: 26.

32. See also Bowers, 1988: 30.

33. As publicized during 1989, Graffiti Stoppers offered a $1,000 reward; Manny Alvarez of the Crime Stoppers Program reported a $2,000 reward at the Metro Wide Graffiti Summit. See also *Rocky Mountain News*, March 22, 1989: 23; *Life on Capitol Hill*, April 7, 1989: 1; comments of Hank Gonzales, Community Affairs Division, Denver Police Department, at the Metro Wide Graffiti Summit.

34. See Chotzinoff, 1989, for the article on which the teenagers were working when they were "apprehended."

35. See Asakawa, 1989: 8; Kreck, 1989: 1C; Filley, 1989a: 3; *Community Accent*, October 1990: 25.

36. See *Life on Capitol Hill*, March 3, 1989: 4; April 7, 1989: 1; Filley, 1989: 7.

37. See Ed Thomas' comments, Metro Wide Graffiti Summit. Anti-graffiti campaigns elsewhere emphasize surveillance through video cameras and other devices as part of this environmental control. One report notes that "good lighting, along with surveillance cameras and motion, fire and smoke detectors, has effectively deterred vandals and kept the [New York Public] library virtually graffiti-free" (Rus, 1989: 269). In addition to this sort of surveillance in refurbished subway stations, New York City authorities have utilized guard dogs, attack dogs, and fences topped with razor wire in an attempt to keep writers out of the yards. They also employ a fleet of vans equipped with high-pressure graffiti-removal jets, and rely on "the buff"—the street name given to a now legendary device for chemically dissolving paint from the sides of trains. In Denver, "buff" has become a subcultural term for any type of graffiti removal, as in, "Shit, that piece must've been buffed." See Vuchic and Bata, 1989: 40–41;

Castleman, 1982: 146–150; Cooper and Chalfant, 1984: 100–101; Hager, 1984: 60–62.

38. On the anti-graffiti poster, see *Life on Capitol Hill,* August 18, 1989: 2; September 7, 1990: 10; *Rocky Mountain News,* December 8, 1991: 2C. New York City programs in this vein include a schoolchildren's contest on "Why I Don't Like Graffiti," high school "Graffiti Busters," anti-graffiti advertisements in various media, and other community outreach and educational efforts. See Vuchic and Bata, 1989: 40; Castleman, 1982: 147.

39. See Ruth Rodriguez's comments at the Metro Wide Graffiti Summit. These programs of psychological evaluation and therapy for graffiti writers tap into the notion of crime and deviance as "sickness"—a notion commonly used to delegitimize deviant activity and trivialize the claims of its perpetrators.

40. In San Francisco, the McKesson Corporation sponsors the Spray Can Art Project, in which "former graffiti vandals" are hired to "decorate" construction sites (*Urban Land,* 1988: 27). Similar programs are under way, with the support of local companies and local radio stations, in San Francisco; Camden, New Jersey; and elsewhere.

41. See Joe Kennedy interview; Chotzinoff, 1988a: 8.

42. See Chotzinoff, 1988a: 8.

43. See Joe Kennedy interview; Chotzinoff, 1988a: 8.

44. See also Cohen and Young's (1981) excellent collection of studies on "social problems, deviance and the mass media"; Fishman, 1978; Bromley, Shupe, and Ventimiglia, 1979; Humphries, 1981; Box, 1983; Pepinsky and Jesilow, 1984; Reinarman and Levine, 1989; Goode, 1989; Ben-Yehuda, 1990; Comack, 1990. "Fried-egg brains" refers, of course, to a particular anti-drug television spot aired endlessly throughout the late 1980s and early 1990s: "This is your brain" (egg); "This is your brain on drugs" (egg frying in pan).

45. Similarly, a New York City official claims that "the public is frightened and disgusted by graffiti and they want us to do something about it" (in Castleman, 1982: 147).

46. Elsewhere, anti-graffiti campaigners present the graffiti menace as a growing threat not only to neighborhoods and cities, but even public

safety. An article coauthored by the Manager of Rapid Transit Support Planning for the New York City Transit Authority claims that "by covering maps, public information notices, and even lights, serious functional damage [is] inflicted" by graffiti, and adds that graffiti "can block progress on modernization" (Vuchic and Bata, 1989: 40, 41).

47. An interior designer concerned with graffiti elsewhere proposes that graffiti writing originates in "poor self image, the need to establish a personal identity, rebellion against authority, [and] hatred of parents" (Rus, 1989: 268). The mayor of New York develops a similarly psycho-pathological "theory" that "graffiti writing 'is related to mental problems'" (Castleman, 1982: 137). For these sorts of psychological explanations of graffiti writing within academic discourse, see Abel and Buckley, 1977; Feiner and Klein, 1982.

48. For similar reports on this group's campaign, see *Life on Capitol Hill*, March 1, 1991: 1; March 15, 1991: 4.

49. At the Metro Wide Graffit Summit, Purser also linked graffiti fear to the Adopt-A-Spot program:

Well, the idea is to adopt a spot. You walk into Taco Bell and say, gee, Mr. Manager, would you want to adopt this piece of public property? It's certainly going to make your business look a lot friendlier and safer to come into. It kind of gives you a feeling of being unsafe.

50. See Durkheim, 1951. At times, anti-graffiti campaigners make these middle-class values explicit. The *Rocky Mountain News* (June 20, 1990: 46) concluded an editorial condemning graffiti and my public defense of it with the following:

Look: If it isn't yours, don't draw on it. We realize this slogan sounds hopelessly middle class, but that's tough. Middle class people and their values just happen to be the mortar that holds this city, and every other, together.

And as Hall et al. (1978: vii-viii) note in regard to the moral panic around "mugging" in Great Britain: "The society comes to perceive crime in general, and 'mugging' in particular, as an index of the disintegration of the social order, as a sign that the 'British way of life' is coming apart at the seams." Hall et al. go on, of course, to note that as part of this process, socially constructed anxieties about youth, race, and crime coalesce around mugging—much as they do around graffiti writing.

51. Writing for an international audience of railway officials and workers, Vuchic and Bata (1989: 39–40) in the same way label graffiti "anarchy, not art" and note the "daring schemes of destruction" through which it comes about. Writing for a broader national audience in *Forbes*, Akst (1990: 334) refers to graffiti as "that symbol of subway anarchy."

52. The State of Colorado legal statute noted earlier—under which graffiti writers can be sentenced to a year in jail—is entitled "An Act Concerning the War on Gangs and Gang-Related Crimes" (*Session Laws*, 1989).

53. In late 1990, Valerie Purser noted that "the city is putting $350,000 behind eradicating graffiti off of public and private property." Gottlieb (1989: 1B) reports that graffiti "costs the city, businesses, and residents an estimated $1 million a year in clean-up costs."

54. Joe Kennedy adds,

Quite a few commissions came out of the [Progreso] show. Actually, people were having people come over and spray their nursery. One gallery owner had somebody come over and spray their child's nursery room. Which is kind of surprising, but quite a few people had large walls done.

55. A well known New York City graffiti writer has noted similar unintended consequences of fencing train yards: "All the fences will do is keep most of us out of the yards. We'll still be able to hit the trains in the lay-ups, and we'll bomb the insides and the outsides of in-service trains with tags—big spray-paint tags like nobody's ever seen" (in Castleman, 1982: 147). Thus, in New York City, Denver, and elsewhere, the clampdown on graffiti writing helps move the graffiti underground from subculture to counterculture.

56. For more on the amplification of deviance and criminality, see for example Cohen, 1972/1980; Marx, 1981; and Young's (1981) classic study, "Drugs and the Amplification of Deviance." Clarke (1976) also discusses the ironies of amplification in regard to British football "hooliganism," skinheads, and youth cultures generally.

Crimes of Style

Denver graffiti exists as an artifact of two collective enterprises. Working within an evolving subculture, Denver writers draw on shared resources of imagery and style in producing moments of illicit creativity, and the tags, throw-ups, and murals which are their result. At the same time, Denver's moral entrepreneurs work to construct this graffiti writing as crime, and to engineer the sort of moral panic which will sustain their undertaking. In this sense, local politicians, judges, and media workers engage in the social construction of graffiti as surely as do the writers themselves. Together, they define the public meaning of graffiti writing in Denver.

Though they originate in vast inequalities of status and power, these two collective enterprises—writers' production of graffiti, and moral entrepreneurs' criminalization of it—intertwine. The previous chapter has revealed one sort of interplay: in criminalizing graffiti, moral entrepreneurs alter the subcultural dynamics within which writers work, and in a variety of ways amplify the very activity they wish to suppress. As participants in an ongoing process, graffiti writers and moral entrepreneurs thus react to each others' reactions, and become partners in a strange dance of criminality and enforcement.

These two enterprises are linked in other ways as well. To begin with, graffiti writing and the official response to it provide parallel avenues into the aesthetics of crime and criminality. As already seen, graffiti writing incorporates aesthetic orientations developed from popular culture materials, art world connections, and the

collective activity of the writers. As will be seen, though, the campaign against graffiti also originates in aesthetic concerns linked to the social affiliations of its managers. Both enterprises, then, provide perspectives on the style and meaning of crime for those involved with it. And together, they not only reveal an interplay of criminality and enforcement, but present a crime constructed out of the clash of alternative aesthetics. Constructed in this way, graffiti writing stands doubly as a "crime of style"; for back alley writers and white-collar anti-graffiti campaigners alike, style matters.

Graffiti writing and the campaign against it also incorporate issues of authority and power, subordination and insubordination, and therefore together suggest a sort of analytic approach which might be labeled "anarchist criminology." The relationship between graffiti writing and this anarchist criminology is less one of subject matter and theoretical model than of cross-fertilization between two bodies of knowledge. Certainly anarchist criminology helps explain graffiti; of the possible criminologies, one which draws on the insights of anarchist thought seems best to account for the intensity of both graffiti writing and official reactions to it. But graffiti in turn helps elaborate anarchist criminology, serving as a revealing case study in the very sorts of issues most central to anarchist thinking and practice, and therefore offering possibilities for the further development of an anarchist approach to crime.

As a concept more often misused than used, "anarchism" calls for a bit of explanation. Anarchism can be defined by its opposition to—or perhaps more accurately, defiance of—authority. In contrast to other progressive orientations (feminism, Marxism), anarchist thought opposes not a particular configuration of power and authority, but all hierarchical systems of domination. Anarchists thus stand in opposition to the exploitative dynamics of capitalism, but also against the repressive operations of the modern nation state; in defiance of the moral mandates of the organized church, and also the particular privileges of patriarchy. And, to the extent that such systems of domination interlock, and in concert concentrate power and privilege in an ever smaller set of people and

institutions, opposition to one inevitably demands opposition to all.[1]

This authority resides in structures of knowledge, perception, and understanding. Systems of authority operate not only through prison cells and poverty, but by constructing and defending epistemologies of universality and "truth." Capitalism and the state, the church and the school, all claim definitive understanding of the world; strive to define for their subordinates the boundaries of perception and appreciation; and in this way share in the spoils of epistemic authority. Anarchism attacks these hierarchies of credibility (Becker, 1967), and seeks to dismantle the mythologies of certainty and truth on which they are built. It undercuts the taken-for-grantedness of the world, the reality which systems of authoritarian knowledge construct.[2]

In dislodging the single-mindedness of authoritative truth, anarchism constructs a new sort of epistemic and aesthetic pluralism. Within this pluralism, the imposition of truth and certainty gives way to an acceptance of multiple stories about the world. Validity as a single criterion for judging these stories gives way to criteria of persuasion, fascination, inspiration, and utility. And truth as progress—as an endpoint toward which knowledge is aimed—gives way to the notion of knowledge as a fragmentary and point-less process. Aesthetically, the hegemony of Style—style as a prefabricated commodity, as a consistent and proper set of social rules—is replaced by a playfulness, a pleasure in constructing multiple styles from a hodgepodge of cultural resources.

Accompanying this fragmented and decentered pluralism is a broader epistemic orientation. This orientation not only allows room for multiple interpretations and styles, but finds cause for celebration in the multiplicity. It stands notions of "confusion" and "disarray" on their heads, transforming them from complaints about disorder into descriptions of plurality. Above all, it replaces the search for authoritative universality and order with a yearning for particularity and disorder. This orientation is *ambiguity*. Ambiguity is the stance, the subtext, of anarchism; it is the context in which anarchism can be carried out. Ambiguities of knowledge

and style, of sexuality and status—all are characteristic of a plural and eclectic world. Where multiple styles replace Style, and multiple meanings replace Meaning, ambiguity ensues—an ambiguity which acknowledges cultural pluralism, and the triumph of confusion over consistency.[3]

Ambiguity constitutes in this sense the epistemic atmosphere of pluralism and anarchy. It provides a useful and humane orientation for negotiating the flux and flurry of a post-authoritarian, multicultural world no longer defined by dominance and subordination. Under such conditions, anomie—the normative disorder of Durkheim's nightmares, and moral entrepreneurs' panic—now takes on positive connotations. The breakdown of order and control, the dislodging of authority, allows for the sweet cacophony of alternative discourses. And indeed, the individual manifestations of anomic social conditions—feelings of free-floating association, rootlessness, and confusion—become less nightmarish phantoms than pleasurable points along a perceptually open road.[4]

The social arrangements of anarchism follow from this dismantling of authority and its epistemic structures. Anarchism supposes a delicate, negotiated balance of collectivity and diversity, a tolerant community of autonomous persons and groups. In place of centralized power and authority, anarchism seeks to decentralize decisions and responsibilities, to disperse control as widely as possible among a plurality of groups. Rather than relying on authority mandated from above, and encrusting collective decisions in immutable rules and regulations, anarchists attempt to solve problems through an ongoing process of collective negotiation. As Kropotkin (1975: 108) wrote in 1910,

> Anarchism . . . is the name given to a principle or theory of life and conduct under which society is conceived without government—harmony in such a society being obtained, not by submission to law, or by obedience to any authority, but by free agreements concluded between the various groups. . . .

And as Tifft (1979: 397) argues,

> interpersonal disputes . . . must be faced directly and collectively
> by restoring these "problems" of human bonding and survival to
> a direct face to face level. This means that instead of denying or
> passing off responsibility to committee or bureaucracy, each and
> all must share responsibility. This means that community will
> have to be restored. . . .

Anarchism thus operates less as a concrete ideology than an inherently social, and communal, process.[5]

If anarchy is a social process, it is a direct, spontaneous, and funny one, as well. Anarchists forego the appropriation of action and authority into "representative" systems—such as the system of bourgeois representational politics—in favor of "direct action" in the situations of daily life.[6] Goldman (1969: 66) thus argued that

> Direct action against the authority in the shop, direct action
> against the authority of the law, direct action against the invasive,
> meddlesome authority of our moral code, is the logical,
> consistent method of Anarchism.

The Industrial Workers of the World (the Wobblies)—perhaps the most effective practitioners of direct action, anarchism, and anarcho-syndicalism in U.S. history—likewise emphasized that "always and everywhere we wanted direct action, by which we meant action at the point of production, in the factories, fields, and mines, by 'a union of, by and for the workers'" (Hall, no date: 231), and added:

> The principal reason that some would-be leaders are yelling
> against "direct action" is that it contains no provisions for the
> service of ex-preachers, shyster lawyers, and real estate sharks
> (*Industrial Worker*, July 11, 1912: 2).

Around the same time, the Russian anarchists urged, "Obey no one. Humble yourselves before no one. Create your own freedom, your own happiness. Create Anarchy!" (in Avrich, 1973: 48). And

recently, punks in the U.S. and Great Britain have resurrected this sense of direct anarchy with their notion of "D.I.Y."—that is, a "do it yourself" approach to musical and cultural production.[7]

This process of direct action—and in fact the larger practice of anarchism—must of course itself somehow avoid becoming a reified, formulaic solution to the problems of social life. Anarchists attempt to avoid this irony—a rigid adherence to the "rules" of anarchism—in two ways. First, they work to integrate thought and action in an ongoing process which evolves interactively between the two. In such a process, neither thought nor action stands prior to the other, or in a position of primary concern; instead, each defines and informs the other. This sort of integrated process, of course, recalls the Marxian notion of *praxis*, the dialectic between analysis and action, ideology and activity. It also demands a good dose of spontaneity and improvisation. When courses of action develop from the contingencies of the moment, from the insights of activity as much as from planned priorities, those involved are compelled to let go of the reins, to ride out the emerging dynamic which they only partially control.

Anarchists find a second corrective to rigidity and encrustation in humor. As Holy Goofs, Tricksters, Mudmen, and others have taught us, humor serves a double purpose in this regard. It protects against taking the social processes in which we are engaged too seriously, against mistaking human constructions for immutable forces deserving of fear and reverence. At the same time, and for the same reasons, humor undercuts the aura of authority which politicians and patriarchs so carefully manufacture; it yanks the loose thread, and unravels judicial gowns, ecclesiastic robes, and even the occasional tweed sportscoat. Given this, it is hardly surprising that the Wobblies as often attacked the authorities with jokes and puns as with fists and guns; that Emma Goldman declined to participate in any revolution in which she could not dance; or that Russian anarcho-futurists began a 1919 manifesto, "Ah-ah-ah, ha-ha, ho-ho! Fly into the streets. All who are still fresh and young and not de-humanized—to the streets! The pot-bellied

mortar of laughter stands in a square drunk with joy" (Avrich, 1973: 52).[8]

In the same way that anarchism moves beyond "truth" to an ongoing process of inquiry, then, it disavows "correct" social models and methodologies in favor of an emergent process of challenge and change. As they move within this process, anarchists encounter a final irony: they must be willing to undermine even "anarchism," to the extent that it becomes a formally defined, respectable alternative to existing arrangements. If it is to remain vital, anarchism must attack its own authority as "ruthlessly" (Marx, 1972: 8) as it attacks that of others; it must remain in a "permanent state of revolt" (Guerin, 1970: 14). As the Wobblies argued,

> The moment a movement becomes respectable in the eyes of those who are not wage workers, that moment it loses its revolutionary character. It dies. . . . We are not "undesirable citizens." We are not citizens at all. We are rebellious slaves, scorning the morals, ethics and institutions of the Plunderbund. Therefore we are not respectable. We admit it and we are proud of it (*Industrial Worker*, October 24, 1912: 2).

Anarchism stands or falls as a disrespectful process; and, to paraphrase Trotsky, Marx and Engels, and Kropotkin, the process must be permanent.[9]

With an eye toward the sorts of issues embedded in anarchist theory and practice, and toward the aesthetics of crime and criminalization, we can now return to graffiti writing and the campaign against it. As we will see, notions of anarchy and aesthetics help uncover the meaning of both enterprises, and begin to explain the conflict between graffiti writers and moral entrepreneurs. This conflict in turn offers insights into anarchist criminology, and points to a variety of related social and cultural issues.

Crimes of Style: Graffiti Writing

Shoplifters of the world, unite and take over.

<div style="text-align: right">The Smiths (1987)</div>

Earlier chapters have explored with some care the subcultural organization of graffiti writing—as manifest in crews, tags, and walls of fame—and the social dynamics of activities like tagging, piecing, going over, and dissin'. Often, these subcultural activities have been examined in fine detail, with accounts of subtle variations in tag names, or the particularities of spray paint. This ethnography of graffiti writing was in turn based on Becker's (1963) and Polsky's (1969) general contention that an understanding of behavior labeled as deviant or criminal must evolve from a close examination of its actual practice. But is it really necessary to know what brand of spray paint graffiti writers prefer, or how they negotiate the design of an illegal piece? Beyond some sort of voyeuristic pleasure, why do such details matter?

To begin with, these details matter because they constitute the experiential setting of deviance and criminality, the immediate, interactional dynamic through which criminals construct crime. Taken as a whole, such details begin to get at the daily experience of crime, at the rhythmic nuances of criminal acts and interactions. If we set out to study crime as a social event, rather than a derivative analytic category; to pay attention to crime as a lived, socially constructed experience, rather than a statistical residue, its subtleties must be taken into account. As a statistical aggregate, or as the product of background variables, crime carries the clean lines of abstraction; as a social event, it takes on the textures and nuances of human interaction.

It is out of this "interactionist" view of deviance and crime, of course, that Becker and Polsky originally made their injunctions, and within this view that "intensive field observation" (Becker, 1963: 193) of crime's social details matters.[10] Recent developments in criminology have taken this sense of crime as interaction a further step, and reemphasized the importance of situational detail. Katz (1988: 312, 317) argues that only through awareness and

analysis of the phenomenological foreground of criminality, of the intricacies of its "lived sensuality," can we understand the "moral and sensual attractions in doing evil," and thus the nature of criminality itself. Because of this, he pays close attention to the badass' "bump" and "whatchulookinat?" ploys, the homeboy's ritually white undershirt, and other phenomena which allow him "to follow in detail the lived contours of crime." Katz thus blends the phenomenologist's precise attention to situational detail with the interactionist's concern for the situation's social negotiation and construction. In so doing, he demonstrates that the meaning of crime develops not only out of long-term interactions and criminal "careers," but out of the precise details of particular criminal events.

The details of the Denver graffiti scene show that writers construct graffiti and its meaning out of this blend of subcultural history and situational immediacy. A night's tagging certainly evolves out of prior tagging experiences, networks of friendship among the writers, and technical and aesthetic expertise developed over the course of writers' careers; but it also takes shape and meaning within the immediate contingencies of boredom, missed phone calls or bus connections, passing cars and pedestrians, and well or poorly-lit alleys. Piecing likewise incorporates shared aesthetic resources, and a certain degree of planning; but particular incidents of piecing also evolve from immediate issues of inter-personal conflict or cooperation, outsider interruptions, dwindling paint or beer supplies, and even changes in the weather. They thus become meaningful for the writers not as moments of generic graffiti writing, but in the immediacy of distinctly shared experience. As with other criminal acts, the meaning of graffiti writing is embedded in the details of its execution.

The social and situational details of graffiti writing matter for a second reason, as well. As previous chapters have shown, this experiential foreground incorporates also the practical aesthetics of graffiti writing. The organization of graffiti writing around the aesthetic concerns of the writers, around matters of style, is no abstract, formal exercise. Instead, it is a collective enterprise negotiated in the emergence of tags and subcultural identities, in

informal sanctions against "trash paint" and "biting," in collaborative piecebook designs and "art sessions," and in the interplay of status and style manifested in "going over" and "dissin'." This essential characteristic of graffiti writing—that it is a "crime of style"—cannot be understood without paying close attention to its particulars, to the actual practice of "doing graffiti." As Becker (1963: 190) argues,

> we often turn collective activity—people doing things together—into abstract nouns whose connection to people doing things together is tenuous. We then typically lose interest in the more mundane things people are actually doing. We ignore what we see because it is not abstract, and chase after the invisible "forces" and "conditions" we have learned to think sociology is all about.

Graffiti writing is not an abstraction driven by the concept of Style, or the force of Aesthetics; it is collective activity constructed out of the practical aesthetics of its writers.[11]

A close examination of graffiti writing, then, reveals it to be a crime of style, grounded in the shared aesthetic resources of the writers. What, though, of other deviant or criminal acts? Would similar attention to detail expose aesthetic or stylistic elements in other less overtly "arty" forms of criminality? Research in a variety of areas shows that it would. Working within the traditions of British cultural studies and the "new criminology," Hall and Jefferson (1976), Hebdige (1979), Cosgrove (1984) and others have demonstrated that nuances of style and meaning lie at the very heart of individual and collective crime and deviance, and have sketched an aesthetics of deviance and criminality from the experiences of zoot suiters, skinheads, rude boys, and drug users. Drawing on these and a plethora of other sources, Katz (1988) has located this aesthetics of crime firmly in the lived experience of criminal events.

Katz, for example, examines the "ways of the badass"—that is, the ways in which young men construct tough, alien identities. Focusing on the interplay of social status, personal identity and style, and the symbolism of the badass, Katz (1988: 88, 90)

considers dark sunglasses, guttural noises, the "ghetto bop and the barrio stroll," tattoos, and other stylistic strategies which together form an "alternative deviant culture." He in turn examines specific manifestations: the "coherent deviant [a]esthetic" of the Mexican-American cholo and the British (and later U.S.) punk; the youth gang's ritualized affection for weapons; the "bump" and other stylized devices of aggression.

In this discussion—as in his discussions of "street elite" style, ritualized Black street talk, and symbolic violence—Katz, like the British new criminologists, grounds the meaning of deviance and criminality in the style of its practice. The black leather jacket and the zoot suit, the cholo's closing "Shaa-haa" and the young black's opening "shit" (see Katz, 1988: 83–87)—these are not mere "affectations" added to deviant projects and identities, but the building blocks of crime and deviance as they are lived and experienced. To speak, then, of the "culture of violence" or the "culture of crime" is to talk not only about background factors which perpetuate violence or crime, but about the style and symbolism—the aesthetic texture—of its foreground.

Katz's inquiry into urban adolescent "gangs"—"street elites"—locates this aesthetic of crime within patterns of social class, ethnicity, authority, and age. Katz (1988: 120, 151, 114, 145) demonstrates not only how these groups "style themselves as elites," follow "[a]esthetic leadership," and battle for "symbolic rewards," but how these styles of deviance and crime develop out of the lived experience of inner city adolescence. Thus, Katz argues, "homeboys" and other low income, minority street elites ritually celebrate their neighborhood ties, where middle income, white adolescents attempt symbolically to conceal or destroy their origins. And, when street elites encounter the "mundane authority" of the school, they can draw on the collective power of the group not only to opppose that authority, but to transcend it symbolically.

Here, as in Cosgrove's (1984) study of zoot suiters and "style warfare," and Hall and Jefferson's (1976) collected studies on "resistance through rituals," we begin to see a third sort of significance to the detailed, experiential foreground of crime and

deviance. The foreground is political; a dynamic of power and authority is embedded in the meaning and style of the criminal experience. The methods and epistemologies of positivist or "structural" criminologies—the dislocated number sets which cross-match crime's background factors in an attempt to measure criminality "objectively"—obscure, therefore, not only the interactional process through which crime is constructed, but its political content as well. To ignore the foreground of criminality in favor of an analysis of political or economic structures is, ironically, to miss the very meaning of these structures in the reality of crime.

If we understand political/economic domination and inequality to be causes, or at least primary contexts, of crime, we can also understand that these are mediated and expressed through the situational dynamics, the symbolism and style, of criminal events. To speak of a criminal "event," then, is to talk about the acts and actions of the criminal, the unfolding interactional dynamics of the crime (both between the "criminals," and among the criminals and victims), and the patterns of inequality and injustice embedded in the thoughts, words, and actions of those involved. In a criminal event, as in other moments of everyday life, structures of authority, social class and ethnicity intertwine with situational decisions, personal style, and symbolic references. Thus, while we cannot make sense of crime without analyzing structures of inequality, we cannot make sense of crime *only* by analyzing these structures, either. The meaning and aesthetics of criminal events interlock with the political economy of criminality.[12]

Youthful adventures in crime—vandalism, theft, and especially shoplifting—exemplify these interconnections. Certainly shoplifting has to do with the creation of needs, the structuring of consumption, and the commodification of desire under late capitalism. Yet these societal processes alone cannot explain the particular, situational dynamic of shoplifting. The event of shoplifting has a "magical" (Katz, 1988: 54) and seductive quality about it that develops independently of any overt need on the part of the shoplifter for the shoplifted items. For the shoplifter, the event unfolds as a sort of thrilling and sensually gratifying game, a

dramatic and illicit adventure. This magically seductive adventure is, of course, tangled up with the illicit acquisition of late capitalist consumer goods; but it is tangled in a particular way that can be neither known nor predicted from afar. Our understanding of both crime and capitalism is thus enriched by paying attention to the particular contours of shoplifting. Shoplifting explains capitalism in the same way that capitalism explains shoplifting.[13]

Graffiti writing likewise embodies the dialectic between structures and situations of crime. The writing of graffiti in Denver and elsewhere unfolds within systems of legal and economic domination, systems which guarantee unequal access to private property and cultural resources. As the previous chapter demonstrated, these systems are in turn utilized and managed by moral entrepreneurs who expand political/economic domination by further criminalizing graffiti writing. But while these factors set the context for graffiti writing, they do not define the writing itself. They alone cannot explain the subtle ways in which writers appropriate and subvert pop culture imagery, and draw on hip hop culture—itself an elegant and elaborate response to political/economic and ethnic domination. They cannot predict the "adrenalin rush" that graffiti's illegality generates for its writers, or the many ways in which criminalization in fact amplifies and reconstructs the writing of graffiti. These details of graffiti writing—these intersections of politics and interpersonal style, of criminalization and criminal event—can only be explained from inside the writing itself.

The political character of criminal events in turn forces us to question conventional distinctions between crime and resistance, to muddy the boundaries between unconscious response and conscious insubordination. As we coordinate the phenomenological stare with the critical gaze of anarchism (and other progressive social theories), we are compelled to re-examine the experience of crime as lived by its participants. And as we do, we may begin to see differently all sorts of sensually appealing, if politically "unsophisticated," criminal events: vandalism, shoplifting, graffiti writing, and the like. Until we understand the meaning of these

events for their perpetrators, we would be hard pressed to dismiss them as without political content, or the possibilities of resistance.[14]

Does this imply that every broken window, every leather-jacketed street fighter spitting teeth and blood, every scooped-out liquor store cash register—every Krylon-tagged alley wall—signifies an act of politically conscious resistance? Absolutely not, and maybe yes. Our answer depends, at least in part, on what we mean by "conscious." The logic of such criminal events is partly situational; understandings and meanings of the event blossom within its interactional boundaries. The question thus becomes, not "Is this crime or resistance," but "In what ways might the participants in this event be conscious of, and resistant to, the contradictions in which they are caught?" Whatever the answer, two things seem certain. The first is that we must take the time to pay attention to what people are actually doing when they are sticking up liquor stores, shoplifting shoes, or spraying graffiti. The second is that political-economic structures—and thus power, control, subordination, and insubordination—are embedded in these events as surely as in governmental scandals or labor strikes.[15]

When we look at graffiti writing in this way, we find its many nuances pointing toward an interesting conclusion: the politics of graffiti writing are those of anarchism. The adrenalin rush of graffiti writing—the moment of illicit pleasure that emerges from the intersection of creativity and illegality—signifies a resistance to authority, a resistance experienced as much in the pit of the stomach as in the head. Guerin (1970: 13) asserts that "anarchism can be described first and foremost as a visceral revolt," and graffiti writing certainly constitutes visceral resistance to the constraints of private property, law, and corporate art. Engaging in "direct action" against these authorities, graffiti writers together celebrate their insubordination in spray paint and marker, and in the pleasure and excitement of doing graffiti. And this forbidden pleasure in turn reveals as much about authority, and resistance to it, as the moments of intellectual clarity gained from a close reading of *The German Ideology* or *The Conquest of Bread.*[16]

That the pleasures of graffiti writing result not only from its illegality, but from the collective creativity of the writers, confirms its meaning as a form of anarchist resistance. Working together, graffiti writers construct an alternative, street-wise aesthetic that subverts the pre-packaged imagery of the culture industry and city hall. Playing with their own images and designs, appropriating and reconfiguring pop culture icons, they engage in a process of cultural resistance enlivened by beauty and style. If Goldman taught us that a revolution without dancing is not worth attending, graffiti writing confirms that resistance without creativity—resistance as a sort of analytic, intellectualized machinery of opposition—may not be worth the trouble. Without the spark of playful creativity, resistance becomes another drudgery, reproducing in its seriousness the structures of authority it seeks to undermine. The imaginative play of graffiti writing and other anarchist enterprises defines their existence outside the usual boundaries of intellectual and emotional control.[17]

As with more violent forms of anarchist resistance, graffiti writing is also notable for the sudden and mysterious manner in which it appears. If graffiti writing escapes the uninspired seriousness of conventional politics, it escapes the scheduled tyranny of deadlines and datebooks as well. This detail of graffiti writing—that writers do graffiti in the middle of the night, when and if they feel like it—carries two sorts of political meaning. It pulls the writers outside the world of daily work, insures that graffiti writing will not itself become a sort of routinized labor, and thus further locates graffiti writing outside conventional channels of authority and control.[18] This spontaneity also contributes to the threat which graffiti writing poses to those in authority. Denver City Council President Cathy Donahue complained to the Metro Wide Graffiti Summit:

> It is illegal to deface somebody's property, but the problem became that no one ever sees them. And people have tried to catch. . . . I've seen acres of graffiti and I have never, ever seen anybody put it on.

Her comments of course recall the lamentations of other authorities faced with episodes of "undisciplined" guerrilla warfare and popular insurgency, as well they might. As a form of aesthetic guerrilla warfare, graffiti writing resembles the resistance waged by Makhno and his anarchist fighters during and after the Russian revolution:

> When cornered, the Makhnovists would bury their weapons, make their way singly back to their villages, and take up work in the fields, awaiting the next signal to unearth a new cache of arms and spring up again in an unexpected quarter (Avrich, 1973: 23).

Any characterization of graffiti writing as "guerrilla warfare," though, must be balanced against another essential detail of its production: its vulnerability. As seen previously, anti-graffiti entrepreneurs take care to portray graffiti writers as forcing their tags and pieces on defenseless victims in a series of violent assaults. The lived experience of graffiti writing, though, shows this assertion to be false in two ways. First, graffiti writers paint not on people, but on property; if their painting embodies disrespect, it is not for individuals, but for the sanctity of private (and "public") walls and fences. Only in a social order that systematically confuses persons and property could moral entrepreneurs hope to confuse graffiti writing with assault. Second, when faced with graffiti on their property, the majority of home owners—and certainly large corporations and the city—have ample ability to erase the offending images and symbols. With access to financial and technological resources far greater than those of the writers, property owners can wipe out in minutes graffiti that may have taken hours to produce.[19]

Rather than forcing their art on helpless victims, then, graffiti writers in fact produce art in and of the urban community. This graffiti art is vulnerable to direct public response in ways that city-administered "public" art is not; and its images intrude on the public with far less impunity than those of the television commercial and the roadside billboard. In fact, unlike the administrators of commercial and "public" art, graffiti writers make no claims as to protecting, preserving, or profiting from their public

art. They own and control their throw-ups and pieces less than they simply expose them to public appreciation (or condemnation). As Eye Six says,

> In that respect, it's probably the dumbest crime you can get involved in. Not only are you in danger of getting thrown in jail and getting fined and such, you don't get any money out of it at all (in Ferrell, 1990a: 10).[20]

Because of this, conflicts over graffiti writing are susceptible to the sort of direct, street-level resolution essential to anarchist social relations. Conflicts among the writers themselves are played out in the dynamics of dissin' and going over. Property owners and the city can resort to the censorship of the sandblaster—with, of course, the possiblity that the writers will return to paint again the clean wall. And, as has happened in Denver, this interplay may eventually result in some agreement or compromise between writers and property owners. While these are not perfectly harmonious processes of community negotiation—partly because they originate in inequalities of privilege and power—they can at least keep the resolution of conflict in the hands of the participants, and outside the authoritarian entanglements of the law. Significantly, the vulnerability of graffiti writing to these direct processes is mirrored in other forms of street art and entertainment. Noting the "eccentric, anarchistic nature of the busker," Parks (1990: 8) argues,

> minstrel buskers remain public property. They are accountable daily to the people. They are naked, vulnerable, and open to judgement every time out. . . . This closeness to hand-to-mouth existence is what expunges the tyranny of the pop show and by example strengthens resistance to it.[21]

The contrast between graffiti art and the "art" of the corporation and the government, and the link between graffiti writing, busking, and other forms of anarchist entertainment, both point to a final dimension of graffiti writing as anarchist resistance.

Graffiti writing breaks the hegemonic hold of cor-
porate/governmental style over the urban environment and the
situations of daily life. As a form of aesthetic sabotage, it interrupts
the pleasant, efficient uniformity of "planned" urban space and
predictable urban living. For the writers, graffiti disrupts the lived
experience of mass culture, the passivity of mediated consumption.
As Eye Six says,

> Your average person is just subservient to whatever is thrown up.
> Whatever building is built, whatever billboard is put up—
> whatever. They just sit on their asses; they pretty much go with
> the flow like all sheep do. . . . At least we act on our feelings. We
> don't just sit around and doodle in our houses, we go out and get
> paint (in Ferrell, 1990a: 10).

For the commuter and the office worker, graffiti provides a series of
mysterious, ambiguous images—and some of the few available
public images not bought and paid for by corporate art programs,
city governments, or NEA grants. As will be seen shortly, graffiti
resists not only authority, but the aesthetics of authority as well.[22]
 Graffiti writing thus constitutes a sort of anarchist resistance to
cultural domination, a streetwise counterpoint to the increasing
authority of corporate advertisers and city governments over the
environments of daily life. Developed not out of particular
intellectual traditions or political programs, but from the direct,
collective action of young writers, graffiti writing tears at the
boundaries of mass culture. As they piece and tag together, graffiti
writers carve a bit of cultural space from the enforced monotony of
the urban environment.
 Like the more general understanding of graffiti writing, this
appreciation of graffiti writing as resistance rests on a sociological
perspective. Such a perspective highlights the collective
construction of graffiti writing's political effects, the interplay
between graffiti writers, home owners, commuters, and others
sharing the urban environment. It focuses less on the psycho-
pathological motivations of individual writers than on the shared
experience of graffiti writing, the situationally negotiated meaning

of adrenalin rushes, alternative aesthetics, and nighttime adventures. And, as above, it pays attention to the political dynamics of criminal events, even when such dynamics appear at first glance not to be known to or articulated by the individuals involved.

Moreover, what would it mean to talk about the political motivations of individual writers? Must an intellectually refined political sense be present (and spoken) to categorize a writer's graffiti as political, or simply an unwillingness to play by the rules, a sense of free floating outside the authority of conventional culture? Eye Six, for example, points out that he is "not into . . . political murals," and adds that "when I'm doing a mural, I try and keep my own personality out of it, in terms of politics." Indeed, his pieces seldom if ever include conventional political imagery. Yet, as just seen, he has a keen sense of cultural domination and subservience, and an appreciation of graffiti as direct action, as well: "When you're doing graffiti, you choose your own vision, you choose your own location, you don't ask anybody's permission, you don't expect any monetary reward, you go in the hole and do your deal" (in Ferrell, 1990a: 10). For Eye Six and other writers, politics may or may not have meaning at the level of mayoral elections or social "issues," as narrowly defined; but it certainly develops out of the praxis of lived experience and aesthetic orientation.[23]

Can we therefore conclude that graffiti writing constitutes an ideal act of anarchist resistance? Probably not, in that graffiti writing is beset by interpersonal conflicts, limited awareness of broader issues, a good bit of heavy drinking, and other "flaws." But if "flawed" means caught within a web of contradictions, and not fully realized, then all resistance is flawed, as is all praxis, and all anarchy. To dismiss graffiti writing—and similarly, hip hop music and culture—as "flawed" is not only to buy into elitist, intellectualized assumptions about culture and cultural change, but to throw away the lived experience of resistance. And if indeed graffiti writing is a flawed act of resistance, it is surely no more flawed than peace marches which file along permitted routes while singing the songs of million dollar rock idols, or political campaigns

which will, at best, elect "progressives" into a representational system of compromise and corruption.

Appreciating graffiti writing as a form of anarchist resistance, then, does not require romanticizing the process of doing graffiti, nor ignoring graffiti's social and cultural limitations. In fact, a sense of graffiti writing as resistance develops from quite the opposite direction: from closely examining the lived details of its production. And when we pay attention to the actualities of graffiti writing, we discover not only these political qualities, but a comparative perspective as well. In many ways, graffiti writing in the cities of the United States resembles that which develops out of Third World political struggles. Although certainly operating in different social and cultural environments, both constitute direct responses to the authoritarian domination of daily life. Both are inherently political acts, in terms of their own internal politics of resistance, and their politicization by those in power. And both engage power in the arena of style, and thus confront the aesthetics of authority.[24]

Crimes of Style: The Aesthetics of Authority

> No matter how good it looks, graffiti is ugly.
>
> Mayor Peña

As seen in the previous chapter, anti-graffiti campaigners build their ideological attacks around the alleged psychopathology of violent graffiti vandals, images of graffiti as a growing menace to the social order, and mythologies of public outrage. A careful reading of these campaigners' public statements, though, reveals a deeper framework for their concern: *the aesthetics of authority*. As local campaigners react to graffiti and characterize it for the public, they read meanings into it which reveal more about their economic and political interests, and the aesthetic orientations which accompany them, than about the nature of graffiti itself.

The *Denver Graffiti Removal Manual* (Clean Denver, 1988: 5), it will be remembered, worries over graffiti's violation of "well-groomed" communities. The *Denver Post* (Johnson, 1987: 7B;

April 13, 1988: 6C) editorializes that "graffiti mark a zone of apathy, anarchy and decay," and that graffiti "breeds an atmosphere of urban lawlessness." Don Turner of the Denver Partnership alleges at the Metro Wide Graffiti Summit that graffiti produces "a perception of . . . chaos in the streets." And Mayor Peña, in a video tape presented at the same conference, argues that "no matter how good it looks, graffiti is ugly."[25] In each of these and countless other instances, figures of authority—political leaders, property managers, newspaper editors—draw on a submerged aesthetic agenda to make claims about the offensiveness of graffiti's style. At the same time, they claim to understand *why* graffiti so offends—to understand what graffiti means, what bothersome messages and perceptions it transmits to those who encounter it. In this way, those in authority attempt not only to define graffiti as inherently "ugly," but to link this ugliness to "atmospheres" and "perceptions" of chaos and disorder that graffiti allegedly fosters in the general public. As an anarchist perspective would predict, they thus utilize their political and economic authority in an attempt to construct definitive aesthetic and epistemic interpretations of graffiti.

Despite their presentation as public perceptions, though, these claims about graffiti's style and meaning do not develop from the public's response to graffiti; when campaign leaders make such statements, they are not simply passing along widely shared understandings. Instead, like the larger campaign, these claims originate in the fears and perceptions of the authorities themselves. Assertions as to graffiti's "ugliness" vis-à-vis "well-groomed" communities, fears that graffiti somehow "breeds" lawlessness and decay, therefore expose an important dimension of authority. They reveal that graffiti threatens not only the economic value of private property, and the political control of property and space, but the sense of ordered style, the aesthetic of authority, that is intertwined with them. When those in authority assign epistemic and aesthetic traits to graffiti, they reveal in the process their own sense of beauty, meaning, and power.

Economic and political authorities, and some of the citizens who participate in the systems of consumption and control which

they operate, share a general sense of what a building, a neighborhood, a city should look like. They may not be able to articulate fully this sense; and even when they do, they will doubtless see it as nothing more than a "common sense" appreciation of clean, orderly, well-planned living environments. But it is much more. The appreciation of buildings stripped of unsanctioned notices and posters, of well-landscaped yards cleared of weeds and clutter, of streets swept free of litter (and "bums")—of cities free of graffiti—is in fact an aesthetic of authority. It embodies an affection for authority, a pleasure in the way property looks when it is under the firm control of its individual, corporate, and governmental owners.

To expose the logic of this authoritarian aesthetic—which, not surprisingly, is embedded so deeply in assumptions about everyday life as to often remain invisible—we can ask a seemingly simple question: Why is a wall on which a tag or piece has been painted "uglier" than a wall without these images?[26] Some would answer, "Because that's *my* wall, and I didn't give permission to paint on it!" This answer, of course, embodies the aesthetic of authority in its most direct form. It overtly links ownership of the wall to control over its appearance, and defines beauty and ugliness in terms of power. Others, though, would not be so blunt. Their answer would have to do not with ownership, but with their notion that the wall no longer has a "neat" appearance, that it no longer matches the other nicely painted walls in the neighborhood. Here also is the aesthetic of authority, but now permeating perceptions of everyday life. A preference for precision, an insistence that colors and patterns "match," a fastidiousness of style—these are all dimensions of authority lodged within everyday aesthetics. They constitute a sense of beauty grounded not only in control of property and space, but in the carefully coordinated control of image and design, in the smoothed-out textures of clean environments. They embody a demand that material culture reflect planned and routinized human activity.[27]

This aesthetic of authority surfaces throughout Denver's anti-graffiti campaign. Mayor Peña's revealing summary—"No matter

how good it looks, graffiti is ugly"—has been echoed in a catch phrase disseminated by Valerie Purser and others in the campaign: "The city cannot be an art critic." Campaigners employ this phrase disingenuously to argue that, since the graffiti which one citizen considers art another may not, the city should not impose its artistic judgement, but should instead wipe out *all* graffiti. As Valerie Purser said in a *Rocky Mountain News* article,

> What may be art to me may be offensive to my neighbor. . . . It's easier to say "no" to all of it than to get into these real gray areas. I don't want my government to be an art critic (in Wolf, 1990a: 8).

Putting aside its particular illogic—that to obliterate all graffiti art is to impose critical judgment of the harshest sort—the phrase retains the logic of an authoritarian aesthetic. It embodies the campaign's objection to graffiti based not on its inappropriate color, proportion, or content, but on graffiti's violation of ownership and control. As Purser says in the same article:

> Yes, there is an artistic element [to graffiti], but they are still putting it up on public and private property without permission. The city's not against the art component, but we still have to say that if you put it up without permission, then it's against the law.[28]

In other words, campaigners don't attack particular instances of graffiti on conventional aesthetic grounds; they don't object to some graffiti murals' being too large, or to others' incorporating obscene images or shocking colors. Rather, they refuse to distinguish, attacking all graffiti as inherently inappropriate aesthetically simply because of its disregard for the structures of authority. And, indeed, why should the city bother with being an art critic, since "no matter how good it looks, graffiti is ugly?"[29]

But if the city judges graffiti to be ugly however good it looks, it also judges graffiti to be ugly no matter how worthy its message or legal its production. The force of campaigners' aesthetic

imperative is such that it carries them beyond their own definitions, forcing them into conflict even with legal advertisements and public service efforts. Purser's statement that the city is "not against the art component" of graffiti, except that writers "put it up without permission," has been contradicted in her actions against graffiti put up *with* permission. During 1990, a local radio station created a graffiti-style billboard on Colfax Avenue, and eventually placed a d.j. on the billboard as part of a publicity stunt. According to Purser:

> The mayor wrote them a letter; I called them. . . . I said look, we're trying to fight graffiti and here you're coming out putting graffiti on the billboards, you know, just the opposite. . . . And they got this graffiti style, graffiti billboard, and so more people will get all upset. . . . And so, the result of that, I mean, it was really kind of embarrassing in one sense to me. . . . Here we're supposed to be hosting the [national] Graffiti Summit in June [and] this guy's been like on nationwide t.v., that billboard.

Even when legal, then, "graffiti style" cannot be tolerated; it threatens and embarrasses subscribers to an authoritarian aesthetic.

The case which revealed most clearly graffiti's threat to an aesthetic of authority, though, had unfolded the previous summer. In August, 1989, the Colorado Department of Health and Project Safe, an AIDS outreach organization, commissioned Rasta, Eye Six, ZoomOne, and other local graffiti writers to paint AIDS-prevention murals targeting IV drug users. Painted behind two neighborhood cafes and a food market in central Denver, the murals urged, "Don't Share. Use Bleach," and included an AIDS-hotline number. Soon after the murals were completed, Health Department and Project Safe officials reported that a "sharp increase" in calls to the hotline had given them "hope that the method is working" (Jones, 1989: 4). And a Health Department spokeswoman announced soon thereafter that "the overwhelming response was positive" (in Chotzinoff, 1989a: 8).[30]

The response of the city and its anti-graffiti campaign, though, was anything but positive. Citing opposition to the murals—like

that of a local business association president, who threatened that "we will be going to the governor's office to ask that the word about AIDS be spread another way"—Valerie Purser and the city government attacked the murals on the grounds that they sent a "double message" in regard to graffiti prevention, and that, moreover, "graffiti breeds graffiti" (in Chotzinoff, 1989a: 8, 9). Working through Denver Zoning Administrator Dorothy Nepa—who announced that "they weren't murals. They were signs. They were erected without permits" (in Kirksey, 1989: 5B)—the city issued "cease-and-desist" orders to the buildings' owners. This maneuver forced the Health Department's hand; in October, it spent $400 to paint over the murals.[31]

Valerie Purser later argued that the murals were harmful to "communities that are trying to revitalize and attract new business," and reiterated her claim that the murals would have fostered more graffiti. As in the billboard case, she also spoke of problems with the murals' "graffiti style," and noted that when she met with representatives of the state Health Department, she suggested that "perhaps you need to consider maybe a different style." Eye Six also analyzed the incident in terms of Purser's problems with "graffiti style":

> Part of her job is to keep graffiti off the streets, and I think it burned her gasket when not only did we get permission to do pieces on the streets of Denver but we got paid to do them and we did a public service in the meantime. . . . But what her real intention [was] and what she was really trying to do was to keep the graffiti style of writing off of the streets. No matter what you say, graffiti style is like a type of script. And that just shows how desperate and ignorant she is (in Ferrell, 1990a: 11).

The primary importance of the murals' style was perhaps best captured, though, in the comments of liquor store owner and Project Safe worker Ted Hayes:

> Two ladies from Keep Denver Beautiful came into the store. . . . They told me, we're trying to save walls here. I told them they

could keep on trying to save walls. And we'll keep on trying to save lives (in Chotzinoff, 1989a: 9).[32]

Legal or illegal, in the interest of preventing AIDS or promoting the reputation of a local crew, graffiti style disrupts the aesthetic of authority. It intrudes on the controlled "beauty" of ordered environments, and compels those invested in these environments to respond to it as an ugly threat to their aesthetic domination. Graffiti may lower the economic value of property, or intrude on the maintenance of city politics; but perhaps more importantly to those who control property and politics, it diminishes the sense of ordered style which accompanies them.

The battle over graffiti in Denver and other cities is thus a battle over style—not style in the abstract, but style grounded in the realities of economic and political inequality. Graffiti style, growing out of the alternative eclecticism of hip hop and the cluttered vitality of the street, clashes with the clean, orderly style of authority. In this light, the severity and intensity of "graffiti wars" in Denver and elsewhere—the generous corporate funding and enthusiastic political support, the excessive legal sanctions and enforced degradation ceremonies, the vitriolic pronouncements of political and business leaders, and the passion with which graffiti writers defy these controls—begin to make sense.

In the battle over graffiti—as in battles over ethnicity, generational identity, or workplace control—symbolism and style cannot be relegated to epiphenomena, to products or representations of the "real" conflict.[33] In the same way that style defines the process of writing graffiti, it defines the conflict between graffiti writers and those in authority. Clean buildings, and the appreciation of them, are as much a part of authority and control as police patrols and prisons; and the markings of graffiti writers are as much a threat to this as are protest marches or rent strikes. Moreover, this politics of style confirms the insight drawn from our earlier examinations of graffiti writing and the anti-graffiti campaign: graffiti writing is an inherently political act, a crime of style entangled with the politics of authority and resistance.

This war between graffiti style and an authoritarian aesthetic in turn calls into question the politics of "public space" and "public art." As defined and operated by political and economic authorities, public space and public art are less reflections of the public's will— that is, the interests of people and their communities—than they are manifestations of an authoritarian aesthetic. Pedestrian malls, urban walkways, shopping mall art exhibits—all of these develop from the aesthetic assumptions of authorities, and are designed therefore to enhance consumption, satisfaction, and control. These public places and events present the pleasant face of authority, the comfortable flip side to barbed wire and jail cells. In so doing, they mythologize "public" space and art, seducing citizens into environments which are least their own.

An anarchist perspective can unpack the mythical properties of public space and art along two lines. The first derives from a basic myth of representational democracy: that "public" officials do indeed fairly represent the general population—the "public"—and therefore have both the expertise and the right to decide for others the use of public space. As Public Service Company's Bal Chavez said at the Metro Wide Graffiti Summit, "Public property is for the public good as determined by public officials." The second, as Schiller (1989) and others have shown, develops from the growing private appropriation of even this sort of "public" space. Much of what we take to be public space—in that it is presented as being available for use by the general population—is in fact space defined and controlled by developers, management companies, multinational corporations, and other private interests. Thus, if we define "public" not as governmentally controlled, or as managed "in the public interest" by ATT or Exxon, but as outside the control of governmental or corporate authorities, precious little public space or public art exists.

Graffiti provides a sort of public art outside political or corporate control, and by its presence reclaims public space from city planners, corporate developers, and their aesthetic of authority. In the railyards and the alleys, under viaducts and on back walls, graffiti signifies public life and community creativity amidst the

prefabricated imagery of the city. With its sweeping scale and sudden visibility, it comes closer to engaging the public in the process of art than do the pieces tastefully arranged around courthouse lawns and bank lobbies. And with its origins not in corporate funding or governmental grants, but in the direct action of street artists, it certainly approaches a more concrete and progressive sense of "public" art. Brecht asked which was the worse crime, to own a bank or to rob one? We might ask which is the worse crime, the carefully planned and monitored aesthetic environments, the controlled uniformity, of downtown shopping districts, subway stations, and gentrified neighborhoods, or the graffiti which interrupts them?[34]

Contemporary graffiti thus raises again the question raised by the Paris barricades of 1871 and 1968, by pachucos, pachucas and low riders, and by street kids and street fighters: who owns the streets? As always, answers to this question form not only around politics, economics, and ethnicity, but aesthetics. The battle for the streets is a battle for property and space, but also meaning, appearance and perception. It is a battle over style.[35]

Graffiti Writing and Anarchist Criminology

> We are so perverted by an education which from infancy seeks to kill in us the spirit of revolt, and to develop that of submission to authority; we are so perverted by this existence under the ferrule of a law, which regulates every event in life—our birth, our education, our development, our love, our friendship—that, if this state of things continues, we shall lose all initiative, all habit of thinking for ourselves.
>
> Kropotkin, "Law and Authority," 1886 (1975: 27)

> People of Petrograd, your first task is to destroy this government. Your second is not to create any other. For every authority brings with it, on the very first day, laws and restrictions.
>
> Russian anarchist leaflet, 1921 (Avrich, 1973: 163)

A careful examination of graffiti writing has shown that it constitutes a form of anarchist resistance to political and economic authority. As a crime of style, it clashes with the aesthetics of this authority as well. For their part, economic and political authorities act as moral entrepreneurs as they attempt to criminalize and suppress graffiti writing. Drawing on their considerable epistemic and ideological resources, they work to reconstruct the meaning of graffiti writing as part of their campaign against it.

Graffiti writing and the anti-graffiti campaign thus serve as the sort of case study in power, authority and resistance that can highlight theoretical and methodological possibilities for anarchist criminology. If we take "anarchist criminology" to mean, broadly, an analysis of crime and criminality informed by anarchist perspectives, a variety of foci can be imagined. Certainly, such an approach would critique the encrustation of human relationships in structures of legal authority. Kropotkin (1975: 30) for example found the law's "distinctive trait to be immobility, a tendency to crystallize what should be modified and developed day by day." Tifft (1979: 397, 398; see Tifft and Sullivan, 1980) therefore argues that "justice must be warm, must be living . . . face to face justice," and advocates "needs-based," retrospective justice in place of current rights-based, prospective systems. Pepinsky and Jesilow (1984: 10, 133) argue similarly that we must move from the current criminal justice system, which serves as a "state-protection racket," to more direct, informal networks of "cross-cutting ties" within communities.

An anarchist perspective on crime and justice also emphasizes that, if law and legality are worth preserving at all, their mission must be radically altered; instead of protecting property, privilege, and the state, as they now do, they must be made to insure tolerance and protect diversity. Tifft (1979: 397) contends that a move to needs-based, retrospective justice would be beneficial, since it would encourage "tolerance of ambiguity, acknowledgement of alternative meanings (and reality systems), and respect for diversity." Kevin Ryan and I (Ryan and Ferrell, 1986: 193) have likewise argued that an anti-authoritarian vision of justice "would

entail respect for alternative interpretations of reality and alternative realities. But further, it would require opposition to any attempt to destroy, suppress, or impose particular realities." To this we might add, as does Tifft, that anarchist justice would also allow for, and even encourage, unresolved ambiguities of meaning and identity now forcefully resolved by the rule of law.[36]

Though these sorts of insights certainly set the context, the following discussion takes a somewhat different direction. Developed out of the present study of graffiti writing and the campaign to suppress it, this discussion of anarchist criminology focuses on the politics of criminality and the possibilities for research and activism around this issue.

To get at the politics of criminality, anarchist criminology—or any useable criminology, for that matter—must integrate approaches to crime traditionally categorized as "political/ economic" and "interactionist." The case of graffiti writing clearly demonstrates that we cannot understand the nature of crime without understanding both its immediate construction out of social interaction and its larger construction through processes of political and economic authority. Graffiti writing further demonstrates that "both" is not enough—in other words, that we must not only use each perspective, but find ways to integrate them in our research and analysis. If, as with graffiti writing, the interactional foreground of crime incorporates the politics of criminality, our analysis of it must likewise incorporate political/economic and interactionist insights. In discussing the development of alternative criminology in Britain in the late 1960s, Cohen (1988: 68) has spoken of the "adoption of a structurally and politically informed version of labeling theory." Turned another way, this theory might be thought of as an analysis of authority and power which looks for their presence in the daily situations of criminality. In whatever configuration, this dialectic between situations and structures of criminality, between the style and substance of crime, lays the foundation for an anarchist criminology.[37]

This dialectic means that anarchist criminologists must look up and down at the same time—that is, must pay attention to the subtleties of legal and political authority, the nuances of lived criminal events, and the interconnections between the two. To speak of this as looking up and down does not imply, of course, reverence towards those above or disrespect for those designated as below. Quite the opposite; such a perspective incorporates a fundamental insight of anarchist and sociological thought—that modern societies are structured into hierarchies of authority and power—and attacks these hierarchies and those who ride atop them. When anarchist criminology looks up, then, it is with a different eye than when it looks down and around. As anarchist criminologists look up at authority, they must do so disrespectfully—that is, they must engage in a "vast operation of deconsecration" (Guerin, 1970: 13). When they look down and around at the lived experience of criminality, they must do so respectfully—not with respect for any and all criminal acts, but for the possibilities of meaning that are embedded in them.[38]

The disrespectful gaze which anarchist criminology turns upwards towards authority will, it is hoped, serve to *dismantle* its legal and political configurations. To dismantle is to engage in two related processes, both of which are appropriate to anarchist criminology. The first involves stripping away—dis-mantling—that which covers or conceals. As seen previously, epistemologies of certainty and truth form the mantle of authority; they present authority as a reasonable and legitimate medium for making sense of the world, and in so doing conceal its abuses. And this authoritarian artifice is nowhere better developed than within the law. Increasingly, political, economic and cultural authority hides behind the law; and the inequity of the law is itself concealed behind mythologies of truth and justice.

A critical, anarchist epistemology can tear away these mythologies, exposing the inherent inequities they are designed to conceal. In particular, anarchist criminology is well-suited for investigating the fundamental mythologies of the legal process— that, for example, legal rules and social facts exist exterior to those

who utilize them, and can thus be apprehended objectively—and
for documenting the specific manner in which the powerful create
these rules and facts in their interest. This investigation, it should
be noted, is not an exercise in philosophy, but sociology. It requires
the very sort of integrated approach noted previously, whereby
anarchist criminologists take a political/economic perspective into
the courtroom and the street to observe the interactional dynamics
between cops, judges, lawyers, and criminals. This process of
epistemic demystification in turn leads to a larger project: revealing
that the "justice" by which the legal system defines itself is in fact a
facade for an elaborate system of institutionalized injustice.
Anarchist criminology must demonstrate in case after case that, as
Billy Bragg (1988) sings in "Rotting on Remand," "This isn't a
court of justice, son, this is a court of law."[39]

This dismantling of authority's concealments also necessitates
paying attention to the many covers under which authority
operates. Legal and political authority certainly does permeate the
dynamics of the courtroom, the street dealings of police officers,
and the operation of the prison. But this authority pervades other
areas of social and cultural life as well. Graffiti writing and the
response to it highlight the aesthetics of this authority, and thus its
presence on clean walls and in carefully planned "public" space.
Kropotkin (1975: 27) reminds us that "the ferrule of a law . . .
regulates every event in our life—our birth, our education, our
development, our love, our friendship." The scope of legal and
political authority is such, then, that anarchist criminologists must
pay attention not just to prisons, courtrooms, and other traditional
concerns of criminology, but to each moment of social life—to
people renting houses, negotiating divorces, drinking beer, visiting
art galleries, and otherwise getting on with their daily lives. Each of
these events forms an appropriate domain for criminology; in each
is embedded various subtle dimensions of legal/political authority,
and therefore the potential for legal conflict, criminalization, and
institutional labeling. Dismantling legal and political authority
requires unpacking the various social cirumstances in which it is
hidden.[40]

Dismantling the law in this way—uncovering the myths and circumstances behind which it is concealed—creates the possibility of a second sort of dismantling, as well: taking apart the law as a means of tearing it down. As anarchist and other progressive criminologists make visible pervasive legal mythologies—and thereby expose the inequitable intrusion of legal authority into every area of social and cultural life—they contribute to a more general disrespect for law and authority. Through their own activist scholarship, and in conjunction with other progressive individuals and groups, they begin to unravel the legitimacy of the law. As they engage in "newsmaking criminology" (Barak, 1988) by investigating and publicly confronting criminalization campaigns, unchecked white collar crime, and crusading politicians, they not only stand up to particular public abuses, but tear down the hierarchy of credibility on which such abuses are predicated.

Especially in those cases likely to receive media attention or otherwise be made public, anarchist criminologists can productively draw on a basic anarchist strategy: making fun of authority. In the case of Denver graffiti, it will be remembered, the Denver police department set up a special bicycle squad to look for graffiti vandals in broad daylight. Denver police "arrested" a photo album at a local gallery opening, took it to police headquarters to be photographed, and later claimed that their photographs of it reflected a summer of "collecting intelligence information" on graffiti. Keep Denver Beautiful Education Coordinator Robin Pfeiffenberger and her Clean Team visited local elementary schools, with Robin playing the part of a wall. The *Denver Post* dutifully helped kick off the 1988 clampdown on graffiti by running a photograph of Fie's "END" piece—still conspicuously visible from a main downtown viaduct three years later. And a local weekly that same year labeled graffiti the "Worst Trash Problem" for Denver. When noted publicly, these and other instances are of course good for a laugh; but because they are laughable, they are also instructive. They teach memorable lessons about the absurdity of authority, and provide opportunities for undermining the legitimacy of law and its

proprietors. And as they accumulate, they make the authorities out to be the dangerous fools that they are.[41]

As part of this dismantling process, anarchist criminologists must actively confront and oppose moral entrepreneurs. Although at times laughable in its blundering intensity, the work of moral entrepreneurs cannot be ignored or discounted, since it stands in direct conflict with the progressive goals of anarchist criminology. While anarchist criminologists attempt to dismantle the machinery of law, moral entrepreneurs work to create new laws and new crimes; while anarchist criminologists work to undercut legal authority, moral entrepreneurs expand the scope, structure, and legitimacy of legality. Kropotkin (1975: 30) noted that there existed

> a race of law-makers legislating without knowing what their laws are about. . . . legislating at random in all directions, but never forgetting the penalties to be meted out to ragamuffins, the prison and the galleys, which are to be the portion of men a thousand times less immoral than these legislators themselves.

Today, these legislators work with evangelists, right-wing interest groups, media consultants, and other moral entrepreneurs as they continue to expand legal control "in all directions."

Indeed, opposition to moral entrepreneurs and their campaigns of moral panic may now constitute the primary project of anarchist criminology. Moral campaigns operate as well-planned exercises in victimization and blame, deflecting the public gaze from those in authority and toward those least able to resist it. As part of this process, they create an ideological context in which legal and political authority can be widely expanded, and resistance to that authority legitimately suppressed. At their most successful, these campaigns thus approach the worst form of authoritarian domination: a hegemonic state in which alternatives literally become "unreasonable" or even "unthinkable." Legal and political authorities fight the "wars" of late capitalist society—the "war on graffiti," the "war on drugs," the "war on gangs"—not only against individuals and groups, but against the possibility of resistance.

These various "wars" share strategies of legal manipulation and control, and together draw on sophisticated ideological machines designed to reconstruct the meaning of everyday activities. Significantly, they for the most part also share a pool of potential villains: the young. The war on graffiti interlocks with the wars on gangs, on drugs, and on other "social problems" in that all serve to focus a broad-ranging clampdown on a youthful (and largely minority) population. In Denver, for example, the anti-graffiti campaign has been paralleled by well-publicized campaigns against youth gangs and youthful "cruising." The 1989 state law "concerning the war on gangs and gang-related crimes"—noted previously for its harsh anti-graffiti provisions—has been supplemented in the Denver area by a variety of control strategies. Denver schools have "outlawed gang colors, insignia, hand signals and other indications of membership . . . in a new policy called 'Zero Gang Tolerance'" (Bailey, 1990: 8). Suburban communities have also passed strict anti-gang laws, and a popular local amusement park has even inaugurated "a tougher policy on excluding known gang members or people wearing obviously [sic] gang-related clothing and paraphernalia" (Ensslin, 1991a: 6).[42] The City of Denver has also passed an ordinance regulating car stereo volume, and initiated a clampdown on the primarily Hispanic kids who "cruise" West 38th Avenue, a local thoroughfare, on weekend nights. The combination of these two control strategies resulted, on a typical spring weekend in 1991, not only in a maze of barricades and police officers, but in 293 traffic tickets and 18 arrests along the avenue.[43]

The politics of this organized assault on the young incorporates the same sort of dialectic already seen, between the interactional foreground of crime and the political economy of criminalization. Writing graffiti, cruising the avenue with a pump-up-the-jam stereo, "gangbanging"—these are not only particularly youthful forms of crime, but particularly *stylish* ones as well. And if we look at other contemporary and historical examples, we find the same pattern: the deviant and criminal identities associated closely with youth—zoot suiters, pachucos and pachucas, skinheads, rude boys,

punks—are also the identities which exhibit the sharpest concern
with aesthetics and style. Clearly, the social construction of youth
in our culture is such that young people and their subcultures
accelerate the development of distinctive styles—and thus
distinctive styles of crime and deviance, of an aesthetically rich
criminal(ized) foreground. In the context of shoplifting and other
youthful "sneaky thrills," Katz (1988: 73, 76–77) suggests that this
has to do with the interplay of private and public identity, and
"personal [a]esthetic triumph."[44] Whatever its individual origins,
this confluence of youth and style points to the fact that
"acceptable" youth cultures—those organized around music and
fashion, for example—and "deviant" youth subcultures exist not as
distinct alternatives, but along a continuum of stylized social
marginality and alternative meaning.

The coincidence of youth, style and crime—this
criminalization of youth—develops therefore out of the politics of
youth, out of the relative powerlessness and marginality of the
young, and out of the particulars of their resistance to this. The
political economy of this coincidence reveals a two-pronged assault.
While entrepreneurs of mass consumption and commodified style
profit from some aspects of stylized youth subcultures—through
record and video sales, fan magazines, and fashions appropriated
and resold—moral entrepreneurs profit from others. Corporate
entrepreneurs attempt to reconstruct the stylistic resistance of the
young as a commodity, and sell it back to them; moral
entrepreneurs—their aesthetic of authority offended by the loud
exhuberance, the sheer audacity of youthful style—work to
reconstruct it as crime. The evolution of hip hop reveals this double
bind. Developed by inner city, minority kids as a multifaceted
alternative style, hip hop has been appropriated in some cases into
mainstream commercial culture, and has in other cases come under
legal and political attack. Thus, while pseudo-emcees now rap for
McDonald's commercials, 2LiveCrew, Ice-T, and assorted graffiti
writers dodge police harassment and jail time. On the one side
stands the velvet glove of commercialism, on the other the mailed

fist of the law; and in the middle, a kid with a tape deck and a can of Krylon.

In attacking legal and political authority, anarchist criminologists must be willing to confront the moral entrepreneurs of the moment, and to push for decriminalization and other strategies that can begin to dismantle some of the repressive legal machinery left over from past entrepreneurial campaigns. But anarchist criminologists must also be ready to comfort the victims of past and present moral panics—that is, to side with young people and the often unpopular responses they make to the authority under which they are placed. In this process of standing up to moral entrepreneurs and defending the young against them, anarchist criminologists of whatever age would do well to remember The Who's (1971) definitive injunction: The Kids Are Alright.[45]

This process of siding with the young, and looking beyond politically constructed stereotypes of them to see possibilities of meaning and resistance in their actions, points to the broader approach anarchist criminologists can take when they look down and around to focus on the lived experience of criminality. At its most basic, this approach embodies the notion that it is worth our while to *pay attention* to the particular dynamics of interaction, meaning, and style that evolve in events labeled as "criminal." Anarchist criminologists cannot begin their work by setting themselves up as authorities on crime, and pre-sorting people and events into theoretically convenient categories: political or apolitical, constructive or destructive, innovative or conformist. Instead, they must begin with attentiveness to and respect for the various lived experiences of those they study, with immersion in the realities of writing graffiti, shoplifting, gang fighting, and stealing cars. Such is the politics of paying attention.

These moments of grounded inquiry draw not only on anarchist commitments to epistemic pluralism and social process, but on recent developments in areas as disparate as mainstream U.S. sociology, British cultural studies, postmodern social theory, and feminist theory. Although certainly not reducible to a single

theme, these emerging analytic orientations cluster around some central ideas: The texture of everyday life—the popular culture of people, groups, and events—matters. The choices made and styles adopted within everyday life are profoundly political. Situated language, symbolism, and meaning stand therefore as definitive components of social life, inexorably intertwined with the economic and political structures of society.[46]

These perspectives confirm what we have already seen in examining graffiti writing and other forms of criminality: that paying attention to the foreground of criminality reveals not only the nuances of situated experience, but the presence of legal, political and economic authority in that experience. And as also seen in graffiti writing and other criminal acts, it is not only authority that is played out in the experience of crime, but various forms of resistance to it as well. Paying attention to moments of criminality, then, means appreciating also the possibilities of resistance carried within them.

The possibility of resistance will of course develop differently within different criminal events; more so in some than others; and not at all in crimes that reproduce the violence of present authoritarian arrangements.[47] Anarchist criminologists should by no means feel compelled to discover moments of resistance in all crimes because they find them in some. Still, anarchist criminology is particularly helpful in appreciating the plural and eclectic forms which resistance to authority can take. In the same way that anarchism embraces a plurality of life choices, anarchist criminology can affirm the plurality of resistances embedded in social events and identities which those in power define as criminal. Breaking curfew or breaking windows, doing drugs or getting drunk, shoplifting jewelry or hotwiring cars, riding with outlaw motorcyclists or cruising the boulevard—none of these should be reified and afforded unquestioned respect, but all should be respected, and investigated, for their possibilities. When anarchist criminologists pay attention to such forms of criminality, they may find that these forms embody orientations that get outside the boundaries of authority, if in ways that are sometimes badly

compromised. They may discover shapes and styles of resistance that others ignore.[48]

Such is the case with graffiti writing. Graffiti writing survives as a creative, playful response to a prefabricated culture, a response as disrespectful of legal and political boundaries as it is the private and "public" property through which they are enforced. Graffiti exists as a public art outside the control of public officials, an alternative style outside the circle of corporate style and consumption. Graffiti illuminates the city, but sporadically, less a series of lasting monuments than evocative moments, vulnerable to the give and take of the street. Ultimately, it stands as a sort of decentralized and decentered insurbordination, a mysterious resistance to conformity and control, a stylish counterpunch to the belly of authority.

NOTES

1. Anarchism thus opposes Churchill and Stalin, Reagan and Gorbachev, Bush and Hussein alike, to the extent that all function as "authority figures," as embodiments of appropriated power and meaning. For a brilliant statement of this viewpoint, see Living Colour, "Cult of Personality," 1988.

2. For more on this sort of epistemic authority, see for example Kuhn, 1970; Feyerabend, 1975; The 2nd January Group, 1986.

3. In describing the development of postmodernism—an orientation which, at its best, shares much with anarchism—York (1980/1983: 211) notes that "whatever it was, it was 'ambivalent' and 'ambiguous.'" A number of other writers on postmodernism—Jencks, 1977; Baudrillard, 1985; Jameson, 1985—use the term "schizophrenia" to denote this condition of multiple, ambiguous meanings.

4. See Bennett and Ferrell, 1987; Durkheim, 1951. The notion of the "open road" is, for anarchism, particulary apt; see, for example, Kerouac, 1955; any issue of the Canadian anarchist journal *Open Road*; and this from the Russian anarcho-futurists of 1919: "Long live the international intellectual revolution! An open road for the Anarcho-Futurists, Anarcho-Hyperboreans, and Neo-Nihilists! Death to world Civilization!" (in Avrich, 1973: 54).

5. The social and cultural possibilities of this approach are many. Architecturally, cultural pluralism takes the form of a democratic and inclusive style more sensitive to locality than to conventions of modern architecture. Jencks (1977) speaks of this architecture in terms of collective eclecticism, improvisation, and multivalence; Frampton (1985, 1986) in terms of a "critical regionalism" which resists cultural domination; and Porphyrios (1986: 30) in terms of "democratic toleration, relativism, and conciliatory culture." See also Venturi, Brown, and Izenour, 1977. Might such an architecture find room on its walls for graffiti?

6. May (1989) in fact characterizes anarchism in terms of its opposition to "representation." And see Kropotkin, 1975.

7. For more on the Wobblies, direct action, sabotage, anarcho-syndicalism, and related issues, see, for example, Thompson and Murfin, 1976; Foner, 1965; Dubofsky, 1969; Ferrell and Ryan, 1985. Interestingly, British punks apparently appropriated the notion of "DIY" from British hardware stores, which are often designated as "DIY" or "Do It Yourself" stores; see also Peter Gabriel's 1978 song, "D.I.Y.," and McDermott, 1987.

8. On the uses of humor by the Wobblies and their affiliate, the Brotherhood of Timber Workers, see Ferrell, 1991. As Brotherhood of Timber Workers writer and publicist Covington Hall (no date: 171–172) said, his work with the union "taught me to get everybody laughing at the enemy if possible; there is nothing so effective 'in getting him!'" And, in the words of the old anarchist cry, "I am an anarchist, I am a ragged clown."

9. See Trotsky, *The Permanent Revolution*, 1969; Marx and Engels (1972: 113): "it is our interest and our task to make the revolution permanent"; and Kropotkin (in Guerin, 1970: 74–75): "Permanent revolt in speech, writing, by the dagger and the gun, or by dynamite . . . anything suits us that is alien to legality." As part of this permanent revolt, anarchists must perhaps eventually give up being "anarchists," in the same way that Bonhoeffer (1972: 280) speaks of "religionless Christianity."

Marx, Bakunin, and the betrayals of the First International, Kronstadt, Makhno, and post-revolutionary Russia aside, Marxism and anarchism have much in common, as the Wobblies so well demonstrated in the U.S. The break develops between anarchism and the sort of state socialism that evolved in the U.S.S.R. and elsewhere, though this of course

begs the question: To what extent is the tendency towards this sort of centralized, state socialism inherent in Marxist thought, and to what extent was it the product of specific historical factors? Interestingly, Engels (in Marx, 1970: 17–18) wrote about the "dictatorship of the proletariat" in 1891: "Well and good, gentlemen, do you want to know what this dictatorship looks like? Look at the Paris Commune. That was the Dictatorship of the Proletariat."

10. Becker (1963: 181) prefers "interactionist theory of deviance" to "labelling theory," and rightly so. Good, basic interactionist sociology lays the foundation for this sort (and any sort) of criminology.

11. Or, as Clarke (1976: 179–180) says, "What must also be stressed is the specificity of each style. This means sensitivity not merely to the objective variations in each style . . . but also to the different material and cultural conditions under which the styles are generated." My thanks also to H. Stith Bennett for his insights as to the concrete nature of "people doing things together."

12. As already seen in the case of graffiti writing, crime is, of course, also directly political in the sense of being defined and constructed by agents of the state, moral entrepreneurs, and other authorities, in their own interest.

13. The Smiths (1987) sing, "Shoplifters of the world, unite and take over." Whatever they mean by this, we might mean the following: Shoplifting embodies both an immersion in commodity culture, and a misshapen but powerful resistance to its rules. But what if everyone shoplifted? Indeed—to what extent would that constitute a united takeover of capitalism? This sort of analysis thus moves beyond Merton to consider the *rebellious politics* of deviant or criminal "innovation." See also Jane's Addiction, "Been Caught Stealing," 1990.

14. For more on notions of crime and resistance, see, for example, Scott, 1990; Sholle, 1990; Atlanta and Alexander, 1989; Hebdige, 1979; and Hall and Jefferson, 1976.

15. As the left realists would remind us, this also means paying close attention to the actual, lived effects of these events on their victims. As we do so, though, we must distinguish between crimes against corporations and the state—shoplifting from chain stores, spraying graffiti on "public" property—and crimes which further victimize women, the poor, and other relatively powerless groups. Again, paying attention to the nuances of

distinct criminal events—rather than, for example, lumping all acts of theft together—is critical. For more on the situated rationality of criminal events, see Katz, 1988.

16. See Lyng (1990) on the social psychology of various "edgework" experiences not unlike the graffiti writer's adrenalin rush.

17. See Hebdige, 1979; Atlanta and Alexander, 1989; Ferrell, 1991. Interestingly, in a discussion of people's remaking of mass culture into popular culture, Fiske (1991: 5–6) argues similarly that

> One has to look for the origins of evasion or resistance in the specific social circumstances of those who do this remaking. . . . The main gain is pleasure and a sense of self-control, or at least control over some of the conditions of one's existence. . . . Popular pleasures are socially located and organized by the subordinate. . . . Popular pleasures are often much more located in the body, in the physical, they are much more vulgar.

And as Hebdige (1988: 19, 34) writes in regard to youth cultures,

> I want to challenge the distinction between "pleasure" and "politics" . . . and to pose instead another concept: the politics of pleasure. . . . "Politics" and "pleasure," crime and resistance, transgression and carnival are meshed and confounded.

18. This distaste for scheduling also creates problems in writers' doing "signpainting" for others. Becker (1963: 97, 117) likewise notes jazz musicians' nocturnal schedules as contributing to their deviant careers. See also Melbin (1987) on the conflicts between "nighttimers" and "daytimers."

19. Neighborhood anti-graffiti activists proudly announced to the 1990 Metro Wide Graffiti Summit that, with newly available equipment, they could remove graffiti far faster than writers could put it up. As *The Denver Post* reported:

> Ray Krupa, a resident of the Barnum neighborhood in west Denver, said he has taken it upon himself to wage a one-man war on graffiti in his area. Last year, he embarked on a cleanup of a 110 square-block area. . . . "I'm more efficient than the graffiti taggers," Krupa explained. "I have a truck and a big roller. They're on foot and have a spray can. I can wipe out 20 hours of their tagging in three or four hours" (in Gottlieb, 1990: 6B).

20. Graffiti that comes in off the streets to be co-opted into conventional art worlds suffers not only from the loss of its street vitality,

then, but also from becoming an individually owned commodity to be sold for a profit. See Sanders (1989: 149–163) on the similarities between the artistic legitimation of graffiti writing and tattooing.

Chalfant and Prigoff (1987: 10) also note the irony of graffiti's "imposition" on others in their discussion of "3D," a British graffiti writer:

> To the objection that writers are forcing their art on a public that has had no say in the matter, 3D answers that people are quite powerless in any case to do anything about the esthetics of their surroundings: "In the city you don't get any say in what they build. You get some architect that does crappy glass buildings or gray buildings. No one comes up and says, 'We're building this, do you like it? Here's the drawings, we'll take a poll.' So why should I have to explain what I do? I live in the city, I am a citizen."

21. Under a section on "Social conditions conducive to anarchy and justice," Tifft (1979: 399) notes: "We continue to break barriers and to be committed to risk and vulnerability." The notion of the anarchist as a "ragged clown" captures not only the humor of anarchism, but this vulnerability as well.

22. On the corporate control of "public" environments, see Schiller, 1989.

23. Pink, a female graffiti writer in New York City, says, "Graffiti means 'I'm here'. . . . People think ghetto children should be seen and not heard, that we're supposed to be born and die in the ghetto. They want to snub us, but they can't" (in Mizrahi, 1981: 20; see Atlanta and Alexander, 1989: 167–168).

24. On Third World graffiti, see, for example, Cortazar, 1983; Chaffee, 1989; Sheesley and Bragg, 1991. See also Bushnell (1990) on Moscow graffiti, and Posener's (1982) excellent photographic essay on politically progressive graffiti in Great Britain. Comparisons of First World and Third World graffiti also recall the sharp similarities between internal and external colonialism. Thus, as before, the politics of graffiti writing transcends a narrow conception of individual motivation; the social meanings of "intentionally" political Third World graffiti and "unintentionally" political First World graffiti overlap in the lived politics of authority and insubordination.

25. Elsewhere, an interior designer claims that "the very word graffiti . . . carries connotations of base vandalism," and argues that graffiti

is "an unsightly blemish that cheapens the integrity of the space on which it is inscribed" (Rus, 1989: 268). A New York City council president tells reporters that "graffiti pollutes the eye and mind and may be one of the worst forms of pollution we have to combat" (quoted in Castleman, 1982: 136). A New York City transit official not only contrasts the "ugliness" of graffiti with "clean and decent systems" free of it, but claims that "trains operating with graffiti indicate that something is wrong with the system, and that nobody cares," and that "scribbles are indicative of problems in the organisation" (Vuchic and Bata, 1989: 39–40). And a national writer refers to graffiti as "that symbol of subway anarchy" (Akst, 1990: 334).

26. This authoritarian aesthetic functions as the sort of "incorrigible proposition" about which ethnomethodologists and phenomenologists speak; see, for example, Mehan and Wood, 1975.

27. This authoritarian aesthetic can thus be contrasted with postmodern/anarchist style, which throws off the tyranny of matching, and instead celebrates the "clash" of various colors and styles. This eclectic aesthetic can be seen in various manifestations today: personal dress, home interiors, musical and visual collages, and others.

28. A pamphlet distributed by the campaign gives this argument an historical twist: "The history of graffiti can be traced back to early man's efforts to record events or express himself on the walls of his dwelling place. Graffiti as vandalism started the day the walls belonged to someone else" (Clean Denver, 1988a).

29. Thus, for anti-graffiti campaigners and others, the distinction between aesthetically offensive and acceptable wall art is based not on the internal characteristics/aesthetics of the art, but the aesthetics of authority.

30. See Booth, 1989: 1B.

31. That November, members of ACT UP protested the city's actions by repainting one of the messages; see Kirksey, 1989: 5B. See also Dorothy Nepa's comments at the Metro Wide Graffiti Summit.

32. Later, a photograph of one of the murals was converted into an AIDS-awareness poster for the Colorado Department of Health/Project Safe.

Chalfant and Prigoff (1987: 11–12) record a similar case in Philadelphia. There, an "anti-graffiti task force" offered writers the chance to paint legal murals. However,

the task force, in an excess of zeal, put pressure on local merchants to get rid of murals done in graffiti style on their shops, even though these had been painted with their permission. The task force was apparently opposed not only to illegal graffiti, but to the graffiti style as well, and they forbade the use of graffiti lettering and B-Boy characters with their aggressive poses and expressions on task-force-sponsored murals, thereby engaging in a sort of ideological censorship. . . . The task force, which represents adult mainstream culture and civil authority, rejects graffiti-style lettering and fly-boy characters because they see in them an adherence to values that oppose their own.

33. See Hebdige, 1979; Cosgrove, 1984; Ewen, 1988; Ferrell, 1991.

34. Thus it is precisely the public nature of graffiti that makes it such a threat to "public" officials. As Atlanta and Alexander (1989: 166) argue in regard to graffiti writing,

the criminality of the act is in the subversion of the authority of urban space. . . . The transgression of official appearance is something in which the whole community can enjoin. . . . The means and ends are the same—the simple assertion of the triumph of the individual over authority, of the name over the nameless."

Within the aesthetic of authority, this myth of public space is paralleled by the myth of private space, as well. While "public" officials and their corporate counterparts battle graffiti, private homeowners' associations battle their own members over the aesthetics of private homes. Thus, in Denver's suburbs, one homeowners' association is suing to have a homeowner remove unauthorized "decorative gravel" (Mehle, 1991a: 34), and another has demanded that an elderly couple "remove the paint" from their house "because they didn't ask permission" to paint it (Mehle, 1991: 16; see 1991b: 56–57).

35. On the communards of Paris, 1871, see Edwards, 1973; Marx, 1970.

36. On tolerance, see also Pepinsky and Jesilow, 1984: 134–138. In addition, see Pepinsky, 1978, 1991; Pepinsky and Quinney, 1991. Labeling theory teaches us that situations and interactions carry multiple, ambiguous meanings, until such time as they come to be categorized and labeled by authorities as "criminal" or "deviant." The notion of anarchist justice presumes that the authorities would be removed from this privileged role, thus leaving the ambiguities tolerated and unresolved, or placing their resolution in the hands of an egalitarian community. And in

this sense, perhaps the law needs not to be altered, but destroyed; as Kropotkin (1975: 30–31) says:

> today we behold . . . the detestable fact that men who long for freedom begin the attempt to obtain it by entreating their masters to be kind enough to protect them by modifying the laws which these masters themselves have created. . . ! All this we see, and, therefore, instead of inanely repeating the old formula, "Respect the law," we say, "Despise law and all its attributes!" In place of the cowardly phrase, "Obey the law," our cry is "Revolt against all laws!"

37. Thus anarchist and other progressive criminologies must move beyond the antinomies embedded in the old debate between political/economic and interactionist, macro-social and micro-social, approaches. See Becker (1963: 177–208) and Henry and Milovanovic (1991) on this issue. This sense of an integrated political economic/interactionist approach also points to the incongruity between progressive criminologies and positivist methodologies. As noted earlier, positivist methods miss not only the interactive nature of crime, but its lived politics as well.

38. This argument for different approaches to "studying up" and "studying down" is based on the work of Marcuse (1965), and on Sagarin's (1973) application of Marcuse's work. Both contend that, given the vast inequalities of status and power in modern society, quite different approaches are justified in dealing with those at the top and those at the bottom. See also Becker, 1967; Ryan and Ferrell, 1986.

39. For more on this use of anarchist epistemology to demythologize the law, see Ryan and Ferrell, 1986. Lawson and Appignanesi (1989) likewise provide accounts of postmodern/philosophical efforts at "dismantling truth" in the realms of scientific/rationalist thought. In this sense (and others), the approach which I here call "anarchist criminology" might also productively be conceptualized as "postmodern criminology."

40. This sense of pervasive legal control is nicely captured in Eugene Chadbourne's punk/rockabilly ode, "Breaking the Law Everyday" (no date; circa 1988), where Chadbourne breaks the law "for breakfast . . . for lunch . . . a bunch." See also Henry and Milovanovic (1991) for a fascinating account of pervasive legal/criminal ideology.

41. This argument draws not only on anarchist strategies, but on Sjoberg and Miller's (1973: 139) contention that researchers must work

the momentary breaches and gaps in otherwise impenetrable structures of power.

42. See also Bailey, 1990a: 6; Gutierrez, 1991: 7; Brown, 1991: 10, 28; Ensslin, 1991a: 16; Soto, 1991: 6; McCullen, 1991: 21.

43. See *Rocky Mountain News*, May 29, 1991: 16; Flynn, 1990: 6. Denver city councilman Bill Scheitler echoed local anti-graffiti campaigners in explaining his support for the clampdown on car stereos and cruising: "Thirty-Eighth Avenue has become a gathering spot for cruisers. The concern I have is for the property rights of the residents" (in Flynn, 1990: 6).

44. Much of Katz's work has to do not just with the seductions of crime, but the seductions of adolescent crime, the moral and sensual attractions of evil for the young.

45. Or, as Kelley (1962) argued some thirty years ago,

> Our young people are all right when we get them. If all is not well with them, it is due to what has happened to them in an adult-managed world. . . . Since nearly everyone believes that the "youth problem" is getting worse as the years go by (and this certainly seems to me to be so) it would be logical to assume that we must be doing something wrong, or neglecting something we should do. Let us then try something different, something which seems to be dictated by the findings of researchers. Let us try: Acceptance of all of our young as worthy, valuable, uniquely blessed with some gifts. . . . Involving youth in what is to be undertaken. . . . Cooperation and democracy in the place of authoritarianism.

And for a powerful contemporary restatement of this viewpoint, see Suicidal Tendencies, "Institutionalized," 1983.

For more on the politics of youth, see, for example, Cohen, 1972/1980; Hall and Jefferson, 1976; Greenberg, 1977; Hebdige, 1979, 1988; Brake, 1980; Schwendinger and Schwendinger, 1985. Pepinsky and Jesilow (1984: 139) note that youthful energy is often reacted to as "pathological." Interestingly, other criminologists who argue that youth and crime are highly correlated often fail to see the construction of this correlation by (old) authorities.

Given this politics of youth, it seems clear that youth must be considered a social/political category along the lines of gender, class, and ethnicity.

46. For a sense of the rediscovery of cultural concerns in mainstream sociology, see, for example, Peterson, 1990. Angela McRobbie's work (see, for example, 1980; 1986; 1989; 1990) offers a remarkable blend of feminist, postmodern, and cultural studies perspectives on these issues. For other British cultural studies and postmodern perspectives, see for example Cohen, 1972/1980; Hall and Jefferson, 1976; Hebdige, 1979; Foster, 1985; Chambers, 1986; Connor, 1989. The work of the Frankfurt School, of course, laid much of the groundwork for any politics of culture.

47. Rape stands as an example of a crime where any trace of political resistance or rebellion on the part of the perpetrator is surely obliterated by the crime's perpetuation of violent, hierarchical arrangements. Thus Eldridge Cleaver's (1968: 25–26) "insurrectionary" raping of white women "as a matter of principle" seems in fact to have promoted not insurrection, but the continued domination of both women and ethnic minorities by white males—that is, the very "system of values" it was designed to violate:

> Somehow I arrived at the conclusion that, as a matter of principle, it was of paramount importance for me to have an antagonistic, ruthless attitude toward white women. . . . I became a rapist. . . . I started out by practicing on black girls in the ghetto . . . and when I considered myself smooth enough, I crossed the tracks and sought out white prey. . . . Rape was an insurrectionary act. It delighted me that I was defying and trampling upon the white man's law, upon his system of values, and that I was defiling his women. . . .

For more on this, see Griffin, 1979.

48. Such forms of criminality seem, at the very least, to slip for a moment the constraints of capitalist consumption and legality, to violate the mandate that we "consume quietly and die." As Thompson (1967: 333) writes in regard to the Hell's Angels,

> they are reconciled to being losers. But instead of losing quietly, one by one, they have banded together with a mindless kind of loyalty and moved outside the framework, for good or ill. They may not have an answer, but at least they are still on their feet. One night about halfway through one of their weekly meetings I thought of [Wobbly organizer] Joe Hill. . . . It is safe to say that no Hell's Angel has ever heard of Joe Hill or would know a Wobbly from a bushmaster, but there is something very similar about the attitudes. [The Angels'] reactions to the world they live in are rooted in the same kind of anarchic, para-legal

sense of conviction that brought the armed wrath of the Establishment down on the Wobblies.

And as Hebdige (1988: 35) argues in discussing youth cultures:

> The "subcultural response" is neither simple affirmation nor refusal, neither "commercial exploitation" nor "genuine revolt." It is neither simply resistance against some external order nor straightforward conformity with the parent culture. It is both a declaration of independence. . . . And at the same time it is also a confirmation of the fact of powerlessness, a celebration of impotence.

References

Books and Periodicals

Abel, Ernest L. and Barbara E. Buckley (1977). *The Handwriting on the Wall: Toward a Sociology and Psychology of Graffiti*. Westport: Greenwood Press.

Adler, Patricia and Peter Adler (1983). "Shifts and Oscillations in Deviant Careers: The Case of Upper Level Drug Dealers and Smugglers." *Social Problems* 31: 195–207.

Agee, James and Walker Evans (1960). *Let Us Now Praise Famous Men.* New York: Ballantine.

Akst, Daniel (1990). "Where did all the graffiti go?" *Forbes* 145 (May 28): 328, 330, 332, 334.

Allen, Harry (1989). "Hip Hop Madness" *Essence* 19 (April): 78–80, 114, 117, 119.

Amble, Marty (1989). "The Capitol Hill Area—The Past Year in Review." *Life on Capitol Hill* (March 17): 1.

Asakawa, Gil (1989). "Tag—You're It." *Westword* (March 15–21): 8.

Atlanta and Alexander (1989). "Wild Style: Graffiti Painting." In Angela McRobbie, ed., *Zoot Suits and Second-Hand* Dresses. Houndmills, U.K: Macmillan: 156–168.

Avrich, Paul, ed. (1973). *The Anarchists in the Russian Revolution.* Ithaca, N.Y.: Cornell University Press.

Bailey, Karen (1990). "Schools target gang colors." *Rocky Mountain News* (October 10): 8, 11.

Bailey, Karen (1990a). "One North student ousted in colors crackdown." *Rocky Mountain News* (October 11): 6.

Barak, Gregg (1988). "Newsmaking Criminology: Reflections on the Media, Intellectuals, and Crime." *Justice Quarterly* 5: 565–587.

Baudrillard, Jean (1985). "The Ecstasy of Communication." in Hal Foster, ed., *Postmodern Culture.* London: Pluto Press: 126–134.

Bawmann, Brad (1986). "The Graffiti War." *Up the Creek* (July 3): 11.

Beaty, Jonathan (1990). "Zap! You've Been Tagged!" *Time* (September 10): 43.

Becker, Howard S. (1963). *Outsiders: Studies in the Sociology of Deviance.* New York: Free Press.

Becker, Howard S. (1967). "Whose Side Are We On?" *Social Problems* 14: 239–247.

Becker, Howard S. (1982). *Art Worlds.* Berkeley: University of California Press.

Bennett, H. Stith and Jeff Ferrell (1987). "Music Videos and Epistemic Socialization." *Youth and Society* 18: 344–362.

Ben-Yehuda, Nachman (1990). *The Politics and Morality of Deviance.* Albany, New York: SUNY Press.

Berger, Peter (1963). *Invitation to Sociology.* Garden City, N.Y.: Anchor.

Best, Joel (1989). *Images of Issues.* New York: Aldine de Gruyter.

Bonhoeffer, Dietrich (1972). *Letters and Papers from Prison.* New York: Macmillan.

Booth, Michael (1989). "Graffiti murals give AIDS warnings." *The Denver Post* (August 7): 1B.

Bowers, Karen (1988). "Graffiti photo album seized at art show." *Rocky Mountain News* (April 23): 30.

Box, Steven (1983). *Power, Crime and Mystification.* London: Tavistock.

Brake, Mike (1980). *The Sociology of Youth Culture and Youth Subcultures.* London: Routledge and Kegan Paul.

Bremer, Tom (1984). "Taking the handwriting off the wall." *City Edition* (August 1–8): 9.

Brewer, Devon and Marc Miller (1990). "Bombing and Burning: The Social Organization and Values of Hip Hop Graffiti Writers and Implications for Policy." *Deviant Behavior* 11: 345–369.

Briggs, Bill (1989). "Writing's on wall: Cops OK graffiti scrub-down." *The Denver Post* (January 25): 2B.

Bromley, David and Anson Shupe and J.C. Ventimiglia (1979). "Atrocity Tales: The Unification Church and the Social Construction of Evil." *Journal of Communication* 29: 42–53.

Brown, Mark (1991). "Police score gains against gangs." *Rocky Mountain News* (March 10): 10, 28.

Bushnell, John (1990). *Moscow Graffiti: Language and Subculture.* Boston: Unwin Hyman.

Carnahan, Ann (1991). "Ban on spray-paint sales to minors weighed." *Rocky Mountain News* (April 10): 6.

Carrington, Kerry (1989). "Girls and Graffiti." *Cultural Studies* 3: 89–100.

Cash Box: The Music Trade Magazine (1989). "Special Issue: Hip Hop: The State of Fresh." (May 27): 52.

Castleman, Craig (1982). *Getting Up: Subway Graffiti in New York.* Cambridge: MIT Press.

Chaffee, Lyman (1989). "Political Graffiti and Wall Painting in Greater Buenos Aires: An Alternative Communication System." *Studies in Latin American Popular Culture* 8: 37–60.

Chalfant, Henry and James Prigoff (1987). *Spraycan Art.* London: Thames and Hudson.

Chambers, Iain (1986). *Popular Culture: The Metropolitan Experience.* London: Methuen.

Charland, William (1990). "Urban corps: a 2nd chance." *Rocky Mountain News* (February 18): 100.

Chotzinoff, Robin (1988). "Spray It, Don't Say It." *Westword* (April 13–19): 9.

Chotzinoff, Robin (1988a). "Goodbye, Old Paint Wars." *Westword* (June 22–28): 8.

Chotzinoff, Robin (1988b). "The Writing's on the Wall." *Westword* (November 9–15): 10.

Chotzinoff, Robin (1989). "Child in the Streets." *Westword* (March 15–21): 10–19.

Chotzinoff, Robin (1989a). "Up Against the Wall." *Westword* (August 23–29): 8–9.

Clarke, John (1976). "Style." in Stuart Hall and Tony Jefferson, eds., *Resistance Through Rituals: Youth Subcultures in Post-War Britain.* London: Hutchinson: 175–191.

Clean Denver (1988). *Denver Graffiti Removal Manual* (Keep Providence Beautiful, 1986).

Clean Denver (1988a). "Now You See It. Now You Don't." (Pamphlet).

Cleaver, Eldridge (1968). *Soul on Ice.* New York: Dell.

Clegg, Nancy (1988). "The Writing's on the Wall." *Westword* (May 4–10): 32.

Clegg, Nancy (1988a). "Home on the Strange." *Westword* (September 14–20): 38.

Cohen, Stanley (1972/1980). *Folk Devils and Moral Panics.* London: Macgibbon and Kee.

Cohen, Stanley (1988). *Against Criminology.* New Brunswick: Transaction.

Cohen, Stanley and Jock Young, eds. (1981). *The Manufacture of News: Deviance, Social Problems and the Mass Media.* London: Constable.

Comak, Elizabeth (1990). "Law and Order Issues in the Canadian Context: The Case of Capital Punishment." *Social Justice* 17: 70–97.

Community Accent (1990). "Graffiti battle gets boost from paint company." (October): 25.

Congress Park Newsletter (no date). Denver: Congress Park Neighbors.

Connor, Steven (1989). *Postmodernist Culture.* New York: Basil Blackwell.

Cooper, Dick (1989). "Panel kills gang-involvement penalty in bill." *The Denver Post* (May 2): 5B.

Cooper, Dick (1989a). "Use of assault weapon in crime to add 5 years." *The Denver Post* (May 9): 3B.

Cooper, Martha and Henry Chalfant (1984). *Subway Art.* London: Thames and Hudson.

Cortazar, Julio (1983). "Graffiti." in *We Love Glenda So Much and Other Tales.* New York: A. Knopf: 33–38.

Cosgrove, Stuart (1984). "The Zoot-Suit and Style Warfare." *Radical America* 18: 38–51.

Craddock-Willis, Andre (1989). "Rap Music and the Black Musical Tradition: A Critical Assessment." *Radical America* 23: 29–38 (Published 1991).

Culver, Virginia (1990). "Leaders join to decry anti-Semitic graffiti." *The Denver Post* (May 24): 1,4.

Culver, Virginia (1990a). "Interfaith group denounces graffiti." *The Denver Post* (May 25): 1B, 4B.

Danto, Arthur (1964). "The Artworld." *Journal of Philosophy* 61: 571–584.

Denver Magazine (1988). "They'll Be Great in '88: Our Yearly Sampler of 50 Dynamite Denverites." 18 (January): 33–42.

The Denver Post (1988). "A stain on our reputation." (April 13): 6C.

The Denver Post (1989). "'Homeless' graffiti defaces Utah Capitol." (February 25): 14.

The Denver Post (1991). "What's Up: Paint Misbehavin'." (May 29): 1F.

The Denver Post (1991). "Sting ensnares graffiti stars." (November 22): 8B.

Dickinson, Carol (1991). "Hands-on show gives worries the brushoff." *Rocky Mountain News* (May 31): 108.

Digby, Drew (1988). "Signal sent to graffiti buffs: Clean up or pay up." *The Denver Post* (April 6): 1.

DiPrima, Dominique (1990). "Beat the Rap." *Mother Jones* (September/October): 32–36, 80–81.

Dubofsky, Melvyn (1969). *We Shall Be All: A History of the Industrial Workers of the World.* New York: Quadrangle.

Duggan, Kevin (1990). "Gang graffiti plague owners of garage." *The Denver Post* (March 5): 2B.

Durkeim, Emile (1951). *Suicide.* New York: The Free Press.

Ebron, Paulla (1989). "Rapping Between Men: Performing Gender." *Radical America* 23: 23–27 (Published 1991).

Edwards, Stewart, ed. (1973). *The Communards of Paris, 1871.* Ithaca, N.Y.: Cornell University Press.

Ensslin, John (1991). "Graffiti and gangs intertwine." *Rocky Mountain News* (March 11): 16.

Ensslin, John (1991a). "3 arrested as Elitch's fights gangs." *Rocky Mountain News* (May 27): 6.

Ewen, Stuart (1988). *All Consuming Images: The Politics of Style in Contemporary Culture.* New York: Basic Books.

Feiner, Joel and Stephan Marc Klein (1982). "Graffiti Talks." *Social Policy* 12: 47–53.

Ferrell, Jeff (1990). "Bombers' Confidential: Interview with Eye Six and Rasta 68." (Part One). *Clot* 1: 10–11.

Ferrell, Jeff (1990a). "Bomber's Confidential: Interview with Eye Six and Rasta 68." (Part Two). *Clot* 1: 10–11.

Ferrell, Jeff (1990b). "Graffiti: Rockin' Denver with a Can of Krylon." *Clot* 1: 12.

Ferrell, Jeff (1990c). "Dancing Backwards: Second-Hand Popular Culture and the Construction of Style." In Jean Guiot and Joseph Green, eds., *From Orchestras to Apartheid.* North York, Ontario: Captus Press: 29–43.

Ferrell, Jeff (1991). "The Brotherhood of Timber Workers and the Culture of Conflict." *Journal of Folklore Research* 28: 163–177.

Ferrell, Jeff and Kevin Ryan (1985). "The Brotherhood of Timber Workers and the Southern Trust: Legal Repression and Worker Response." *Radical America* 19: 54–74.

Feyerabend, Paul (1975). *Against Method.* London: Verso.

Filley, Dwight (1989). "Heard on the Hill." *Life on Capitol Hill* (March 17): 7.

Filley, Dwight (1989a). "Heard on the Hill." *Life on Capitol Hill* (April 7): 3.

Fishman, Mark (1978). "Crime Waves and Ideology." *Social Problems* 25: 531–543.

Fiske, John (1991). "An Interview with John Fiske." *Border/Lines* 20/21: 4–7.

Flynn, Kevin (1988). "Graffiti growing like mushrooms in secret places." *Rocky Mountain News* (April 21): 1, 11.

Flynn, Kevin (1990). "Plan aims to quiet booming car stereos." *Rocky Mountain News* (October 11): 6.

Foner, Philip (1965). *History of the Labor Movement in the United States, Volume IV: The Industrial Workers of the World, 1905–1917.* New York: International Publishers.

Fong, Tillie (1989). "Westminster official orders white-power graffiti removed." *Rocky Mountain News* (November 30): 13.

Foster, Hal, ed. (1985). *Postmodern Culture*. London: Pluto Press.

Frampton, Kenneth (1985). "Towards a Critical Regionalism: Six Points for an Architecture of Resistance." in Hal Foster, ed., *Postmodern Culture*. London: Pluto Press: 16–30.

Frampton, Kenneth (1986). "Some Reflections on Postmodernism and Architecture." in *ICA Documents 4: Postmodernism*. London: Institute of Contemporary Arts: 26–29.

Gablik, Suzi (1982). "Report from New York: The Graffiti Question." *Art in America* 70: 33–37, 39.

Gammage, Stephanie (1990). "A nose for crime." *Fort Worth Star Telegram* (August 9): 1,14.

Gamson, William (1988). "A Constructionist Approach to Mass Media and Public Opinion." *Symbolic Interaction* 11: 161–174.

Garfinkel, Harold (1956). "Conditions of Successful Degradation Ceremonies." *American Journal of Sociology* 61: 420–424.

Garofalo, Reebee (1984). "Hip Hop for High School." *Radical America* 18: 27–34.

Garnaas, Steve (1988). "Sprocket spies go on graffiti alert." *The Denver Post* (August 11): 1, 20.

Gavin, Tom (1987). "In memoriam." *The Denver Post* (January 25): 1B.

Goffman, Erving (1961). *Asylums: Essays on the Social Situation of Mental Patients and other Inmates*. Garden City, N.Y.: Doubleday.

Goldman, Emma (1969). *Anarchism and Other Essays*. New York: Dover.

Goode, Erich (1989). "The American Drug Panic of the 1980s: Social Construction or Objective Threat?" *Violence, Aggression and Terrorism* 3: 327–344.

Gottlieb, Alan (1989). "City renewing fight to wipe out graffiti." *The Denver Post* (February 19): 1B, 10B.

Gottlieb, Alan (1989a). "Spray-paint artists defend their craft." *The Denver Post* (February 19): 10B.

Gottlieb, Alan (1989b). "Graffiti signals Denver gangs looking at new neighborhoods." *The Denver Post* (February 20): 1B, 6B.

Gottlieb, Alan (1989c). "Codes, terms indentify 2 biggest gangs in Denver." *The Denver Post* (February 20): 1B.

Gottlieb, Alan (1990). "City leaders vow to persevere in battle against graffiti." *The Denver Post* (May 12): 6B.

Graf, Thomas (1988). "City OKs graffiti—on 1 wall." *The Denver Post* (July 17): 1B.

Greenberg, David (1977). "Delinquency and the Age Structure of Society." *Contemporary Crises* 1: 189–223.

Greenwald, Ted (1984). "Brown and Bambaataa: Funkified." *NY Talk* (August): 24, 26.

Griffin, Susan (1979). *Rape: The Power of Consciousness.* New York: Harper and Row.

Guerin, Daniel (1970). *Anarchism.* New York: Monthly Review Press.

Gutierrez, Hector (1991). "Anti-gang laws approved." *Rocky Mountain News* (May 29): 7.

Hager, Steven (1984). *Hip Hop: The Illustrated History of Break Dancing, Rap Music, and Graffiti.* New York: St. Martin's.

Hall, Covington (no date). *Labor Struggles in the Deep South.* (Unpublished manuscript).

Hall, Stuart, Chas Critcher, Tony Jefferson, John Clarke, and Brian Roberts (1978). *Policing the Crisis: Mugging, the State, and Law and Order.* London: Macmillan.

Hall, Stuart and Tony Jefferson, eds. (1976). *Resistance through Rituals: Youth Subcultures in Post-War Britain.* London: Hutchinson.

Heath, Jennifer (1988). "The mayor's 'troops' overreacted." *Rocky Mountain News* (April 29): 8W.

Hebdige, Dick (1979). *Subculture: The Meaning of Style.* London: Methuen.

Hebdige, Dick (1988). *Hiding in the Light: On Images and Things.* London: Routledge.

Henry, Stuart and Dragan Milovanovic (1991). "Constitutive Criminology: The Maturation of Critical Theory." *Criminology* 29: 293–316.

Herrick, Thaddeus (1991). "Driving out the drug dealers." *Rocky Mountain News* (February 28): 7.

Howard, Betsy (1988). "'Bombing' with the Outlaws." *Muse* (August/September): 12

Howorth, Lisa (1989). "Graffiti." In *Handbook of American Popular Culture*, 2nd ed., Vol. 1. New York: Greenwood Press: 549–565.

Huber, Joerg and Jean-Christophe Bailly (1986). *Paris Graffiti.* New York: Thames and Hudson.

Humphries, D. (1981). "Serious Crime, News Coverage, and Ideology." *Crime and Delinquency* 27: 191–205.

Iler, David (1990). "King of the Hill." *Up the Creek* (January 5–11): 8–9.

Industrial Worker (1912). Spokane: Industrial Workers of the World.

Jameson, Fredric (1985). "Postmodernism and Consumer Society." in Hal Foster, ed., *Postmodern Culture*. London: Pluto Press: 111–125.

Jazzy V. (1989). "Hip-Hop History: D.J. Red Alert Goes Berserk." *Cash Box Magazine* 52 (May 27): 8–9.

Jencks, Charles (1977). *The Language of Post-modern Architecture*. New York: Rizzoli.

Johnson, Gregory H. (1987). "Graffiti can destroy a city." *The Denver Post* (December 2): 7B.

Jones, Tamara (1989). "Writing's on the wall as officials get the word out about AIDS risk." *Los Angeles Times* (August 14): 4.

Katz, Jack (1988). *Seductions of Crime: Moral and Sensual Attractions in Doing Evil.* New York: Basic Books.

Keefe, Mike (1988). Editorial cartoon. *The Denver Post* (April 8): 6B.

Keep Denver Beautiful (no date). "Graffiti Adopt-A-Spot." (Application form).

Keep Denver Beautiful (1990). "Graffiti: You Can Stop It!" (Program for Metro Wide Graffiti Summit).

Kelley, Earl (1962). *In Defense of Youth*. Englewood Cliffs, N.J: Prentice-Hall.

Kelly, Guy (1990). "Volunteers declare war on litter." *Rocky Mountain News* (April 8): 6.

Kerouac, Jack (1955). *On the Road.* New York: New American Library.

Kirksey, Jim (1989). "AIDS activists replace murals after message whitewashed." *The Denver Post* (November 14): 5B.

Kirksey, Jim and Marilyn Robinson (1988). "Racial slurs at Hinkley High miss mark as students reject 'stupidity.'" *The Denver Post* (March 16): 2B.

Kisling, Jack (1988). "The lawless artists have upgraded." *The Denver Post* (April 7): 7B.

Kreck, Dick (1989). "Denver dumpster art now considered trash." *The Denver Post* (March 30): 1C.

Kropotkin, Peter (1975). *The Essential Kropotkin* (ed. Emile Capouya and Keitha Tompkins). New York: Liveright.

Kuhn, Thomas S. (1970). *The Structure of Scientific Revolutions.* Chicago: University of Chicago Press.

Kurlansky, Mervyn, Jon Naar, and Norman Mailer (1974). *The Faith of Graffiti.* New York: Praeger.

Lachmann, Richard (1988). "Graffiti as Career and Ideology." *American Journal of Sociology* 94: 229–250.

Lawson, Hilary and Lisa Appignanesi, eds. (1989). *Dismantling Truth: Reality in the Post-Modern World.* New York: St. Martin's.

Leland, John and Robin Reinhardt, eds. (1989). "Droppin' Science." *Spin* 5 (August): 48–52.

Liberatore, Tanino and Stefano Tamburini (1984). *Ranxerox in New York.* New York: Catalan.

Life on Capitol Hill (1989). "Graffiti Meeting Draws Angry Standing Room Only Crowd." (March 3): 1.

Life on Capitol Hill (1989). "Linker Named to Anti-Graffiti Post." (March 3): 3.

Life on Capitol Hill (1989). "Adopt A Spot." (March 3): 4.

Life on Capitol Hill (1989). "Graffiti Numbers You Should Know." (April 7): 1.

Life on Capitol Hill (1989). "Graffitidiots Driven to Begging." (Photo and caption.) (June 2): 1.

Life on Capitol Hill (1989). "Graffiti Not Art." (July 7): 3.

Life on Capitol Hill (1989). "CIA Slates Graffiti Removal Day." (August 18): 2.

Life on Capitol Hill (1989). "Deface a Building for Christ?" (October 20): 11.

Life on Capitol Hill (1989). "Right/Wrong." (Photo and caption.) (December 1): 1.

Life on Capitol Hill (1990). "Career Cop Ed Thomas To Head CHUN." (January 19): 1.

Life on Capitol Hill (1990). "Anti-Graffiti Poster." (September 7): 10.

Life on Capitol Hill (1990). "Heard on the Hill." (November 2): 5.

Life on Capitol Hill (1991). "CHUN Awards 23 Good Neighbors." (January 4): 2.

Life on Capitol Hill (1991). "LIFE's Man and Woman of the Year, 1991." (January 18): 8.

Life on Capitol Hill (1991). "CHUN Re-Elects Ed Thomas, Others." (February 1): 1.

Life on Capitol Hill (1991). "Unsinkable Group Will Take Back Streets." (March 1): 1, 8.

Life on Capitol Hill (1991). "Warning: Drug Free Zone." (March 15): 4.

Lignitz, Amy (1991). "Graffiti isn't art but is expensive." *The San Bernardino Sun* (August 30): 12A.

Lopez, Greg (1991). "Artist moves from bricks to paper." *Rocky Mountain News* (December 13): 8.

Lopez, Lou (1989). *Gangs in Denver: A Resource Booklet.* Denver: Lou Lopez.

Luckenbill, David and Joel Best (1981). "Careers in Deviance and Respectability: The Analogy's Limitations." *Social Problems* 29: 197–206.

Lyng, Stephen (1990). "Edgework: A Social Psychological Analysis of Voluntary Risk Taking." *American Journal of Sociology* 95: 851–886.

Marcuse, Herbert (1965). "Repressive Tolerance." In R. Wolff, B. Moore and H. Marcuse, *A Critique of Pure Tolerance.* Boston: Beacon: 81–123.

Marx, Gary T. (1981). "Ironies of Social Control: Authorities as Contributors to Deviance through Escalation, Nonenforcement and Covert Facilitation." *Social Problems* 28: 221–246.

Marx, Karl (1970). *The Civil War in France.* Peking: Foreign Languages Press.

Marx, Karl (1972). "For a Ruthless Criticism of Everything Existing." In Robert Tucker, ed., *The Marx-Engels Reader.* New York: Norton: 7–10.

Marx, Karl and Frederick Engels (1972). *On Historical Materialism.* New York: International Publishers.

May, Todd (1989). "Is Post-Structuralist Political Theory Anarchist?" *Philosophy and Social Criticism* 15: 167–182.

McCullen, Kevin (1990). "Longmont landmark torn down." *Rocky Mountain News* (October 11): 26

McCullen, Kevin (1990a). "Longmont will resurrect landmark 'bulletin board.'" *Rocky Mountain News* (November 3): 30.

McCullen, Kevin (1991). "Protesters to target Boulder mall." *Rocky Mountain News* (June 26): 21.

McDermott, Catherine (1987). *Street Style: British Design in the 80s.* New York: Rizzoli.

McQuay, David (1988). "Graffiti puffs up gangs' image, not neighborhoods'." *The Denver Post* (December 27): 1C.

McRobbie, Angela (1980). "Settling Accounts with Subcultures: A Feminist Critique." *Screen Education* 34: 37–49.

McRobbie, Angela (1986). "Postmodernism and Popular Culture." in *ICA Documents 4: Postmodernism.* London: Institute of Contemporary Arts: 54–58.

McRobbie, Angela, ed. (1989). *Zoot Suits and Second-Hand Dresses.* Houndmills, U.K: Macmillan.

McRobbie, Angela (1991). *Feminism and Youth Culture.* Boston: Unwin Hyman.

Mehan, Hugh and Houston Wood (1975). *The Reality of Ethnomethodology.* New York: Wiley and Sons.

Mehle, Michael (1991). "Couple paint selves into a sticky corner." *Rocky Mountain News* (March 1): 16.

Mehle, Michael (1991a). "Association sues homeowners over landscaping." *Rocky Mountain News* (April 18): 34.

Mehle, Michael (1991b). "Covenants breed resentment." *Rocky Mountain News* (June 2): 56–57.

Melbin, Murray (1987). *Night as Frontier.* New York: Free Press.

Metro Wide Graffiti Summit (1990). Author transcription (May 11). Denver, Colorado.

Misch, Laura (1987). "Spray-paint Picassos bloom." *Rocky Mountain News* (August 23): 1, 35–36.

Mizrahi, Marilyn (1981). "Up from the Subway." *In These Times* (October 21–27): 19–20.

Morgenstern, Matthias (1991). "Ein Sprayer tritt ans Tageslicht." *Suddeutsche Zeitung* (July 9): 20.

National Graffiti Information Network (1990). "National Graffiti Information Network December Update."

National Graffiti Information Network (no date; circa 1990–1991). Press Release.

Newcomer, Kris (1988). "Graffiti artists get chance to do their thing." *Rocky Mountain News* (July 17): 8.

The New York Times (1990). "Feminist Graffiti Prompt Debate on Free Speech." (October 14): 39.

O'Keefe, Mike (1990). "Longmont's Love Shack." *Westword* (September 19–25): 6.

Onrust, Ger Jan (1991). "'Tags' en 'pieces' langs Hoornse lijn." *De Volkskrant* (August 7): 13.

Onrust, Ger Jan (1991a). "Politie vindt de daders aan de hand van 'tags'." *De Volkskrant* (August 7): 13.

Onrust, Ger Jan (1991b). "Schrobben, schuieren en schuren." *De Volkskrant* (August 7): 13.

Owen, Frank (1989). "Bite This." *Spin* 5 (November): 35.

Paige, Woody (1989). "The defacing of Denver." *The Denver Post* (May 9): 7B.

Parks, Ron (1990). "Busking." *Border/Lines* 19: 7–8.

Pepinsky, Harold E. (1978). "Communist Anarchism as an Alternative to the Rule of Criminal Law." *Contemporary Crises* 2: 315–327.

Pepinsky, Harold E. (1991). *The Geometry of Violence and Democracy.* Bloomington: Indiana University Press.

Pepinsky, Harold E. and Paul Jesilow (1984). *Myths That Cause Crime*, 2nd ed. Cabin John, Md: Seven Locks Press.

Pepinsky, Harold E. and Richard Quinney, eds. (1991). *Criminology as Peacemaking.* Bloomington: Indiana University Press.

Peterson, Richard, ed. (1990). "Symposium: The Many Facets of Culture." *Contemporary Sociology* 19: 498–523.

Point (1990). Denver: Alternative Arts Alliance (September).

Polsky, Ned (1969). *Hustlers, Beats and Others.* Garden City, N.Y.: Doubleday.

Porphyrios, Demetri (1986). "Architecture and the Postmodern Condition." in *ICA Documents 4: Postmodernism.* London: Institute of Contemporary Arts: 30.

Posener, Jill (1982). *Spray It Loud.* London: Pandora Press.

Public Service Company of Colorado (1988). *Update: A Monthly Information Report to Customers* (July).

Pugh, Tony (1988). "Castle Rock breaks out in graffiti." *Rocky Mountain News* (July 21): 26.

Pugh, Tony (1990). "Mad Dads scrub away gang graffiti." *Rocky Mountain News* (March 5): 8.

Rafter, Nicole (1990). "The Social Construction of Crime and Crime Control." *Journal of Research in Crime and Delinquency* 27: 376–389.

Reinarman, Craig and Harry Levine (1989). "The Crack Attack: Politics and Media in America's Latest Drug Scare." In Joel Best, ed., *Images of Issues.* New York: Aldine de Gruyter: 115–137.

Reisner, Robert (1971). *Graffiti: Two Thousand Years of Wall Writing.* New York: Cowles.

Riding, Alan (1992). "Parisians on Graffiti: Is It Vandalism or Art?" *The New York Times* (February 6): 6A.

Roberts, Jeffrey (1989). "Bill seeks to add teeth to state's war on gangs." *The Denver Post* (February 2): 1.

Roberts, Jeffrey (1989a). "Panel OKs $2.3 million to attack gang violence." *The Denver Post* (February 15): 5B.

Robinson, David (1990). *Soho Walls: Beyond Graffiti.* New York: Thames and Hudson.

Rocky Mountain News (1984). "Peña seeks to erase Denver graffiti." (February 22): 8.

Rocky Mountain News (1989). "Man arrested in graffiti crackdown." (March 14): 26.

Rocky Mountain News (1989). "Graffiti put on Crime Stoppers list." (March 22): 23.

Rocky Mountain News (1990). "A pox on graffiti." (June 20): 46.

Rocky Mountain News (1990). "One man's graffiti is another's art." (July 8): 48.

Rocky Mountain News (1990). "Rangeview High hit with racist graffiti." (October 11): 26.

Rocky Mountain News (1991). "Spray-paint ban hits obstacle." (April 17): 16.

Rocky Mountain News (1991). "Crackdown on cruising nets 18 arrests." (May 29): 16.

Rocky Mountain News (1991). "Graffiti: vandalism or art?" (August 30): 207.

Rocky Mountain News (1991). "Man, 25, found dead in elevator shaft." (October 14): 167.

Rocky Mountain News (1991). "Art Institute teaches with charity projects." (December 8): 2C.

Rose, Cynthia (1988). "New Wave Jazzers." *New Statesman and Society* 1 (November 25): 13–15.

Ross, Joe (1989). "Graffiti Hotline Quiet These Days." *Up the Creek* (December 8): 5.

Rus, Mayer (1989). "The Writing on the Wall." *Interior Design* 60: 268–269.

Ryan, Kevin and Jeff Ferrell (1986). "Knowledge, Power and the Process of Justice." *Crime and Social Justice* 25: 178–195.

Sagarin, Edward (1973). "The Research Setting and the Right Not to be Researched." *Social Problems* 21: 52–64.

Sanders, Clinton R. (1989). *Customizing the Body: The Art and Culture of Tattooing.* Philadelphia: Temple University Press.

Santoro, Gene (1990). "Public Enemy." *The Nation* 250 (June 25): 902–906.

Schiller, Herbert (1989). *Culture, Inc: The Corporate Takeover of Public Expression.* New York: Oxford.

Schrader, Ann and Alan Gottlieb (1990). "Solvent sniffing: deadly and growing." *The Denver Post* (September 23): 1,8.

Schwendinger, Herman and Julia S. Schwendinger (1985). *Adolescent Subcultures and Delinquency.* New York: Praeger.

Scott, James (1990). *Domination and the Arts of Resistance.* New Haven: Yale.

Second January Group, The (1986). *After Truth: A Post-Modern Manifesto.* London: Inventions Press.

Session Laws of Colorado: First Regular Session and First Extraordinary Session (1989). Chapter 153: "An Act Concerning the War on Gangs and Gang-Related Crimes." Denver: Bradford Publishing: 872–878.

Sheesley, Joel and Wayne Bragg (1991). *Sandino in the Steets.* Bloomington: Indiana University Press.

Shiflett, Dave (1991). "Stevens paints a rosy resume while city council targets paint." *Rocky Mountain News* (April 13): 71.

Sholle, David (1990). "Resistance: Pinning Down a Wandering Concept in Cultural Studies Discourse." *Journal of Urban and Cultural Studies* 1: 87–105.

Shover, Neal (1983). "The Later Stages of Ordinary Property Offender Careers." *Social Problems* 31: 208–218.

Sjoberg, Gideon and Paula Jean Miller (1973). "Social Research on Bureaucracy: Limitations and Opportunities." *Social Problems* 21: 129–143.

Slivka, Debra (1989). "Capitol Hill Neighbors Outlast Graffiti Creeps." *Life on Capitol Hill* (March 3): 5.

Soergel, Matthew (1989). "Teens turn gang graffiti into mural." *Rocky Mountain News* (March 31): 12.

Soto, Natalie (1991). "Gang policy at Elitch's questioned by parents." *Rocky Mountain News* (June 16): 6.

Spector, Malcolm and John Kitsuse (1987). *Constructing Social Problems.* New York: Aldine de Gruyter.

Strunk, William, Jr., and E. B. White (1959). *The Elements of Style.* New York: Macmillan.

Thompson, Fred W. and Patrick Murfin (1976). *The I.W.W: Its First Seventy Years.* Chicago: Industrial Workers of the World.

Thompson, Hunter S. (1967). *Hell's Angels: A Strange and Terrible Saga.* New York: Ballantine.

Tifft, Larry (1979). "The Coming Redefinitions of Crime: An Anarchist Perspective." *Social Problems* 26: 392–402.

Tifft, Larry and Dennis Sullivan (1980). *The Struggle to be Human: Crime, Criminology and Anarchism*. Orkney, U.K: Cienfuegos Press.

Toop, David (1984). *The Rap Attack: African Jive to New York Hip Hop*. Boston: South End Press.

Tranquada, Jim (1991). "Graffiti suspect made presence known." *The San Bernardino Sun* (January 14): 5B.

Trotsky, Leon (1969). *The Permanent Revolution and Results and Prospects*. New York: Pathfinder Press.

Turner, Ralph H. and Samuel J. Surace (1956). "Zoot-Suiters and Mexicans: Symbols in Crowd Behavior." *American Journal of Sociology* 62: 14–20.

Up the Creek (1986). "Graffiti War Turns Physical." (July 11): 4.

Up The Creek (1988). "Graffiti Worst Trash Problem for Denver." (August 5): 4–5.

Up the Creek (1990). "Raw Power." (June 1): 4.

Urban Land (1988). "San Francisco Project Winning the War on Graffiti." 47 (October): 27–28.

Venturi, Robert, Denise Scott Brown, and Steven Izenour (1977). *Learning from Las Vegas* (revised edition). Cambridge: MIT Press.

Vuchic, Vukan R. and Andrew Bata (1989). "US Cities Lead Fight Against Graffiti." *Railway Gazette International* 145: 39–41.

Weber, Max (1958). *The Protestant Ethic and the Spirit of Capitalism*. New York: Scribner's.

Westword (1988). "Best Graffiti: The Greenway." (June 29): 17.

Wolf, Mark (1990). "Sociologist defends graffiti." *Rocky Mountain News* (June 19): 8.

Wolf, Mark (1990a). "Art or not, city wants graffiti gone." *Rocky Mountain News* (June 19): 8.

Wright, James G. (1990). "Erasing a community stain." *Rocky Mountain News* (March 11): 7.

York, Peter (1980/1983). *Style Wars*. London: Sidgwick and Jackson.

Young, Jock (1981). "Drugs and the Amplification of Deviance." reprinted in Earl Rubington and Martin S. Weinberg, eds., *Deviance: The Interactionist Perspective* (4th ed.). New York: Macmillan.

Film

Beat Street (1984). Stan Lathan, director. Orion.

Night of the Living Dead (1968). George Romero, director. Continental.

Style Wars! (1985). Henry Chalfant and Tony Silver, producers.

Turk 182! (1985). Bob Clark, director. Twentieth Century Fox.

Wild Style (1983). Charlie Ahearn, director. First Run Features.

Television and Radio

Ellis, Curtis (1991). "Report on National Graffiti Informaton Network Conference in Denver." Mutual Radio Network (August).

"In the Public Eye" (1989). Televised documentary. KBDI, Denver, Colorado.

Wood, Marcia (1990). "Graffiti Ban Challenged." Mutual Radio Network (July).

Discography

Bragg, Billy (1988). "Rotting on Remand," *Workers Playtime*. Elektra.

Chadbourne, Eugene (c. 1988). "Breaking the Law Everyday," *Vermin of the Blues*. (Eugene Chadbourne with Evan John and the H-Bombs). Fundamental Music.

Clash, The (1979). "(Working for the) Clampdown," (Strummer/Jones), *London Calling*. CBS/Epic.

Gabriel, Peter (1978). "D.I.Y.," *Peter Gabriel*. Atlantic.

Ice-T (with Afrika Islam) (1987). "Squeeze the Trigger," *Rhyme Pays*. Sire.

Ice-T and Afrika Islam (1988). *Power*. Sire.

Jane's Addiction (1990). "Been Caught Stealing," *Ritual de lo Habitual*. Warner Bros.

Living Color (1988). "Cult of Personality" (Reid/Calhoun/Glover/ Skillings), *Vivid*. CBS/Epic.

Public Enemy (1988). "She Watch Channel Zero?!" (Ridenhour/Griffin/ Shocklee/Sadler and Drayton); "Night of the Living Baseheads" (Ridenhour/Shocklee/Sadler), *It Takes a Nation of Millions to Hold Us Back*. Def Jam.

Smiths, The (1987). "Shoplifters of the World Unite" (Morrissey/Marr), *Louder Than Bombs*. Sire.

Suicidal Tendencies (1983). "Institutionalized" (Muir), *Suicidal Tendencies*. Frontier.

Who, The (1971). "The Kids Are Alright" (Townshend), *Meaty, Beaty, Big and Bouncy*. MCA.

Formal Interviews

Three years of intensive involvement with the Denver graffiti underground has of course generated innumerable informal "interviews" with graffiti writers and others in and around the scene. The following interviews are only those that were carefully recorded and transcribed, and that provide many of the direct quotations in the book. A lengthy interview with Eye Six and Rasta 68 has also been published in two parts; see Ferrell, 1990, 1990a.

Eye Six (February 20, 1990). Denver, Colorado.

Fie (August 28, 1990). Denver, Colorado.

Kennedy, Joe (February 8, 1990). Denver, Colorado.

Purser, Valerie (December 17, 1990). Denver, Colorado.

Rasta 68 (October 25, 1990). Denver, Colorado.

Voodoo (October 10, 1990). Denver, Colorado.

Z13 (December 6, 1990). Denver, Colorado.

INDEX

ACT UP 202n
"adrenalin rush" of graffiti
 writing 28–29, 73, 82, 148,
 171, 172
Aerosol Art Magazine 10
aesthetics of authority 178–
 186, 202n
 and AIDS-prevention murals
 182–184
 and graffiti-style billboard
 182
aesthetics of crime 159–160,
 167–169, 173
 (*see also* style)
Agee, James 54n
Ali 17n
Alternative Arts Alliance 40
Amaze 36
amplification of crime 146–
 149, 157n
anarchism 160–165
 and ambiguity 161–162, 176,
 188, 197n, 203n
 anarchist epistemology 161–
 162, 179, 189–190, 197n,
 204n
 and architecture 198n
 direct action 163–164, 172,
 176, 198n
 graffiti writing as anarchist
 resistance 172–178, 197

and humor, play 164, 173,
 191–192, 197, 198n
and the open road 162, 197n
opposition to representation
 163, 198n
and postmodernism 197n,
 204n
and public art, public space
 185–186
Russian anarchists 163, 164,
 187, 197n
and vulnerability 174–175,
 201n
anarchist criminology 160,
 186–196
 and the dismantling of
 authority 189–192
 and making fun of authority
 191–192
 and opposition to moral
 entrepreneurs 192–195
 and paying attention to crime
 195–196
anarchy
 imagery of in anti-graffiti
 campaigns 142–143, 157n
Anarchy Alley 55n
anomie 143, 162
anti-graffiti campaigns 5, 152n,
 154–157n, 202–203n
 national scope 12–15, 17n

229

Printed in the United Kingdom
by Lightning Source UK Ltd.
130325UK00001B/283/A